# *THE* Education an Art Director

edited by
Steven Heller and Véronique Vienne

**ALLWORTH PRESS**
NEW YORK

School of
VISUAL ARTS

**Dedicated to Frank Zachary,**
art director, editor, patron of artists, designers,
photographers, and art directors

10   09   08   07   06          6   5   4   3   2

Published by Allworth Press
An imprint of Allworth Communications, Inc.
10 East 23rd Street, New York, NY 10010

Cover and interior design by James Victore Inc.

Page composition/typography by SR Desktop Services, Ridge, NY

ISBN: 1-58115-435-6

Library of Congress Cataloging-in-Publication Data
The education of an art director/edited by
Steven Heller and Véronique Vienne.
p.      cm.
Includes index.
ISBN 1-58115-435-6 (pbk.)
1. Commercial art—Study and teaching.    2. Art direction—
Vocational guidance.    I. Heller, Steven.    II. Vienne, Véronique.
NC1001.E38   2006
707.1'1—dc22
2005028696

Printed in Canada

# Contents

## 04 Is an Art Director an Editor?

## 05. Is Art Direction Design?

## 06. Do You Want to Be an Art Department Manager?

## 07. How Do Art Directors Collaborate with Others?

## 08. Is There an Art to Art Direction?

## 09. Is It "Us" Against "Them"?

## 10. When Is the Editor an Art Director?

## 11. Who Remembers the Good Old Days?

# Acknowledgments

Thanks to all the art directors, designers, editors, publishers, and creative people who contributed so generously to this volume by taking the time to talk to us and share their insight and passion. We are particularly grateful to those who sat down at their keyboard and committed to words their thoughts, beliefs, and observations. Indeed, art direction is a métier that is not easily learned but acquired through experience and through the examples set by celebrated role models, mentors, and peers. The dedication of our contributors confirmed our suspicion that everyone comes to art direction with a sense of purpose and mission.

Thanks to our editors at Allworth Press: Nicole Potter, senior editor, Monica Lugo, associate editor, and Michael Madole, publicity director. Much gratitude to Tad Crawford, publisher, for his continued enthusiastic support of this entire *Education of . . .* series. Also, tips of our hats to James Victore for his cover and interior design.

**—SH and VV**

# Foreword

## On the Phenomenon Known as Art Direction
### A Conversation between
### Steven Heller and Véronique Vienne

**Steven Heller:** Educationally speaking, art direction is a curious phenomenon. Even though I've never seen a class devoted to it, it is a huge profession. Every magazine, newspaper, book publisher, record company, advertising agency, etc., employs art directors. But how do you become one? I've been an art director for thirty-five years (from when I was seventeen years old and still counting). You were one for fifteen years, before becoming a writer. I never went to school to learn how to be one; neither did you. I stumbled into a job and learned by trial and error, with emphasis on error. How do you think art direction should, or can, be taught?

**Véronique Vienne:** My story is similar to yours. I haphazardly studied architecture and industrial design, only to discover, fifteen years into a slapdash career as an exhibit/product/packaging designer, that what I liked best about design was looking at the work of other architects and designers in magazines such as *Domus* and *Graphis*. At the time, I had assembled a huge collection of European design magazines, which I dragged along with me wherever I moved. One day I took a deep breath and decided to dump the third dimension cold turkey and go 2-D—into "flat" design—in order to indulge my passion for glossy pages reeking with the smell of ink and varnish. I boldly looked for a job as a "magazine designer." Back then, I didn't know what an art director was.

I landed two jobs, the first as part-time art director of *Interiors* magazine, the second as assistant to the assistant of the assistant of the art director of *Vogue* magazine. I tried to hang on to both positions, in order to support myself and my daughter, and learned by making so many mistakes I am overcome with embarrassment in hindsight. I still can't figure out how I pulled it off. The one thing I wished I had learned was typography. That's how one can tell whether an art director is trained or self-taught: his or her handling of type.

Do you agree with me that typography is the one essential skill a designer needs to acquire in order to eventually develop into a great art director?

Everything else can be learned on the job—if you have talent—but understanding type is something you cannot fake.

**SH:** I have to admit, in fact sadly so, that I did not know type when I became an art director and have never really mastered the craft. When you luck into a job you don't always come with a full skill set. I believe that typography is the foremost skill necessary in all of design. But I question whether an art director needs to be an entirely skillful typographer. Just the other day I hired a great typographer to finesse a cover that I had done in a rudimentary fashion. I can set a page of type, but I can't make it sing the way this person can. As an art director, I can hire others to make type work, or produce illustrations, or take photographs. I can orchestrate, but I can't play any of the instruments well, if at all. Do you think this is a detriment? Do you believe that an art director is in a curiously jaded position? Or is the art director I'm describing a charlatan?

**VV:** Okay. Art directors are much more than mere layout artists! But art directors with a knowledge of type history and a familiarity with old and new typefaces—their graphic characteristics, their idiosyncrasies, and their limitations—usually have a sharper sense of what a page is all about. It's not so much what they have learned that makes the difference, but the fact that they have spent a lot of time staring at letterforms in relationship to one another. Typography is training for the eye—with a concern for readability, impact, balance.

That said, I was never an accomplished connoisseur of type. So maybe I am just fantasizing. But how else can you acquire the skills you are going to need to combine words and images on the same surface—in such a way as to communicate ideas? Do you think that, all things considered, being a photographer or an illustrator is as good a place to start?

**SH:** Well, now we really have to start defining what an art director really is. And there are many job descriptions that sometimes make the title seem like many jobs. For example, is an advertising art director the same as an editorial one? I don't think that advertising ADs really focus on type (some do, but not all). Moreover, in this new media world, many advertising art directors are more concerned with the look of commercials, wherein type is usually not an issue. Then there are book art directors. Are they the same as corporate or interactive art directors? These Talmudic distinctions can take pages to explain (and we'll do that in the body of this book). But I think we need to start with the operative word in the basic title: *art*.

Sure, we also call this position "creative director," "design director," "graphic communications director," and other honorifics. But this book features "art director" in its title. So what do we mean by *art* in this context? You ask whether an art director should also be a photographer or illustrator (or filmmaker, for

that matter). I think an art director has to be a jack of many trades before becoming an overseer of art. If we first address the issue of art then we might be able to determine how best to evolve into an art director.

**VV:** I am afraid that talking about art in the context of art direction is opening up an even bigger Pandora's box. *Art* is such a scary word for most Americans. In fact, I think that the relationship between word people and image people would be greatly improved if we could get rid of the "A" word. I am a firm believer that the title "visuals editor" is a much better way to describe the profession. That is the title of Elisabeth Biondi, who is the visuals editor at the *New Yorker.* I would love to borrow her title for art directors, who are, in my mind at least, "editors" more than "directors." By the way, the *New Yorker* is a magazine where typography is not center stage. And, like the *New York Times Book Review*—yes, your magazine—it is a well-designed publication that doesn't require the art director to be a maverick typographer. So you can rest your case! Typography is not a major issue. Your point is well taken.

I also agree with you that we need to define in broad terms what is art direction. Maybe we should compare an art director to a chef who must be able to cook up a meal with whatever ingredients are available. The end result is what matters. Is it visually exciting, appetizing, nourishing, stimulating, and, like a great meal, does it encourage people to get together and share ideas and opinions?

In other words, instead of trying to define what an art director does, should we try to define what he or she produces?

**SH:** You are so French. I love the chef analogy. Indeed the art director, or visuals coordinator, or whatever we will eventually call this field, works with many ingredients and various sous-chefs. The only difference—and correct me if I'm wrong—is the editor. I presume you would say that the proprietor (owner) is the editor. For the owner sets the tone, or theme, of the restaurant and the chef creates a menu that adheres to that theme. Unless, of course, you are Mario Batali or Jean-Georges who are both editor and art director, then you conceive the theme and oversee the product (food) as well. As I say this, I realize how perfectly apt this analogy is.

So let's talk about the product. The art director must develop a "menu" (or some might call it a "toolbox") of visual concepts and formats that can be applied by all who work under him or her and that establishes the personality or aura of the entity being art directed. A magazine is closer to a restaurant insofar as there are so many ingredients that must fuse together into an identifiable whole (like the "specialty of the house"), but then surprise is also wanted (like the "specials" of the day). Books, records, advertising are more one-of-a-kind, and the chef must be fairly eclectic or accept eclecticism from the sous-chefs.

Anyway, I've taken the analogy as far as I can. What do you think is the art director's prime responsibility to content and product?

**VV:** Okay. I'll take the chef analogy one step further before dropping it. The prime responsibility of the art director is to feed readers dishes that are both nutritious and appealing—in other words, present the material in ways that are 1) thoughtful and 2) graphically exciting. The thoughtful part—the content—is not as readily visible as the graphic part, and this is sometimes overlooked by art directors who are trained to make things look good, no matter what. Yet, my experience as an art director—and as a fairly decent cook—have taught me that skillful design without quality content is a bad recipe. In contrast, strong ideas, well articulated, usually produce great visuals.

So here we have it. Wouldn't you agree that the prime responsibility of the art director is to think visually?

**SH:** Visual thinking is key. And this is why an art director must be fluent in the languages of illustration, photography, typography, and even decoration— or, at least in a less pretentious sounding way, be adept at working with all of these genres. Art directors determine the look of things, or hire and commission others to develop the styles and forms that contribute to that look. This goes back to the chef analogy or, even more precisely, that of an orchestra leader. The latter hears all the instruments in his or her head. Likewise the art director sees the component parts separately and as a whole and knows the right people to harmonize with.

But the question of content is interesting. How much does an art director contribute to magazine, newspaper, or book content per se? How much is this really about packaging? At what levels do art directors control the environment they work in? At what point are they merely the "hands" of others, who are often less visually minded?

**VV:** Even though the art director seldom contributes to the content directly, it is up to him or her to make the material look smart—inviting, readable, relevant, exciting. If the packaging of the content is poorly thought out and executed, the entire thing is worthless. Often I cringe when I see my own writing in print. It is presented in such a way even I wouldn't read it if I came upon it! In the context of a bad layout, even the most brilliant writing makes no sense at all.

So I would say, the role of the art director is to provide visual intelligence. How do you do that? That's a tough question because it all depends on the editorial direction of a magazine or the branding strategy of an advertising campaign. If, for instance, the editor is unclear about the personality of the publication or if the client is under pressure to solve short-term problems, the art director is almost powerless. But if, on the other hand, the product he or she

is art directing is well articulated, then the sky is the limit as far as creativity and inventiveness is concerned.

When looking for an art director's job, one should steer clear of positions that require you just to jump in and try to do your best while the suits are sorting out their options. In this type of situation, it is almost impossible to be visually intelligent. That's my experience. Whenever I tried to do what's called a "save"—to package something in such a way as to hide its structural flaws—the result was always atrocious. But maybe it's my failing. Were you ever able to make silk purses from sow's ears?

**SH:** Not to be modest, mind you, but I think I've been responsible for a share of sow's ears. But putting self-criticism aside, what you describe raises additional concerns. I believe that design must be integrally wedded to editorial content. Some people read images, others read words, but most of us read both. So the overall design, art, photography, text, and sometimes even the typography should be, in the best of cases, considered "content." Hence the art director's content must complement the editor's content. If the latter is uninteresting, no amount of good design will make the silk purse. A smart art director knows how to wed good editorial to superlative visual material.

Nonetheless, no matter how much I might argue that art direction and editing are equal parts of the same whole, invariably the editor's name appears first on the masthead (unless you are Alexander Liberman), and therefore the art director is beholden to the talent and subject to the temperament of the editor. If all an editor wants is to make the package look good, that's fine. But "good" is a relative term. When visions coincide, the job of art director is easy; when they collide, the art director must subsume his or her vision to the boss. I have never been in a situation as an art director where my ideas were totally disregarded (there has always been a healthy give and take), but I indeed have worked for (and with) editors who wanted different approaches than those I wanted to follow. In baseball, a pitcher must adjust to different batters' hitting styles. Likewise, an art director must adjust to different editing methods. I have managed to do some work that pleases me in situations where I compromised. But I don't think I've ever been able to do the "genius" work that some art directors have produced when they have that rare equal footing with an editor.

Do you think it is possible to have such a sure footing? Or is the job of an art director always compromised by compromise?

**VV:** Invariably—and much to my regret—when trying to assign various roles to the editor and art director of a magazine, I end up with a marriage metaphor, with the editor-in-chief in the traditional role of the husband. But while the bonds of matrimony are loosening up in real life, with spouses today encouraged to redefine their respective roles to fit their aptitudes and talents, in

the world of publishing the bonds of editorial etiquette are still rigidly enforced by the establishment.

Do we need the equivalent of women's liberation for art directors? Should ADs march in the streets to demand equal pay with editors-in-chief? Equal benefits, perks, and bonuses? The right to attend strategy meetings? A say in marketing decisions? Equal opportunity to be invited to pontificate on television? Their names in bold in gossip columns? A spot on the best-dressed list? And full credit for their contribution in the launch or redesign of a magazine?

Is it just me, or are you also upset by the way ADs are systematically marginalized?

**SH:** I agree that some are marginalized, but others—indeed a minority—are not. Bruce Mau, Fabien Baron, the late Tibor Kalman, David Carson, Neville Brody, Fred Woodward, Chip Kidd, Roger Black, and let's not forget George Lois and Milton Glaser, have received their fair share of bold face in mainstream newspapers. This does not take into account great names from the past, like Alexey Brodovitch, Cipe Pineles, Bradbury Thompson, Henry Wolf, and more. Each is or was a designer and art director and their respective visions (and styles) have been deemed important enough to earn them praise from their peers, but more importantly respect in the publishing and advertising worlds.

Glaser got the ball rolling by giving himself the title of "design director" (which has also been morphed into "creative director"). The title alone does not make the man, but it is a more charged alternative to "art director." It further establishes a hierarchy that puts one on a higher level than the other. As design director you are the editor-in-chief of your bailiwick—the lord high sheriff of graphic arts. Of course, it helped that Glaser was a partner in *New York* magazine (with editor Clay Felker and others) and so was indeed on an equal footing. But the title opened the door for others with strong personalities and skill sets.

I don't think we need an Art Directors Liberation Front, but we do need liberated art directors. Whatever the title, this person must show enough confidence, skill, and talent to make a major difference. If this means seamless collaboration, so be it. If it means arguing, fighting, and over-compensating for the second or third rung on the hierarchical ladder, then that's fine too. We all know great art directors who keep their respective entities functioning above the average. Those I've mentioned above are among the leaders, but there are more who are less well known and no less effective.

Okay, before you cut me off, we cannot ignore the facts. Even the most influential art directors are beholden to someone in charge. But so are the editors. So are the publishers. No one is safe from the axe if it is destined to fall. But given that art directors are lower on the ladder, they are often in a more precarious creative position. We've already said that, depending on the specific

editor or publisher, an art director can creatively suffer from their ignorance or benefit from their enlightenment. I believe that one of the purposes of this book is to address how to make the relationships work. Sure, there are plenty of art directors who simply want to hang onto their jobs and will do whatever their master says, even if it is counter-intuitive. So how, in fact, should an art director establish his or her authority? What factors must exist not simply to allow for a smoothly running operation, but for one that encourages the art director to perform brilliantly?

**VV:** The question you raise is so crucial—and the answers so complex— that I am tempted to say: art directors should read this book if they want to stay on the top of their game.

But there is one aspect of the job we have not touched on yet, one that has a lot to do with establishing one's authority. The art director must act as an impresario—as a talent broker. He or she is valuable as someone who knows who's who out there in the art world—designers, photographers, illustrators, stylists, agents, etc. Being able to work with other creative types while managing their fragile egos is a very special skill. The best art directors can develop the reputation of formidable art patrons, and be respected as such. That's why, more important than the salary or the title of an art director, it is the size of the art department's budget that will define his or her status in the team.

When friends call to ask my advice on how to negotiate a salary for an art director's position, my first question is always "What's your budget?"

The money you spend, not the money you make, is a measure of your authority.

Sure, great editorial art directors can come up with wonderful art on almost no money. But it is to the detriment of the artists they hire. And don't get me going on that topic. I am appalled by the way illustrators, for instance, are compensated for their work for magazines. As far as I am concerned, exploiting starving artists should not be part of the art director's job description. The only way to justify the low fees some creative people receive is to feature their work in a first-rate context. Thus, to attract great talent, it is imperative that the art director provides a well-designed environment in which to showcase the work of contributors. Unfortunately, award-winning design makes editors nervous. Have you ever been in a situation where your design solution was rejected as being "too pretty" or "too designy," or "too self-conscious?"

**SH:** Let me address the first part of this first. Budget is indeed very important, and almost a book unto itself. But this all falls under the question of authority. A good editor or publisher will accept a reasonably high budget for the good of the publication. An art director with authority will be able to dictate the terms of that budget. Sure, there are factors beyond the art director's

or editor's control, but an art director must be able to advocate the best possible rates for the most creative work. I hate to say that it comes down to this, but it comes down to who actually holds the purse strings, and how big the purse is. You are correct to say that a smart art director can make a silk purse out of a sow's ear, but that only goes so far. Really being in authority means having the resources to wield that authority.

Now, about "too pretty" or "too designy": I don't think I've ever faced that. But I have faced editors who think so literally that their wants destroy my design. It's not about pretty versus functional, it's about how their ignorance will undo a great page or spread. But when I say "ignorance" I'm not being entirely fair. These editors have a legitimate view of how their publication should look. It is the art director's job to interpret this view and convince them that their goals can be achieved in a smart visual manner either through design, typography, and/or images. I have sometimes met with frustrating resistance to my ideas, and this is what I call ignorance. But who is to say I am right? Who is to say the editor is wrong? Of course, I can feel it in my bones, but maybe the feeling comes from biases that must sometimes be reassessed and altered. That said, I know when I'm not doing a good job (or at least living up to my expectations) because of interference on the editorial side.

Do you believe that art directors are always right? What is the measure of our correctness? Must we have the license to do whatever we think is best, even if the editor does not? I know a few art directors who adamantly stick to their aesthetic and formal beliefs, and reject what the editor wants, saying it is Philistine. Is this the way we must act to reinforce our authority? Or is there another way?

**VV:** Like you, I have run into quite a few art directors who somehow have managed to force their personal aesthetics onto others: Fabien Baron, David Carson, Chip Kidd, just to name some of my favorite mavericks. I don't know how they were able to pull it off—they are probably endowed by nature with a healthy sense of self-worth. And you know what? I envy them. Admire them even. They are not trying to second-guess anyone, yet their work captures a cultural moment—it serves as a visual reference for all of us.

So let me end on a not-so-politically-correct note. Even though some of the best art directors are consummate communicators, facilitators, conciliators, translators, collaborators, and mentors, others, just as good, are visual tyrants with intractable egos. Bless them. They make art direction fun. Edgy too. And unlikely to be hijacked by bean-counters, marketing consultants, productivity experts, and metrics specialists.

In this book, we attempt to define what art direction is—yet my secret wish is that it will forever remain an ill-defined profession.

# Intduction

## Made Not Born: Becoming an Art Director
### Steven Heller

That old chestnut, "so and so was born to greatness," was probably true for Mahatma Gandhi, Mother Teresa, and Martin Luther King. But few, if any, are bestowed with the genetic code or divine destiny to become a great art director. Art direction is not a gift that will alter world events. Yet self-deprecation aside, while art direction may not bring peace, feed the poor, or end racial enmity, it does serve a valuable function that should bring pride to the many who practice it. When done well, art direction is integral to the smooth and aesthetically pleasing flow of communication—which is no small accomplishment in a glutted information age.

But art directors are definitely not born into their caste. In fact, they are barely educated to be art directors. Few art or design schools have dedicated courses. Instead, art direction is a byproduct, and for some it is an unintended consequence. Call it fluke or luck, one basically falls into art direction while trying to be a designer, illustrator, photographer, painter, or whatever else propels one to the crossroads. Art direction is a convergence of various expertise and talent all with a similar focus—to create a visual and textual entity. It is, moreover, a practice that does not demand expertise or talent in any one particular discipline, but rather an understanding (or instinct) that enables one to identify and "direct" others with those skill sets.

Becoming an art director does not require years of art director school, even if one existed. It does, however, demand a smattering of many competencies derived from varied educational and work experiences. Certain art directors are better at photography or illustration, while others are more adept with motion or three-dimensional space, but overall, to be a good art director one must know how to delegate—who to call for the best work to achieve the final product, which is ultimately the result of collaboration.

Ask most art directors in any discipline—magazines, advertising, retail, exhibition—and they will doubtless say they were something else before becoming an art director. I was a cartoonist—or at least I wanted to be—but the newspaper I worked for needed a layout artist. In a way, doing layout was

like an actor waiting tables in anticipation of landing the big role. I got bit parts—I was able to publish a few drawings now and then—but my livelihood (such as it was) came from making newspaper pages for a small underground weekly. As it happened, I learned a lot about typography, composition, color, and the general dynamics of publication design from doing this work. Conversely, my drawing did not improve one iota. I learned a valuable lesson: As a cartoonist I was not nearly as good as I wanted (and needed) to be, but as a layout man I was truly enjoying the process of piecing together (designing) an entire publication. Moreover, I was fulfilled by hiring others to draw and photograph those things that I could not do as well. So I made the decision to stop cartooning and start art directing in earnest when, surprisingly, I was offered the art director's job after my predecessor left for greener pastures.

As a layout man, I was learning the trade and teaching my eye to see in a critical manner. As an art director, I had no clue what I had to do. Running on the fumes of instinct could only get me so far, so it was imperative that I get an education, or at least some quantifiable instruction that would get me to the next professional level. I soon found that I could learn to be a designer, typographer, and even a manipulator of form and technology (in fact, I learned how to strip negatives and make photostats to achieve certain graphic effects), but I was forced to rely on chance to turn myself into an art director.

I had a chance meeting with a remarkable illustrator, Brad Holland, who in turn introduced me to one of the most exceptional art directors of his day, Herb Lubalin. By studying his work for *Eros* and *Avant Garde* magazines, and briefly watching him work, I absorbed more in a short period of time than any extended semester of study would have provided. It wasn't that art direction was easy, but through osmosis I acquired an understanding that made it more comprehensible. Of course, comprehending is not doing, and it took years of doing just to become confident enough to feel like I was truly an art director. Experience is its own reward. Yet in the short term, I carried out art directorial duties as I learned them, in this order: design formats and pages; select art and photographs; argue with editors; hire assistants; determine what will make the best covers; argue a bit more with editors; fine tune the details; argue with editors some more; be proud of and learn from the end product. I also learned that art direction was equal parts management, aesthetics, and personality: Managing the page and all its components (which includes directing the art); setting the aesthetic standard of the publication; and imbuing it with a unique identity that relies on collaboration yet is inextricably part of your own visual personality.

Not everyone can be an art director. It takes a unique temperament. It means having an ego but taking pleasure in the ego of others. It means being comfortable as a catalyst for others' talents. It means having faith in others' talents enough to fight and defend when challenged. It means knowing how to make another's work better. It means accepting the limits of one's own

competence and seeking out the talents of others to bolster it. It means having vision enough to see, define, and direct the total picture.

What is amazing to me about becoming an art director is that everything I learned during this formative stage has accompanied me throughout my thirty-five-year art directorial career. The media, technologies, and styles have changed, but the fundamental notion of what an art director is remains and is now second nature to me. I am not a cartoonist (or any other type of commercial artist), nor do I consider myself a graphic designer per se, but after trial and error, I became an art director. I was not born one, but I have stayed one and will continue to be one.

# 01: Can Art Direction Be Taught?

## Editorializing: Directing Others to See What You See

### Véronique Vienne

I used to think that typography was to art direction what classical architecture was to traditional painting and sculpture: the ultimate discipline, the key to mastering the finer points of an art. I was prejudiced. My grandfather was a typographer, and my great-grandparents were printers. With ink in my DNA, I'd swoon at the sight of metal type. I was ecstatic when I got hired as a paste-up assistant in the art department of *Vogue* magazine, a job that required me to handle pristine sheets of printer's proofs, their black letterforms freshly stamped on thickly coated paper as immaculate as powdery snow.

That was then. Decades later, when my French niece declared that she wanted to become an art director, I encouraged her to study typography at one of the Paris design schools. She looked at me like something that had just crawled out of some pre-Cambrian sinkhole. "You can't get into a good design school in France unless you know how to draw," she explained. "And I can't draw, so I'll never get in." And why should she bother with typography, anyway? She had hundreds of typefaces at the tip of her fingers in her computer.

Next time I was in Paris I managed to wrestle an appointment with one of the drawing teachers at the prestigious École Nationale Supérieure des Arts

Décoratifs (ENSAD), where drawing is not only a prerequisite for admission into the graphic design program—my niece was right—it is also an intrinsic part of the school's philosophy. Founded in 1766, the "Arts Deco" school was originally created to turn mere artisans into accomplished graphic designers (then called "decorators"), people capable of producing high-quality, competitive luxury products such as engravings, porcelain motifs, and wallpaper patterns. It was one of the first schools to acknowledge the role of fine arts in the formation of commercial artists.

"Drawing is a tool for creation," explained Simeon Collin, a senior faculty member at ENSAD. "It is not about illustration. We don't teach students to draw what they see, we teach them to *draw in order to see.*" Needless to say, "decoration" is no longer on the school's curriculum, yet a certain "style" is not excluded. "There is always an element of seduction in French products," he did concede. "The ornamentation is there, no longer on the surface, but hidden in the form itself."

Back in New York, I decided to test Simeon Collin's approach on my School of Visual Arts graphic design students. But since I could not bring into the classroom a live model—nude figure drawing would have raised quite a few eyebrows—I asked them to copy a black-and-white photograph that had been published in the *New York Times* that very morning, a journalistic shot taken at a Baghdad newsstand the day after the general election.

"Show me what you see in this picture," I told them. "Use pencil lines as you would words. Tell me what it is you want me to look at—describe the image by making a drawing of it."

Here, I need to explain what I believe art direction is all about. The role of the art director is to literally "direct" the attention of the audience. Using "art" as an indicator, or a pointer, he or she guides readers as they navigate the page and decipher the information. The layout is a map that tells how to go from point A to point B to point C. Words are road signs. Pictures are pieces of a landscape. Looking at a layout is a physical event not unlike that of crossing an intersection. It is the job of the art director to make sure you don't get run over as you figure out which way to go.

As soon as my students began to draw what they saw in the photograph, they found that they had to make a series of urgent calls. Where should they start? What was the dominant feature? What details should they omit for the sake of clarity? Could they get away with only an outline? How important were shadows? A studious hush fell over the room with only the sound of lead scratching paper—and no one, not even the most awkward draftsman among my students, complained that he "couldn't draw."

Cézanne couldn't draw. His famous still lifes are arrangements of ceramic fruits and paper flowers so that they would not wilt and rot as he painstakingly labored over a sheet of paper, erasing sketch after sketch. Models would refuse to work for him, unwilling to hold a pose long enough for him to capture their

likeness as he painted and repainted over his canvases for days on end. Yet his unwieldy technique was a boon. Where would we be today without Cézanne? He directed us to see things we had never seen before.

My students' drawings were not Cubist masterpieces, but each one of them was revealing in a different way, each one highlighting a unique aspect of the photograph—the density of the crowd, the diversity in facial expressions, the dynamism of the scene, the strangeness of the background.

"Now," I said, "you are ready to art direct."

I gave them a copy of a newspaper article published that same day (a lengthy essay on self-interest as a motivator for human behavior) and asked them to do with words what they had done with their pencil.

"Tell me how you would direct an illustrator to deal with the content of this piece. Which aspects of the story would you want him to dwell on, and which ones would you advise him to disregard?"

The interesting thing is, none of the students asked their imaginary illustrator to "illustrate" the piece. Instead they did what good art directors do: they editorialized. They mined the text for ideas that brought out original angles or provoked unexpected questions. They drew from the text the same way they had drawn from the photograph.

Certainly, studying typography is a worthy discipline. In the past, you were instructed to draw typefaces by hand in order to understand their idiosyncrasies. But similar benefits can be accrued from drawing just about anything—fruits, flowers, animals, landscapes, or nude bodies. And copying a painting, picture, or photograph can be just as engrossing. What seems to matter in this exercise is the physical participation, the hand touching the paper, the sound of the pencil pushing against the grain, the eyes moving back and forth, the sensual pleasure of the task.

Art directing is not simply an intellectual enterprise. The verb *to direct* suggests movement, action, progression. Art direction, above all, requires a dynamic and vigorous involvement with forms.

# Art Direction with Materials at Hand: Studies in Word and Image

## Heather Corcoran and D. B. Dowd

### One

The challenges of professional art direction include concept formation, clear communication, typography, image construction, and visual assembly—making things "fit" inside the visual space and within the concept.

The Visual Communications program at Washington University in St. Louis, Missouri, is dedicated to helping students explore the interplay of word and image. The program has long taken a synthetic approach to graphic education, bringing illustrators, graphic designers, and advertising designers into close contact. Given the current state of hybridization in the marketplace and the potential of interdisciplinary study for broader learning in the field, we have begun to de-emphasize the use of the traditional nouns—e.g., "illustrator" or "art director"—and focus discussions instead on the roles assigned to text and image in the development of creative work. All students are asked to engage the challenges of image-making, copywriting, and typographic investigation, and ultimately, to identify a particular set of strengths. If art directors integrate image, language, and typography, then the rising student must engage these elements individually and severally to learn the creative dynamics of visual communication. We aspire to develop visual decathletes.

In the first year of this program (the junior year), students simultaneously are introduced to the fundamental visual vocabularies of the field and challenged to become visual problem solvers. The first priority for the beginning student is to develop a set of methodologies that consistently yield interesting and clear results. Because this student is new to the material—type and image—his skills may take some time to catch up. Students are asked to find visual ways to record visual phenomena that they observe, book hypothetical trips to assigned destinations and track their journeys, and package objects and animals in nonsensical ways. In each case, there are compositional and design questions to be addressed, but there is also a larger communication problem to be solved. In our experience, if students are exposed to a sandbox of problems (even fictitious ones) early on, they develop a way of thinking that forms the foundation for all of their work. This way of thinking includes a set of visual activities and an order in which to complete them, an approach to analysis, and skills in visual refinement.

### Two

Students across the visual communications curriculum participate in a messaging project at the beginning of their second semester. This project is meant to help them assemble images and text to communicate ideas quickly and efficiently.

4

To begin, students are provided with a list of verbal messages typically encountered in an industrial or commercial context or inside a social organization. Examples include:

- Objects in mirror are closer than they appear.
- Shallow water: don't dive.
- Employees must wash hands before returning to work.
- Watch your tongue.

Each student is asked to produce three (visually unrelated) posters to pay off the given message. But the three posters are not equivalents. In the first, the student communicates the message using the given text and an image that she makes or appropriates. In the second, she makes an image that does the communicating, unaided by textual support. Finally, the student solves the same communication problem typographically—limited to the text of the given phrase.

The categorical limitations of each poster help to establish its communicative possibilities. In the text and image solution, students must find appropriate, interrelated roles for each element of the poster. A Pop Art image of a car crashing into a wall needs the phrase "left lane ends" to communicate its idea; in this context, word and image merge to create meaning.

The pictures in the image-only posters must work harder. Without text, they may require the use of metaphor or integrate several visual sources in order to create communicative associations. Thus, a seat on an airplane rendered in the manner of a life jacket suggests, "Your seat cushion may be used as a flotation device." A metal one-gallon can drips onto the profile of a hand, creating an unnatural-looking divot; we infer "Hazardous material inside." An image of a hand opening a Tupperware container with a desert inside becomes the solution for "Store in a warm, dry place."

The typographic posters are another category altogether. The weight of the communication must be carried by the words. The act of reading is fundamental, but associative leaps are also possible. The counter forms in the *as* in "Employees must wash hands before returning to work" become water droplets; the letterforms of "Stop, drop, and roll" are made from bits of torn paper that suggest fire. The experience of the audience as a reader can be heightened or even counteracted by the behavior of type.

In the end, the student finds a different approach for each poster within given limitations. If she can recognize the potential of an image to solve a particular kind of communication problem, the opportunity for type to solve another, and the potential for a canny combination to address yet a third, she has gained an understanding that will be valuable in future projects.

For an art director, the assembly of elements—however generated, gathered, and shaped—is the name of the game. An art director builds a pithy whole. Students at Washington University are taught to incorporate multiple methodologies into their making processes, always with communication and problem solving top of mind.

# The Ten Rules of Design: Eyetracking Guidelines

## Roger Black

### Rule One: Put Content on Every Page.

Design shouldn't be mere decoration; it must convey information. Or entertainment. A reader should never have to click through button after button to get simple news. Content should be at the surface on every single level.

On the front page of a newspaper, you don't put a picture of George W. Bush shaking hands with Tony Blair; we've already seen that picture, and so it has lost all its meaning. You use the picture of them smiling at each other knowingly, or the picture of the observer on the sidelines looking skeptical.

With Web sites, it's the same thing: try to get to the content. Oddly, the latest design sensation—the blog—works very well in this regard. In the log section of a blog, the latest posting is on top. This makes it easy for the user and the producer.

### Corollary to Rule One

Nobody reads anything. The only person who will read every word of what you've written is your mother. Everybody else is too busy. And most people don't read all the way through a word. On the Web, they move on as soon as they grasp a meaning. To see how people read a content site, see Poynter's Eyetrack III study (*www.poynterextra.org/eyetrack2004/index.htm*)

In magazines and on Web sites, people skim and surf. If you don't give them something quickly, they absorb nothing.

Make it easy to read. Most sites try to crowd too much onto a page—much better to break information down into smaller bits. This is not to suggest that you always throw out text; just try to make it as accessible as possible.

### Rules Two, Three, and Four: The First Color Is White. The Second Color Is Black. The Third Color Is Red.

Calligraphers and early printers grasped this more than five hundred years ago, and experience has proven them to be exactly right.

In print, white is the absence of all color, while in video, it's every color firing at full strength. It is the brightest color; it should be used much more in design. And it's even more important on the Web. White is the best background (see the logo for Google.com). Black holds the highest contrast to white, and so it is the first choice for type set on a white background. Yet we still see—on the Web and in print—designers running amok and putting yellow type on an orange background, or worse. (You can't read it because there isn't enough contrast between the figure and the ground.)

Why do designers do it? Because it's easy to do and they labor under the misconception that they must be novel. (Sorry, illegible design has been around for years.)

(Hint: If you can't stand a white background, use a black background with white type. The worst that can happen is that people will think you support free speech of the Net). Last choice: a light gray or neutral color background, to soften the page a bit.

And then there is red. Yellow won't read against white; blue fades against black. But red is perfect. Red headlines sell magazines on newsstands twice as fast as any other color. There are certain hardwired facts about human visual response that you'd be a fool to ignore. Like instinctive reactions to colors. Red is nature's danger color and it is a great way to add accent to a black-and-white page. (Warning: Some shades of red work better than others against a black background.)

## Rule Five: Never Letterspace Lowercase.

When you do this, the natural, built-in rhythm of the letters is ruined. Despite the current trend in book jackets, this is simply not done. Frederic Goudy put it best: "A man who would letterspace lowercase would shag a sheep."

## Rule Six: Never Set A Lot of Text Type in Small Caps.

It's much harder to read. (Exception: The late Hunter S. Thompson)

## Rule Seven: A Cover Should Be a Poster.

A single image of a human being—preferably a female model in a swimsuit—will sell more magazines than multiple images or all type. This works with the centerpiece or stage of home pages too.

## Rule Eight: Use Only One or Two Typefaces.

Because of the total availability of fonts, we see designers employing scores of fonts on every screen and page. But designs are pulled together with only one or two. The best combination of two: one light and one bold. (Hint: This works with colors too.)

## Rule Nine: Make Something Big.

Type looks great in big point sizes. A bad picture always looks better bigger. The contrast is boosted if one item is big. Of course, a Web site is not a poster, and people expect a lot of functionality (and content) on a page. But if you emphasize one image, it makes the design come alive. It's all relative.

## Rule Ten: Get Lumpy!

The trouble with most design is that it contains no surprise. Page after page of HTML type may be okay if you are running a scientific research site, but if you really want normal people to pay attention, you have to change your pace.

What is lumpy? A magazine of consistent texture (say fifty-fifty text and graphics) that suddenly runs three two-page spreads, or several pages with a hundred items.

What we get too often is a monotonous rhythm of pictures, headline, picture, text, ad, headline, picture, text, ad, headline, picture, text, ad, and so forth. A pudding without the raisins. A stew without chunks of meat. Newspapers are the worst offenders. No wonder no one under thirty reads them! Why can't a newspaper occasionally run a full-page picture? Or a ten-thousand-word essay? Wake the reader up!

The world is still waiting for lumpy Web sites.

*Adapted from "Web Sites that Work," Adobe 1997. With Sean Elder.*

# 02: Can *Anyone* Become an Art Director?

## Lauren Monchik

I lied about everything. I said I used Macs, knew Quark, and lived in New York. The truth was I couldn't use a mouse, hadn't heard of Quark, and lived in Massachusetts. But I was sitting in an art director's office, facing the possibility of landing my dream job—working at *Ms.* magazine.

It was 1995 and I had just graduated from the type of college that proudly does not teach job skills. At the time, Wesleyan's English Department had a soft spot for theory, the Victorian era, and Marxism, so as an English major my transcript was full of straightforward, punky course titles like "Girl Talk," "Organizing for Popular Rule," and "Displacing Traditions." But I also studied biology and spent six months living on a research vessel in the Gulf Stream. It was this experience that helped me the most during my *Ms.* interview. The art director loved manatees and although my research had nothing to do with manatees (I was studying the concentration of tar and plastic throughout the Gulf Stream), we spent most of the interview talking about various funny-looking but loveable sea creatures.

Even though I didn't really know anything about manatees and had an English degree instead of a portfolio, *Ms.* hired me. I couldn't wait to "learn on

the job"—it sounded so grown up. I pictured myself trying to keep up with my art director, taking notes as she rattled off advice, explanations, and introductions, imagining a world of photographers, writers, and long lunches. But the closest I got to writers and photographers was inputting text corrections and running portfolios back and forth to the mailroom. And my heels did not click down the hallway in tandem with my art director's, mentor's, and protégé's, as they did in my imagination. High heels were scarce and hallways were short at *Ms.*

In 1995, the magazine, like feminism, was redefining itself. Editorially, *Ms.* was trying to be relevant to two generations of readers—women who came of age in the early 1970s and women who were born in the early 1970s. Several saucy, pop culture–focused feminist magazines like *Bust* and *Bitch* were launched around the time I started working at *Ms.*, and although I subscribed to them, I loved working with women who had lived through the early days of the feminist movement.

My art director taught me how to use and critique the power of design. My first assignment required me to spend hours looking at offensive ads. At the time, *Ms.* did not print paid advertisements, but it did reprint sexist ones. I was responsible for laying out a monthly section called "No Comment" in which we selected the most obnoxious ads submitted by our feminist readers (a leggy woman sprawled on the hood of a hot rod, for instance) and reprinted them without any commentary. The ability of chauvinistic design clichés to predictably titillate and offend was fascinating. By simply reprinting them, *Ms.* editors transformed a commercial tool into a political statement. I was hooked.

Design at *Ms.* focused on content and context. My art director taught me to use the inherent power of photography, illustration and layout to enforce our political agenda and subvert others. As the "baby designer," as my assistant art director lovingly called me, I searched for not-too-thin models and commissioned illustrations that included more than just white skin tones. And when that failed, I used Photoshop. (Unlike my junior designer friends at Condé Nast, I did not use the stamp tool to erase and lighten.)

But my art director didn't teach me *how* to design. We were at a monthly two-color magazine. We used two typefaces—Sabon and Cheltenham—and adhered to a nice, clean three-column grid. There was not a lot of room within the template to experiment. And my Quark skills were still a bit limited. She did, however, teach me to have margarita lunches after stressful closings and how to color spec the perfect coffee (the shade of a brown paper bag).

At *Ms.* I learned about context; after a while, however, I felt that I needed an art director who could teach me craft. So I left Gloria Steinem for Martha Stewart. Or, more accurately, for Martha Stewart's book publisher, Clarkson Potter.

Originally I worried that I would never find the close-knit and inspiring community I left at *Ms.* I was wrong. Although *Ms.* and Potter were opposites in

many obvious ways—*Ms.* was then a financially struggling, two-color political magazine (it is now profitable and four-color), and Clarkson Potter is an illustrated lifestyle book publisher within Bertelsmann, one of the world's largest media corporations—both art departments were run by very strong and nurturing female art directors.

At Potter there were few conversations about abortion rights or welfare reform. There is not a lot of opportunity to discuss politics when you are working on books titled *Blue and White Living, Adirondack Style*, and *Lorenzo's Antipasto*. Instead, we talked about typography, especially my art director's soft spot for illuminated manuscripts. She taught me how to kern and cast-off and tried not to look too horrified when I said the leading on my first project was "auto." She called me "Miss Lauren" (which sounded surprisingly empowering), referred to my dates as "beaux," and cared for her art department like a mother hen. Instead of overtly fighting for a political cause, she fought for us—her designers. More acting locally than thinking globally. I think Bella Abzug would have been proud.

Mostly, she gave us time to play and fail. She embodied her motto "a job is what we do for money; work is what we do for love," and we all worked hard. But she scolded us for working late too often and left every day at 5:30 to be with her family. When I did stay late or came in on weekends, I rarely confessed to it—I was embarrassed that I couldn't do the work during regular working hours. I learned to value sketching and exploring. I stayed at Potter for several years.

After learning from two art directors with entirely different interpretations of design, but similar methods of teaching it, eventually I became an art director. I interviewed portfolio-less designers and asked about Quark skills. As a little "baby" designer, I never realized how hard it was to determine what a new designer needs to know and how to teach her what she doesn't know. I started by having them critique a bunch of popular advertisements and calling them "Miss . . .".

# A Girl for the Job: The Most Unlikely Sports Chick

## Nancy Cohen

I hear myself at lunch. Seated at a power table on 57th Street, over seared tuna, looking consciously professional in my black fitted jacket, I hear myself make a strong, impassioned pitch to be the creative director of a sports magazine. I tell the editor-in-chief, Gary Hoenig, that his baby, his startup publication needs a unique, never-before-seen visual presence and that I, Nancy Cohen, am the man for the job.

Gary's aura is overwhelming; he's a New York bear of a man, furry and neurotic. Ever since our conversations began about my coming on board to design a prototype and test issues for a new *ESPN* magazine, I have been drawn to his warmth, to his egalitarian, magnanimous approach. He is a smart man, and somehow it feels like I've known him my whole life. The idea of working with someone who wants to bring a little wit and self-deprecating humor to the world of sports really appeals to me. As he asks for his fourth individual baguette (this was pre-Atkins), I want very badly for him to take me to a Knicks game and buy me a hot dog. I can see us now: I'd be wearing a well-broken-in pair of 501s, brown cowboy boots, and red lipstick. I'd start checking the scores in the paper, and would rip off stats with the greatest of ease. I'd forgo my veggie burgers for chicken wings. I'd be the ultimate sports chick of the nineties.

But wait. Sports? I've spent five years designing an esoteric architecture and design publication, *Metropolis*. Our most recent cover featured an avant-garde $95 toilet brush. Now, I was getting itchy to branch out, to have an actual budget, to make my mark on a more mass publication (and to have someone else do the scanning!). Sports? I could be passionate about Sports. Sports are okay. Sports.

"Sports!" I say to Gary, trying to look him in the eye and rally around his ideas. Sports. He probably played football. Sports. I did once play Varsity field hockey. Each fall I would break out my little red and blue kilt and attempt to present myself as a jock. Of course, I had absolutely no muscle or body weight to speak of and was, in general, terrified of getting hit with the stick. This didn't seem to bother Gary, who was busy pontificating as he eyed my leftover risotto cake. "It's about spirit. It's about the fan. Fuck the journalist, what does the sports *fan* want? We're all part of a team," Gary says, describing his staff and the collaborative editorial process he hopes to create. He could change the face of sports journalism and I could be a part of it. I could muster up a little team loyalty for the sake of being on his. Why not! Sports!

Soon after I arrived at our enclave within Hearst Magazine Development, it was evident that Gary had not just made an exception for me—I was not the only one who knew little about the topic. He had clearly put together an eclectic staff from different editorial backgrounds. And, most interestingly, it was a decidedly co-ed group. Granted, there was a definite division of labor. Most of

the editors and researchers were men; the women were in other roles: photo editor, copy editor, managing editor. They weren't jocks either, and, along with the guy editors, came from a broad spectrum of magazines and newspapers. It was a smart strategy on Gary's part, conscious or not. For it would have been all too easy to stock the place with an all-male sports-fan staff. There is certainly no shortage of straight male art directors in dire need of proving their testosterone levels (isn't that why, after all, we have awards ceremonies?). I wound up hiring two women for the art department, as well as our lone gay man, the production director.

The mix added a nice tension. Not necessarily sexual tension because, at least as far as I know, there were no extracurricular activities going on in the sidelines. But the back and forth banter, the relationship advice, the lunchtime debates on OJ, Columbine, Whitewater . . . our group dynamic was certainly made more lively by the fact that there were members of both teams around (well, three if you count our production director). A great *His Girl Friday* energy hung in the air.

The tension didn't just make our group socially interesting, it also affected the content and process of getting the magazine out. Clearly, the female influence was invaluable. Yes, things could have gone more smoothly. Yes, meetings sometimes ran longer because things had to be explained over and over again. But those simple breakdowns that were required—plain, everyday language— became the basis for our user-friendly approach to sports journalism. After all, if you can't explain something clearly to a novice, how can you squeeze a big idea into a small caption or a 150-word sidebar? Soon I was beginning to understand the difference between yards-per-rush and yards-per-pass.

I felt right at home very quickly. The males in my own family were also loud and demanding sports fanatics, and they—along with the women—were equally vocal with strong opinions on just about everything else. A healthy debate was constantly brewing somewhere in my house—over anything, and our holiday dinners, in particular, were basically a competition for "the ball" (only the loudest voice got game). This "training" was useful to me. Story meetings at *ESPN* were . . . just like Thanksgiving! These hairy guys were just like my dad and brothers, and in a few weeks on the job, I was somehow able to muster up unyielding point of views about a subject I knew next-to-nothing about. Plus, the good news was that my family *finally* understood what it was that I did for a living. All of a sudden, I was the envy of all of them. After designing issue after issue at *Metropolis* on topics like "The Greening of Architecture," "Achille Castiglione," or "Furniture Fair Roundup," this was finally something my family could . . . grasp. "Oh, sorry, can't make it to that BBQ. I'm heading to Orlando to shoot Ken Griffey at spring training." "Just got back from a Cal Ripken shoot, you should see the gym he's got behind his house." "Oh, I was in D.C. doing a feature on some new kid from G.W., Allan Iverson" (they'd never heard of him).

Photographer: Timothy Greenfield-Sanders; art director: Nancy Kruger Cohen; ESPN Pro Basketball; Fall 1995.

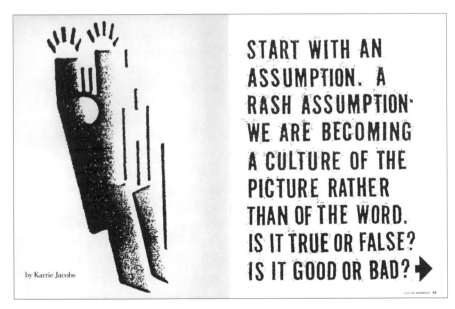

Art directors: Carl Lehmann-Haupt and Nancy Kruger Cohen; illustration: from *Handbook of Pictorial Symbols*, by Rudolf Modley; *Metropolis* magazine; June 1991.

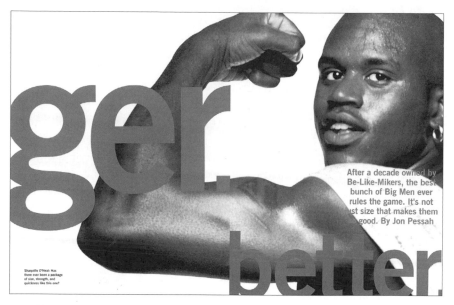

After a decade owned by Be-Like-Mikers, the best bunch of Big Men ever rules the game. It's not just size that makes them good. By Jon Pessah

Shaquille O'Neal: Has there ever been a package of size, strength, and quickness like this one?

Photographer: Mark Seliger; art director: Nancy Kruger Cohen; ESPN Pro Basketball; Fall 1995.

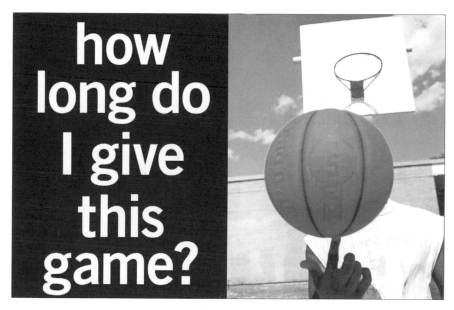

how long do I give this game?

Art director: Nancy Kruger Cohen; photographer: Evan Kafka; ESPN College Basketball; Fall 1995.

Needless to say, there hadn't been much discussion at *Metropolis* about who would be the first-round draft pick. There, we were into deconstruction and irony, rewarded for subtlety and intellect. Each month at *Metropolis* had been a typographic experiment; we were self-consciously into using one font—a different one each issue—soup to nuts, in everything from headlines to captions to body text. I also had developed a preference for all lowercase type (which in the early nineties was not mainstream). My style at the time was certainly not demure, but it also was not within the norm of "guy sports magazine." Gary was tired from a lifetime of looking at expected, traditional sports iconography. For ESPN's new magazine, he wanted it to be as groundbreaking as the cable network, and was open to just about anything. To me, he seemed to speak in Trade Gothic Bold Two, all lowercase. We used it for headlines, decks, pull-quotes, captions, everywhere but the body text; this was quite different from the cold and aggressive "all caps" type used at other sports publications. It seemed open and approachable, not unlike Gary. And not unlike the voice we wanted to be—conversational, friendly, the guy sitting next to you at the game. It couldn't have been speaking to a more different audience than the urban planner or architect I was used to facing. I was not only learning a whole other language, but, as a group, we were creating one too.

All the editors seemed comfortable speaking in Bold Two, too. And soon, we girls in the art department were able to tell you the team colors of just about every team in the NFL, NBA, and Big Ten ("Oh, Robin, that sweater you are wearing is soooooooo Michigan yellow"). And in between the nuts-and-bolts profiles on coaches and all-stars, we were able to take some of the staples of women's magazines and translate them into something relevant for our reader. For example, we did a fashion timeline on the history of basketball shorts (hemlines go up, hemlines go down). Or a roundup of helmet styles throughout the century. We used a lot of silhouetted headshots of players, also a style that back then didn't usually make it into men's magazines. But it was always done in a straightforward and unfussy way, so as not to alienate our macho reader.

Of course, no art director can resist layouts or typography that work on multiple levels. And, after all, Gary said we never wanted to talk down to our audience. One of my favorite concepts was the table of contents for our "Year in Sports" issue: a still-life photo of a remote control, which took up the whole page. Each sport we covered corresponded to a different page-numbered button. This clicker seemed to embody everything we were about, and we were, after all, the print version of the world's most successful sports channel (it was also the one layout we did that won an SPD silver medal). And in a feature about a Russian hockey player, we used bold red pull-quotes in perfect square-shaped boxes (much to the chagrin of the editor, who had to edit them down to fit perfectly). It is doubtful that our average hockey preview reader ever caught the reference to this player's Soviet communist past, but at least it looked good in the portfolio.

The outsider influence on the magazine was perhaps most visible in our approach to photography. Although today it may seem like no big deal not to use traditional "sports photographers," back in 1995 this was a novel concept. My experience at *Metropolis* clearly was an influence; there, we could not afford to pay competitive rates, but people would work for us anyway: the bigger names, because they got to do something unusual or personal (basically, whatever they wanted); the young unknowns, because it was their chance to be published.

At *ESPN* we departed from the longstanding "your father's magazine" tradition of action shots and sports portraits, and instead invited photographers from other genres—fashion, architecture, documentary—as well as young upstarts to create the photographic narrative of the pages. It paid off; these photographers challenged convention, and showed us a different view of sports heroes. Instead of a blurry action shot of Keshawn Johnson, we captured an image of him in the middle of Times Square, looking like the phenomenon he was about to become.

Granted, there were trouble spots. For our "Who to Watch" issue, there was a piece about a rookie baseball player named Alex Rodriguez (few had ever heard of him back then). The portrait, done by a fashion photographer, was gripping. We made it even more intense by blowing up his face across the whole spread.

The reaction was startling. Editors (read: guys) would come into our office, take one look at the layout comp on our wall, and just stare at it, uncomfortably shifting from leg to leg. Others said, "I'm not sure . . . I don't like that so much" but couldn't (or wouldn't) verbalize why not. Gary simply said, "Too close!" But I argued for it, and won. When it was printed, I took the signatures home to my boyfriend and told him about the comments back at the office. He looked at me and said, "Well . . . he looks . . . um . . . kissable." I looked again. Ah. Those pouty lips. Implants? Pinky red. Ah. Beckoning. Ahhhhhhhh. *Too close!*

I did what I could to hide my complete cluelessness about the world of sports. As I headed for the airport to Utah to shoot the cover of our Football Preview, I dialed my boyfriend and asked, "I'm late, but tell me something— quickly, who's Steven Young?" He replied, "This job is wasted on you." (He married me anyway.) For those of you RISD folks who don't know either, back in 1995 he was, like, the David Carson of the NFL.

My problems with Steve didn't stop there. Back in the office after editing the film (and bragging to the staff and my brothers that I even got to rub mud on his too-clean uniform at the photo shoot), we were trying to decide on the image for our first cover. A shot of Steve hopping onto the goalpost seemed the obvious choice. After working on the cover design for about a week, I was feeling characteristically insecure, and invited a friend and mentor to come give me some feedback. She will remain nameless, but let's just say that she's no longer a designer, but a writer and editor of books on art direction. And she's

French. "Oh, I love it, but the goalpost should go up and to the right . . . not down. Down is depressing . . . up is hopeful . . . friendly . . . it says 'Read me! Open me!'" So we flopped it (luckily for us, Steve wore a very palindrome-atic number 8). Apparently, it also says "Wrong!" We didn't count on the fact that the fans, as well as Hearst management, would notice that the drop shadow on the number was heading in a backwards direction. This wasn't just sports, this was journalism. Numbers mattered. No one was pleased.

Times like those certainly made me doubt myself, and my decision to stick it out. But Gary was an incredibly patient editor-in-chief. He also had become somewhat of a guru for most of us, and the vibe in the office was addictive. After months of working through all of our personality and style differences, after figuring out a way to order lunch in for the entire group (adding tofu and steamed vegetables to the mix of hoagies and mozzarella sticks), after going through repeated closings from hell together, we really had formed a family, complete with sibling rivalries and dysfunctional cousins, but also with a very intense and loving bond. And what other job could you have where, in the middle of a closing, the entire staff sneaks off to a *Jerry Maguire* matinee. Mouths full of popcorn, my creative cohorts and I glanced at each other knowingly, all of us thinking that we would never feel this way again. (Our mood shifted when Tom Cruise said "You complete me." Then, we slumped down in our seats, siblings embarrassed to be watching a make-out session in front of each other. *Too close!*)

The creative think tank our father figure had assembled, male and female alike, was what was addicting. When you get a random group of talented people together, give them a safe haven to experiment, nurture them, and push them creatively beyond where they've ever been before, well, amazing things start to happen. Ideas flow, rules get broken, and yes, something like the face of sports journalism starts to change. But it's hard to maintain that kind of intensity forever, to put your heart and soul into something, into each other, for so long. It becomes exhausting. Years later, most of us have moved on. Some are higher up on different prestigious mastheads, some have gone on to big jobs in advertising or totally unrelated fields, some are still working in a different position at *ESPN*, which became one of the most successful biweekly launches in history. People might be making more money now, or might have more time to spend with their families. But most everyone on our original staff would probably say that the happiest time in each of our careers—our best, most inspired moments in any job—was the time we spent figuring it all out together. Today, I have lost any ability to talk current players or scores, but those editors and designers are still some of my best friends. And I realize that the most important thing to me—more important than subject matter or status—is finding a team that I can feel comfortable with, where the day-to-day process of collaborating with a group of self-chosen, sometimes clueless, but always opinionated relatives becomes the reason for going to work each day.

When browsing through old issues, I found this quote from one of Gary's letters from the editor: "When I was a kid and got to pick first in a choose-up game, I always managed to put together a team that was . . . well, more interesting than good. I thought it was more fun to win with an underdog."

It was. Sports!

# Of Men and Monks: The Art of Storytelling
## Sunita Khosla

At the end of the day, we are all just storytellers. All we can do is hope that what we feel in our hearts resonates in the hearts of others.

Ideas are so transient, so fragile, so easily lost. I believe an art director's most important role is to protect the integrity of the idea and not let it get diluted by self-conscious execution. People should remember *what* you said, rather than *how* you said it.

It doesn't matter in which medium you're working. The basic rules remain the same. You have to touch people. You have to trust your instincts. You have to use the "intelligence of the heart."

I think empathy, curiosity, and intuition are an art director's greatest gifts. I am not too impressed when someone tells me they are good at Photoshop, or some new-fangled software. Those are technicians' tools. An art director's tools are ideas. Technology will keep luring us with fancy new inventions and dulling our imaginations. I am more interested in what makes people tick: what excites them, what moves them, what are their dreams and aspirations.

Though I value the computer as a powerful design tool, I despair at its over-use or misuse. There is an intangible emotion, texture, and fluidity in something created by the human hand that even the most sophisticated software is still unable to replicate. I sometimes miss the old days, when perfection wasn't easy, when you had to work hard to hone your own skills and explore your own imagination.

I have spent almost forty years in advertising—I'm not sure if I'm a writer who loves to art direct or an art director who loves to write. All I know is that I start each project with a sense of adventure and fun.

The most valuable lesson I have learnt is that if you want to be a good communicator, you have to be a good listener. You can't sit at your desk and wait for inspiration. You have to get out and talk to people.

I always insist on a direct brief from the client. There are subtle nuances that you might miss in a written brief. Sometimes a chance remark can trigger an idea for a campaign.

Twenty-five years ago, when I was working at Ogilvy & Mather in Bombay, I was assigned to create a campaign for the Indian Cancer Society. The objective was to persuade people to come in for a regular cancer check-up. The "brief" comprised a list of the dreadful symptoms and the number of people who died of the disease each year. I began to feel very depressed. How was I going to persuade people to come in for a checkup; no one wants to find out they're about to die.

I decided to meet the client, Dr. Jussawalla, to get a better insight into the problem. "Doctor, there's so much research going on in the field of cancer. Isn't there more hopeful news for patients today?"

In the course of the conversation, Dr. Jussawalla said, "We have made a lot of progress in the treatment of cancer. But people have a much better prognosis if we detect the cancer early. In fact, many of my patients are now leading normal lives."

I felt something stir inside me. I asked if I could meet some patients and hear their stories. Over the next few days, I was introduced to some of the most vibrant and joyous people I have ever met. Their stories became the inspiration for my campaign. I realized that my theme was not fear and the threat of death—but hope and the promise of life.

My headline just wrote itself: "Life after Cancer . . . It's Worth Living." The campaign caused quite a stir. It was the first time any cancer ad had shown active, happy people. The stories were simple and direct. Only at the end was there a gentle nudge to the reader. "It wasn't luck that saved Ruby. It was an early cancer checkup. Don't delay yours."

Less than a week after the campaign broke, the client told us that the response had been quite remarkable. Earlier, barely two or three people a day used to register for a cancer checkup. Now they had started getting thousands of calls. In fact, they couldn't cope with the rush and the waiting period had already crossed a month.

I'd like to believe that we were able to save a few lives. Doing your job well is not about winning awards. It is about making a difference in the lives of people.

It also helps to meet customers and try to discover how the product fits into their lives. In the ten years that I handled Xerox in India, I must have met about two hundred customers. I traveled to the remotest corners of the country with the sales teams to dig up unusual stories. One of the joys of being an art director in India is its delightful unpredictability—you never know what you'll discover.

For instance, in a little corner of a crowded street in Calcutta, we came upon an astrologer who told us that the Xerox copier had completely transformed his own future. "Most people still believe in arranged marriages. As soon as a girl turns eighteen, her parents start looking for prospective grooms and send out about a hundred copies of her horoscope. Earlier, I had to draw each one by hand. It used to take me a whole day to draw just two or three. I had to be so careful. If I missed a single line, it could change the girl's entire destiny! Now I can make a hundred copies in ten minutes on my Xerox copier and earn so much more!"

You have to be alert and look for opportunities to inject visual drama in an ad. Sometimes the best ideas come to you in the most ordinary situations.

Once, in the middle of a shoot at a Xerox warehouse, I noticed a box addressed to a remote Buddhist monastery in the Himalayas. I was intrigued and probed further. I discovered that the monastery was situated twelve thousand feet above sea level; the only way to access it was by foot, or on a

donkey. It was an extraordinary story of customer care. It took me a second to make my decision and ten minutes to convince the client.

A week later we launched our campaign with a stunning photograph of the cold desert landscape of Ladakh in the Himalayas, with a Xerox copier being carried to the monastery on the back of a donkey! A long row of monks ranging in age from six to sixty walked nonchalantly down the mountain blissfully ignoring the copier. The photograph was so interesting, Rank Xerox requested permission to reproduce it in their annual report.

Art direction is about getting every little detail right. You have to ensure the authenticity of props and costumes, hunt for the ideal location, plan the lighting and mood of a photograph, cast the right models, listen for the right emotion in a voice, inject richness into a soundtrack, sit in on the editing . . .

It is a real challenge in India, because it's virtually twenty-one countries rolled into one. It's like creating one ad that is right for every single country in Europe. How do you choose the location, the model, the accent? Each Indian state has its own unique culture, costume, mannerisms. Often your ad has to be translated into twenty-one languages!

I don't think it is necessary for an art director to be a skilled illustrator or photographer, but you must know how to brief your team and ensure that everyone is on the same wavelength. You must know how to judge creative work and weave everything together like an intricate tapestry.

Art direction is not just about knowing how to do your own job well—it's also about knowing how to get the best out of others; to make everyone feel that they are part of a great magical process.

There are often times when I wish I had gone to a good design school. But I feel that you can also learn a lot by interacting with great designers, deconstructing their work, imbibing what they have to say. Today, my advice to budding art directors is: keep your heart and mind open, trust your instincts, observe life, rely on your team, never lose the human touch . . . and always tell a good story.

# I Would Have Fired Me: Bad Typography
## at *Interview* Magazine

## Steven Heller

Back in 1971, my name appeared on three issues of *Interview's* masthead under
the title "Layout." That year I redesigned the magazine, and, if I do say so
myself, it was cleaner and smarter than the dozen previous issues, which were
grungy and messy.

When founded in 1969, at the legendary Warhol Factory on Union Square
in Manhattan (just a block away from Max's Kansas City), *Interview* was pop
artist and fame-monger Andy Warhol's very own DIY magazine before the term
"Do It Yourself" was officially coined. Actually, he didn't really do it himself—
he had others, like me, do it for him (and from such a distance that I never even
met him). But his blithe spirit pervaded the entire enterprise.

The initial issues of *Interview* (with a logo that read: INTER/view)
premiered a few years before Punk made DIY into a generational style, but they
adhered to the slap-dash tradition of the late-sixties underground press—the
granddaddy of all DIY. Given its art world pedigree, *Interview* may have also
been influenced by George Maciunas's Fluxus newspapers—although I never
heard any *Interview* editor mention Fluxus by name. Yet all the same, it seems a
reasonable assumption. I did see the editors frequently poring over the cheap-
chic newsprint fashion magazine *RAGS* (published by *Rolling Stone's* Straight
Arrow Publishing Co.), which was somewhere between underground and
middle-ground, so it may have had some overall influence. The editors also
periodically glanced at John Wilcox's *Other Scenes*, a sloppy underground
tabloid edited by one of the founders of the *Village Voice*, who also wrote a
politico-culture column for the *East Village Other*. Whatever its roots,
*Interview's* early issues, most produced as newsprint, quarter-folded tabloids (a
larger tabloid page folded in half to create a magazine look), were consistent
with the alternative-media culture of that time, though not unique in any
exceptional way.

Warhol rarely got his hands dirty with newsprint ink. He ruled *Interview*
from a safe distance, many blocks from where I did my work, and was listed
alphabetically as second on the masthead under co-editor and *Chelsea Girls* star
Paul Morrissey. Not only had I never met Warhol, I was never even told that he
(or Morrissey) saw or passed on my redesign before it went to press. Instead,
Warhol was being channeled through "managing editor and art director" Robert
Colaciello, an affable, stylish guy who became an editor, trend-spotter (friend of
Jackie-O), and most recently author of a book about Ronald and Nancy Reagan.
As associate editor, Glenn O'Brien, long a witty and insightful cultural
commentator who writes for various au courant magazines today, also had lots
of input into the editorial mix. The three of us sat at my drawing board

together as I sketched pages and pasted pictures of film stars and Warhol friends into place. And during these sessions I was vicariously excited by the little tidbits of gossip that Colaciello and O'Brien revealed about the chicest of the chic, from Mick Jagger to Marisa Berenson.

At that time I was also art director of a rock music tabloid, and I thought I was hired to be the art director of *Interview* because all of the type and graphic choices for the redesign were mine. Instead, Colaciello, who selected all the photographs, in addition to writing many and editing all of the articles, assumed the AD title for himself. It was not an unpleasant relationship; Colaciello chose those images he knew would please Andy, but he never proscribed type or prohibited me from using my two favorite typefaces in the magazine. Which, in retrospect, was a big mistake.

At least Andy should have vetted my typographic choices for reasons that will become obvious. Before becoming America's leading artist, he was, after all, an accomplished graphic designer and illustrator (with a distinctive hand-lettering style) and should have been the first to realize that my pairing of art deco Broadway type for the nameplate *Interview* and the curvaceous Busorama typeface for the subtitle "Andy Warhol's Film Magazine" was one of the dumbest combinations ever. In addition to being slavishly retro and therefore inappropriate for a progressive journal, the two faces lacked any harmony whatsoever. Add to that the heavy Oxford rules I placed at the top and bottom of each page and, if I had been in charge, I would have fired the designer. But no one uttered a displeased peep, and the magazine kept my logo for six issues, even after I voluntarily left for another job. Finally, with Vol. 2, No. 10 the editors (or maybe Warhol himself) switched to a handwritten version that read *Andy Warhol's Interview*. And it has more or less stuck on the cover ever since.

The most memorable issue that I worked on was devoted to Luciano Visconti's film version of Thomas Mann's *Death in Venice* (Vol. 2, No. 4) and was filled with luscious film stills of Dirk Bogard, Silvana Mangano, and Bjorn Andersen, as well as two nude shower scenes of Marisa Berenson. It was actually a stunning issue yet was among the last to use handout photos. *Interview* gradually shifted from relying on publicity stock to creating its own photosessions with the eminences of celebrity and fashion photography—Robert Mapplethorpe, Barry McKinley, Francesco Scavullo, Herb Ritts, Ara Gallant, Peter Beard, Bruce Weber, Berry Berenson Perkins. These and others were given the freedom, not the editors, to "create their most unforgettable and original work." Despite the continued use of yellowing newsprint, these photographs jumped off the pages; some are still iconic today.

Typographically, however, the first decade of *Interview* was functional and staid. Compared to *Rolling Stone*, which reveled in typographic exuberance, *Interview*'s interior format was fairly neutral, allowing the photographs to take center stage. It wasn't until the nineties, when Fabien Baron (and later Tibor Kalman) became creative director(s), that the magazine's graphic attributes

were totally integrated into a dynamic whole. During the seventies, *Interview* was still uncertain whether it should hold to its avant-garde, alternative-culture root or lead the march from underground to fashionable mainstream. When I was its designer, it was neither well designed nor fashionable. But I learned more about art direction than any school or class could hope to teach.

# 03: Are All Art Directors Alike?

## On the Film Set: Making It Happen for the Camera

### A Conversation with Lilly Kilvert
### Film Production Designer, Los Angeles

*Véronique Vienne: In the print world, the art director is responsible for the entire look of a publication or an advertising campaign. But in the movie business, who "art directs" the film—the production designer or the person whose title is "art director"?*

**Lilly Kilvert:** At the Academy Awards, the Oscar for Best Art Direction goes to the production designer, not the art director. It's one of those confusing things. Unlike an art director in the print world, the person who holds the title of art director on a full-scale movie set is not responsible for the look of the overall picture. A film art director is more like a manager on a building site, someone who reviews the plans and detail drawings (done by set designers) and who supervises the construction crew.

"Art direction," as you define it, is really "production design." That's my job. I am the head of the entire art department, a large team that includes a number of art directors and set designers, as well as painters, plasterers, set decorators, graphic artists, "greens" people (who take care of the plants and flowers), location scouts, and even accountants. The production designer is responsible for the overall look of the picture—the world in which the film lives.

***VV: The great film art directors of the past, Cedric Gibbons (The Great Ziegfeld), Williams Cameron Menzies (Gone with the Wind), Perry Fergusson (Citizen Kane), were production designers as well as set decorators. What changes have brought this splitting of the roles?***

*LK:* As productions got more expensive, and more than one art director was needed to manage all the sets, the position of production designer was created to supervise the look of the film. A film production designer is the equivalent of a print creative director or editorial director. Titles mean nothing.

***VV: How do you work?***

*LK:* First I sit down with the film director to discuss his vision of the film. We also talk about what I will build from scratch versus what we will shoot on location.

The next step is location scouting. I will travel to New Zealand to find a location for a film that's supposed to take place in Japan, or I'll go to Prague for a cheaper alternative to shooting in Paris. Eventually, I'll narrow down my choices and show my options to the director.

Then the art director(s) and I layout the ground plans for what we will build. We hand somewhat rough sketches to the set designer(s) who will develop them further. It is the job of the art director to figure out what size stage we will need and it is with him or her that I determine whether we use paint or a translite (large transparency) for the background.

Only then do I meet with the set decorator to discuss what feel we are looking for. He or she takes snapshots of various pieces of furniture, lamps, rugs, and fabric samples. Then I repeat the process with the greens people, the painters, plasterers, metal fabricators, model makers, property men—all along refining our vision and budget issues.

When we are ready to shoot, I give the set decorator time to dress the set without interfering. When he or she is ready, I walk in and together we make changes or edits. It can be as simple as adjusting the height of a lampshade or changing the color of a blanket.

Looking at the overall effect with the set decorator—checking the paint, flooring, wall surfaces, moving furniture around, re-hanging pictures—is one of my favorite moments of the entire process.

***VV: How do you learn all that stuff? Do you need to acquire the same skills as an art director and a set designer in order to do your job?***

*LK:* Yes, the details are endless. Beyond going to film school, you need a certain kind of brain, both logical and creative. Frankly, it's not something I would be able to teach anyone. For me, each film is an education.

**VV: Do you get to hire everyone on your team, or does the director decide who's designing the set and who's doing the costumes?**

*LK:* I hire all set designers and set decorators, painters, plasterers, carpenters, prop people, graphic artists, location people, greens people, etc. . . . I am always involved in deciding who the costume designer should be and very often I speak to him or her at some length before the director does. I run a pretty tight ship and want everything that goes before the camera to have gone before my eyes first.

**VV: What is the most challenging part of your job? Aesthetic decisions? The budget fights? Managing egos?**

*LK:* Well, lets just say that creating the vision of the film in my head is the easiest part of my job. I spend most of my time getting my vision in front of the camera—and making sure the cameraman shoots it!

Money issues are massive. Keeping control over the budget is no small responsibility, since what the art department spends represents about ten percent of the cost of actually making the film (not including salaries!).

As for ego maintenance? Don't ask. Lots of my time gets invested there, first making sure that my team is happy, and then monitoring the decision-making process between the director and the cameraman.

**VV: Who do you report to? The film director? The production people? The cameraman?**

*LK:* The director is my boss. He or she hires me. I work with the production folks on the money and logistics issues. My relation with the cameraman is that of a colleague. It is crucial that we get along and work closely through the design phase and the actual shooting. I am designing for the camera!

**VV: What is the most gratifying part of your job?**

*LK:* First, I love my team. I love collecting all these fine minds and solving problems with them. I love getting them galvanized to do their very best and together see it all come to fruition. The research period is wonderful too, and keeping the budget in check is something of a thrill. Then, of course, I love seeing what was in my head realized—on the set and on film.

But, to tell the truth, what I love most is paint! I spend a great deal of time with my painters, mixing pigments, adding glazes or veils, working out the texture of the plaster. I love to mix it, splash it, thin it, muck it up—and get it to do exactly what I want in terms of texture, brilliance, and finish—all to get the right look on film.

**VV: What aspect of your job gives you a sense of control?**

*LK:* I think that my passion is visible to everyone and it has a way of inspiring people to do their best work. Every film has its own flavor. I love that

it is always different, forcing me to find the visual language that will tell a powerful story. To feel in control, I have to be fully invested, artistically and emotionally.

**VV: What are some of the most difficult things you have ever done?**

**LK:** Everything is complicated in different ways. Perhaps the most frustrating is a situation where the director has no idea what my job is—and how much he can use me to improve his storytelling. Because, ultimately, I am a storyteller too, one using different tools.

**VV: Would you like to become a film director?**

**LK:** I am too lazy—even though I work very hard as a production designer, up to eighteen hours a day before we start shooting. It is very difficult for a woman to become a film director. It is an uphill battle. I'd rather use my energy to hold on to my position as one of the top female production designers in my world.

# The Idea Factory: An Assembly Line for Creativity

## A Conversation with Alex Bogusky
### Executive Creative Director,
### Crispin Porter + Bogusky

***Véronique Vienne: You describe the job of an art director/
copywriter at CP+B as "manufacturing ideas." Can you explain?***
**Alex Bogusky:** Truth be told, we don't really know where ideas come from. But anyway, most people think that once you got an idea, what you do is perfect it and maintain it. This is really not our way. Our way is much more of an ongoing process. Our office is an assembly line, except that what we do is custom work.

Ideas are just the clay. We take it around to different parts of the assembly line, and each person helps mold it, shape it, improve it. It gets better and better as it moves through the factory. In the end, the final concept is really different from that original idea.

***VV: What's the specific role of art directors in the idea factory?***
**AB:** Art directors are not the most important crew at CP+B. In fact, clients are the critical crew. They help shape ideas in a big way. Here, we embrace the notion that clients are intrinsic to the creative process. Their impact on the work we do is on par with that of the film directors or the photographers we hire to shoot commercials or ad campaigns.

As an art director, you have to know when to let go—and when to take a hold of a concept. Clients have to do that too: trust us at some point, and then, when the time is right, reclaim the process in a big way. Sometimes, of course, I resent it. But the reality is that the job of the client is to let go, hold on, let go, hold on. When we work well with other professionals, with film directors in particular, we do the same thing.

***VV: Your office is laid out to encourage this process of cross-
pollination between people. Though it is linear, like an assembly
line, it is also an open environment where ideas move freely from
each and every person. There is no hierarchy—there are no corner
offices, for instance.***
**AB:** We didn't want anyone to have a corner office, or even an office with a window! That's why the place is like a building within a building. Even my office, which looks larger than most offices, has a divider in the middle, and the space in the back is officially not mine—it's community property, for gatherings. And I don't have a window on the outside. Like everyone else, my office looks toward the inside.

**VV: How is the "no-hierarchy" approach actually helping the day-to-day functioning of the idea-manufacturing process?**

**AB:** It's part of our culture and as such it is part of our way of working. In our old place, they had five corner offices. The most senior people occupied the five best offices. But there was always someone who deserved a corner office who ended up in a less grand location. And people talked about it, even though it was such a dumb thing. So we decided to all share the same glass-enclosed but windowless cubicles, and have all the offices be the same size.

**VV: Like a factory, this place is very noisy. Is that too part of the process?**

**AB:** The noise is only a problem in the very first part of the process, when you want to be alone. But, in fact, a lot of people really "concept" in the noisiest part of the office, which is the agora-like central theater with steps that create an open seating area. Going there is like going to a park. Parks are noisy, but it's easy to think there because the noise is not specific. Whereas when we are in an enclosed office that's almost quiet, every little noise becomes a distraction. The drone of the agora is a kind of a silence.

**VV: There is paging going on all the time, like inside an airport. Isn't it distracting?**

**AB:** I usually page people all the time. I love paging! But I also encourage a lot of talking. There is an access ramp between the ground floor and the mezzanine offices. From the top of the ramp, I can yell and get to about anyone I want. I can be upstairs and call to someone downstairs. I can go on the ramp and say "Dave! Check this out!" and he will hear me. And I can hold up a piece of paper and he will be able to see what I mean.

Tons of ideas happen right there on the ramp. And it usually happens on the spur of the moment, with one person saying to the other, "Hey, by the way, I wanted to ask you . . . dah, dah, dah . . ." Did you know that walking actually stimulates the part of the brain having to do with creativity?

**VV: Is your job as executive creative director to keep the factory going?**

**AB:** Our philosophy is what some people have called "goal-oriented play." Here, we want to do the things that make us happy. The rest takes care of itself. People are happy here, and they are really nice to each other. You have your private space to work, of course, but the office is mainly a public space where you bump into everybody all day long. Whatever you do, there is going to be a certain amount of mingling. Coming to work here is a little bit like going to a party.

# The Curator as Art Director: Designing a Conceptual Exhibition

## Laetitia Wolff

Trained in literature and communication as well as museology, my interest in design has taken the multifarious routes of the written word and the constructed event/project. Trend analysis and historical interpretation, reporting and conceptual thinking are some of the things I like to do best. That's why, when I was editor of *Graphis* magazine, I often wished I had more leeway in bringing designers, photographers, and illustrators together to think about what they do and what they could be doing. My favorite activity was brainstorming with them in order to engage their analytical perspective and come up with fresh, one of-a-kind proposals.

Usually, in magazines that deal with design such as *Graphis*, the editorial terrain allocated to an art director is quite limited. For a number of reasons, design is discussed and shown in a clinical, objective, non-interfering fashion.

What I wanted was to transform the magazine into a more organic, reactive form of expression. In the process, I was striving to make the role of an editor closer to that of an active co-owner of the magazine's content—as an orchestrator of ideas rather than simply a reporter of ideas. I was displaying the famous, century-long symptoms of the editor frustrated with not being the art director.

I had a chance to bridge the gap between my editorial and creative ambitions when I was invited by the city of Saint-Étienne in France to curate the American section of the 2004 International Design Biennale. I decided to use this invitation to redefine the responsibility of the curator and bring it closer to that of an editor/art director. For some reason, I think of an exhibition as a looser, more permissive structure than a magazine, one that provides an experience that is generally more emotional than cerebral. I hoped that this assignment would allow me to explore ideas and let design convey the subject matter, "taking design as an agent of communication and a mediator of human behavior," to quote our own exhibit catalog introduction. In other words, as an advocate for design, I wanted to generate projects that bring design talent together and break the traditional formats and genres of design curating—I wanted the exhibition to become a think tank, an observatory for societal trends, and even a civic statement.

So, instead of limiting myself to collecting existing artifacts, something I had done before and could have done again, I proposed a special show based on original design commissions. In collaboration with design writer Aric Chen, I came up with a special themed show.

Since my goal was to tease the creativity of an often politically apathetic design community and challenge creative thinkers to react to relevant and

daunting socio-political questions, I chose a controversial topic, America's obsession with overeating, diet, and weight loss.

Faced with the national plague of obesity—now considered a disease reimbursable by Medicare that affects nearly 30 percent of the U.S. population—very little design thinking had been put forth in the search for solutions and innovative discourse, other than furniture manufacturers extending the width and depth of their seats and sofas.

Inspired by recent initiatives of design associations (e.g., American Institute of Graphic Arts' special programs to redesign the voting ballots) as well as independent groups' efforts to challenge and question the government's public policies, our aim was to encourage designers to think about "bigger" issues than themselves. And although there was a conscious tongue-in-cheek character to representing America at an international design fair through the sensitive topic of obesity, we wanted to push creatives to address political problems and social situations where design solutions are really needed.

Admittedly, as a French person never brainwashed by American political correctness, there was a definite tongue-in-cheek aspect to my curating a show about American Design and Obesity in my home country. Yet mocking was not my intention at all. I saw it more as a way to counter-effect the trendy obsession with food as art, as celebrated by the current fascination for Baroque excesses and extreme luxury.

Another great advantage of an exhibit, as opposed to an article, is the fact that it creates opportunities for cultural/public programs that generate direct, human interactions.

Formulating the design brief was a difficult process for us curators, as we did not want to fall into the cliché of the now-trendy anti-corporate and anti-McDonald's attitude conveyed by films such as *Super Size Me*, or books such as *Fast Food Nation*. How do you address a sensitive subject matter via humor without falling into the gross, caricature-like, spoof, anti-campaign tone? How do you stay intellectually provocative while keeping the projects accessible to the general public? We wanted to leave the door open to a large scope of interpretations given the diversity of talents and disciplines we had approached to respond to our brief.

The logistics were complex as well—to bring together twenty different personalities, styles, demands, disciplines, and schedules, from East to West Coast, from corporate high-power players to "indie" low-budget Brooklyn studios. However, across the board, we got the incredible support of the participating guest designers. Everyone undertook his or her project freely, seriously, and happily. Most gratifying for me was the element of self-reflection the guest designers brought to their projects on what is truly American, versus what is just a cliché about Americans and nutrition.

One of the things I particularly appreciated was the designers' ability to take off from the expected, to raise above the anticipated, to really be

USA Obesity Propaganda Map Design Guys; Minneapolis, Minnesota. Styrofoam panels, polystyrene drinking cups with paper inserts. 12 x 8 feet. *Fabrication*: Stafford Norris III, Joshua Norris, Lily Carlson, Steve Sikora. *Diagrams*: Anthony Buckland, Dan Holley. The USA Obesity Propaganda Map is a monumental, three-dimensional map of the United States, made up of approximately 600 plastic drinking cups, some of which make out the subliminal pattern of McDonald's Golden Arches. It represents the country in a landscape of obesity statistics. The interiors of the cups have been color-coded according to the obesity rates in corresponding states. Figures from 1994 are indicated on one side of the cups, and those from 2002 are on the other, so that the extraordinary increase in obesity levels becomes dramatically apparent as viewers walk from left to right.

imaginative, never taking the assignment literally but challenging themselves to respond to the topic in the most unique and unlikely manner. Paradoxically, all the design consultancy giants took the route of humor and quirkiness, while some independent designers often proposed solutions closest to real-life applications.

Among the submissions were inventions that pushed the boundaries of familiar objects, like shoes that act as scales measuring weight and fat percentage, from Scott Henderson; mirror-like place settings that visually increased the amount of food on your plate, from Garth Roberts; and a high-tech jewelry pendant that discreetly vibrates to alert you when you are about binge, from Ecco's Eric Chan. Other designers used irony, like Yves Behar's "Phat" furniture, as flabby as overweight people; Modern Dog's Last Supper painting showing the apostles eating junk food; or Steve Sandstrom's eight-gallon drum—the average American consumer's yearly supply of corn syrup. Still other designers, among them Mark Randall and Luba Lukova, addressed the social and ethical implications of eating, some going so far as to develop implementable activist programs to promote more healthful habits.

Overall, the designers showed great interest from the get-go—they were hooked pretty quickly. But we also had some strange reactions: a designer became increasingly upset, almost insulting us for broaching a very personal and intimate topic. When he repeatedly failed to meet deadlines, I understood there was something more personal than conceptually problematic. It turned out he grew up in a family of obese people and thought that our exhibit was not respectful of a certain social reality, i.e., that obesity is synonymous with poverty.

Some other designers kept calling me, changing their minds every week, going back and forth, sometimes using the excuse of the time constraints and financial burden this project was putting on them while "real clients" demanded their attention. One designer dropped out of the project the day before we shipped all the pieces to Saint-Étienne. All along, I tried to be supportive of the designers' thinking processes, helping them with everything from typographical problems to production issues. This struggle gave me a sense of what an art director really does, and I must say, I really liked it—as long as it did not include babysitting.

This curatorial experience opened up new possibilities for me. I now see how the brainstorming/ideation process can combine several of my interests: design discourse, trends observation, exhibit design—and art direction.

# Visual DNA: The Global and Local Image of Kiehl's

## A Conversation with Victoria Maddocks
## Creative Director, Kiehl's Inc., New York

**Steven Heller: What does the term** art director **mean to you?**
**Victoria Maddocks:** Someone who is responsible for the look and feel of the project, which could be created in any medium: typography, photography, illustration, film, etc.

**SH: As creative director of Kiehl's, what is your overall responsibility?**
**VM:** My responsibility includes ensuring that the company image (across all disciplines: retail, packaging, print, and Web) is consistent with our values and mission, as well as evolving and pushing the image to be effective on a global level. Since our retail mission is to avoid being "cookie-cutter" and also to become part of the communities in which we serve our customers, it actually means constantly tweaking our image so that it is somewhat different and personalized on a local level yet holds together as a global image. Naturally, in accomplishing all of the above I hire and manage all creative personnel.

**SH: Given all this, what is the single most important aspect of your role?**
**VM:** Ensuring that we stay true to our intent and that our image does not become homogenous with any other cosmetics company.

**SH: In working with your "client," which in your case is your "company," how do you fulfill its needs while retaining your own creative integrity?**
**VM:** As I joined Kiehl's right after the acquisition by L'Oréal, I was part of the team that defined the "Kiehl's DNA," which would be effective for global expansion. In effect, I created the parameters and was instrumental in codifying the brand's vocabulary, thus creating a platform for good work. Believing in the products and the mission of the company also makes it a lot easier to create work that you believe in, not to mention that I am encouraged to push the creative envelope.

**SH: Would you say that you have an art directorial style, or is your style the company style?**
**VM:** I believe it is somewhat dangerous for designers to impose their "style" on a company—that's when brand images begin to blur. I heard Paula Shear say years ago that design is about appropriateness, and I agree. While I am quite a classic designer by training, I make sure I approach each client differently by hiring a diverse group of designers who understand, have fun with, and deliver on the Kiehl's aesthetic.

**SH: What does style mean to you?**

*VM:* It's the ultimate form of an individual's expression—the substance of an individual's creative genesis, if you like.

**SH: How much of your job is managing design? And how is this accomplished?**

*VM:* A great deal of my time is spent managing and motivating designers. I have coached them to schedule time on my calendar so that our time together is uninterrupted and focused on moving projects forward.

**SH: How strictly do you manage other designers? Is there room for creative experimentation?**

*VM:* I believe in hiring the best talent first and foremost and giving each designer the opportunity to experiment and feel empowered about his or her projects.

**SH: What is your ultimate goal?**

*VM:* To constantly evolve both as a designer and as a creative director. To not limit myself, yet at the same time continue to hone and refine my own craft.

# Magazines vs. Newspapers: Right Brain, Left Brain

## A Conversation with Ronn Campisi
## Magazine and Newspaper Design Consultant,
## Boston, MA

*Steven Heller: As a newspaper and magazine art director, what do you think are the differences between the two media in terms of design method?*

**Ronn Campisi:** More than anything else, a newspaper's need for speed, the ability to put together pages extremely fast, in hours, instead of days, is what defines the method of design. Partly because of that speed need, newspapers tend to be more rational and logical, consisting of modular pieces that you can quickly mix and match and put together.

Magazines, in general, can be more expressive and emotional.

*SH: Does technology make a difference?*

**RC:** Aside from the obvious production differences—printing quality, paper, time available to produce pages, and art budgets—I'm not sure why we tend to get stuck in the framework of newspapers being more formatted and structured. Certainly the technology at our disposal today makes just about any design possible. Also, there are many parts to a newspaper. Many of these parts, feature sections for example, can go off the grid and be more magazine-like.

*SH: Does design affect readability and circulation?*

**RC:** I think one reason younger people no longer read newspapers is because most newspapers look like . . . newspapers! I believe every new generation interprets the visual world differently. It all depends on what media they grow up with.

I recently read a story about a blind man, Michael May, who lost his vision at age three, and now in his forties recently had his vision restored in one eye. His eye, now able to have clear vision, is fine. Unfortunately, his brain never learned to process the visual world. He can't distinguish a sphere from a cube, recognize faces, or facial expressions.

Which leads me to believe that people growing up weaned on video games and computers experience the visual world, especially the world of information, in a fundamentally different way.

*SH: Is this why we feel the need to break magazines up into smaller and smaller pieces? Is this why newspapers seem so out of it? Because they cling to the forms defined by a previous generation?*

**RC:** As a practicing publication designer, it's my job to create the look and feel of both magazines and newspapers. So to get back to your question, the

difference in design method is mainly a way of thinking about the forms. Newspapers, in my mind, are eighty percent left brain, twenty percent right brain. Magazines are probably more like forty percent left brain, sixty percent right brain. Meaning that newspapers are more structured and predictable, following a more linear thought process. Magazines, generally, are defined more by tone and attitude, with an obvious underlying structure but one that is more malleable.

**SH: Okay, what are the similarities between the forms?**

**RC:** Both magazines and newspapers need devices to engage, entertain, and inform the reader. Finding just the right mix is often elusive. There are so many people involved—writers, editors, photographers, illustrators. Everyone has to be on board. And I guess just like any other manufactured product, it means you have to have strong leadership within the organization to define the direction and rationale of the publication.

In the 1980s, when I was the art director of the *Boston Globe* magazine, I had an unusual opportunity to pretty much do whatever I wanted to do in terms of design and art. Because the magazine was only a small part of the newspaper, in an odd way, it wasn't that important to the editors and the publisher. The emphasis on everything within the organization was clearly on the news sections. I ended up having total freedom and control over the look of the magazine. No one really had to approve anything I did. So I would pass on that freedom to the illustrators and photographers I worked with. That's when I

Client: Microsoft; publication: *Executive Circle*; illustrator: Adam McCauley; art director: Ronn Campisi.

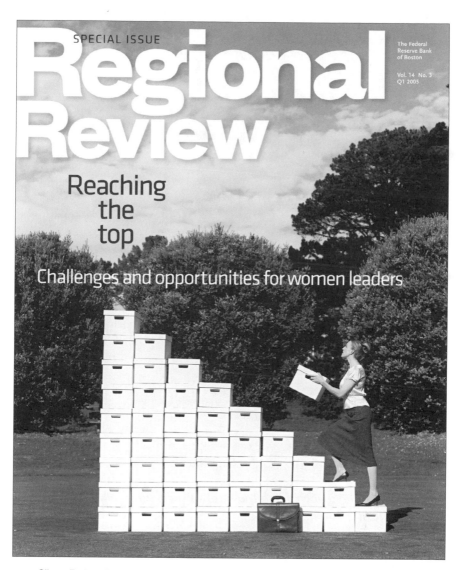

SPECIAL ISSUE

The Federal
Reserve Bank
of Boston

Vol. 14  No. 3
Q1 2005

# Regional Review

## Reaching the top

### Challenges and opportunities for women leaders

Client: Federal Reserve Bank of Boston; publication: *Regional Review*; photographer: Kathleen Dooher; art director: Ronn Campisi.

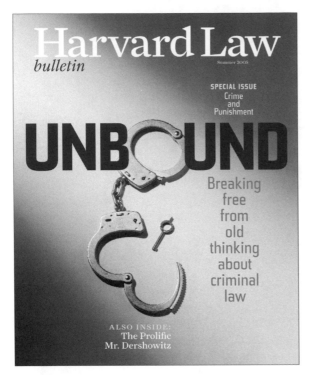

Client: Harvard Law School; publication: *Harvard Law Bulletin*; photographer: Christopher Harting; art director: Ronn Campisi; associate art director: Alicia Jylkka.

learned not to art direct, to just pick the best person for the job at hand and let 'em go. And because we did fifty-two issues a year I would take all sorts of crazy chances. Knowing the shelf life was only a week was very liberating.

One of the great things about publication design, magazines and newspapers, is that you get to do the same thing over and over again. Each issue presents an opportunity to do something greater and better than the last issue . . . or so you hope! Working within those constraints, trying to figure out what to repeat, what to change, how far you can push the format before it becomes something different . . . for me, that's what I love.

**SH: How would you define the optimum working relationship with an editor in either media?**

**RC:** The best editors to work with are those who have a clear, succinct vision of the publication and are able to communicate that vision to others with a sense of positive energy and enthusiasm. In terms of design, they have to be smart enough and confident enough to let me, as designer, interpret that vision, and add to it, in my own way.

It is really a collaborative effort. An editor has to think like an art director, and an art director has to think like an editor.

**SH: Even though newspapers and magazines are a combination of various editorial personalities, how as art director do you maintain your design personality?**

**RC:** Maintaining a personality is the biggest challenge for any publication. How narrow should the definition be? How wide can it be? Can you go too far and lose the personality? Sometimes I feel like no matter how hard I try, the stuff I do

ends up having a certain look. As I get older and am able to experience different trends in design coming and going, the question is, how do I keep my own work fresh? How do I allow myself to respond to what's going on in popular culture without turning into a mindless hack? Illustrators and photographers, it seems to me, also have this problem. Long-term success means being able to adapt and change with the times, while knowing how to keep your core personality intact.

Because I work on many different magazines, I try to give each magazine its own visual personality. The differences are in the typefaces, the underlying grid, spatial relationships, and the editorial subject matter. I will admit I get them mixed up sometimes!

**SH: Do you have a visual preference between illustration and photography, and if so, what is that? If not, how does each form work in your art directorial context?**

**RC:** In the past, I definitely favored illustration over photography. It always seemed so much more expressive to me. The ability of an illustrator to transform an empty page into an image filled with emotion is truly magic.

While I still assign many, many illustrations in the magazines I currently art direct, lately I've been leaning toward using more photography.

My sense is that no one trusts the media anymore. Readers have a yearning for more honesty, truthfulness, and reality in the publications they read. Photography is one of the ways to address that. Images that use natural light and don't appear contrived to fit into this scheme.

At the same time, the illustrations I like to use look like they were done by human beings, not computer-generated.

**SH: What is your definition of a well-art-directed periodical?**

**RC:** One that has character, wit, style, and appears effortless. Which means great typography, amazing images, and good pacing.

**SH: In the hierarchy, where do you see yourself and why?**

**RC:** There is no hierarchy. I see myself as the center of the universe. Ha ha. But seriously, if you think about it, any publishing endeavor, no matter what the media, is about taking ideas, information, whatever, and putting it into some kind of tangible, real, visible form. The minute you do that, you are designing and art directing. Therefore, the design, the form the information takes in the real world, becomes the thing that defines everything you do.

Let's say you have a story to tell—for instance, "The chicken crossed the road. . . ." The way you tell the story is different if you are telling it in video, still pictures, words, on a stage, in a diagram, or music. You're still telling the same basic story, but each is dramatically different from the other because of the form the information takes. Even within a form, the differences can be dramatic depending on art direction.

So actually, I'm not really kidding when I say art direction and design are the center of the universe. In fact, when enough people finally realize this, there won't be a need for art directors anymore. In the future, everyone will be an art director.

Or maybe that has already happened. More and more of our transactions with the world now tend to take place through a computer screen, erasing the physical boundaries that once existed.

**SH: But there are distinctions between art director and editor and client, right?**

*RC:* The distinction between art creator and client has been blurred. Whether it's between illustrator and art director, art director and editor, everyone now believes they understand and can do the other's job because they use the same tools.

# A Neat Job: A Media Agnostic in a Branded World

## A Conversation with Brian Collins
### Creative Director, Brand Integration Group (BIG), Ogilvy & Mather, New York

**Steven Heller: What does the term** art director **mean to you?**

**Brian Collins:** A media-agnostic, collaborative leader with a passion for visual storytelling who can work transmedia—across communications, products, and environments. A neat job, frankly.

**SH: And what does it mean to the world?**

**BC:** Art directors really came into power once television commercials, a visually driven medium, began to dominate the advertising industry. When radio and print were the powerful media of their day, writers ruled the roost. You can still see their names on the agencies born before the TV revolution. Leo Burnett, Young & Rubicam, Foote Cone & Belding, Ogilvy & Mather—those were the writers and account people on the door. No art directors' names, really, appear on the important doors until the 1960s.

I love old fifties Hollywood movies about advertising where you see the copywriters, usually twirling cigarettes to punctuate their thoughts, are always sending their ideas off to the "layout men" down in the "bullpen." It was only after the brilliant writer Bill Bernbach pulled the art directors out of their "bullpen" and made them full partners with the writers that the golden age of American advertising started. (Interestingly, the guy who turned Bernbach onto this way of working was his first partner, Paul Rand. Yes, *that* Paul Rand. )

As interactive media will eventually dominate everything, the new marketing environment driven by new technology has similar potential to spark another golden age. Young people are entering the advertising business in a time of profound change, more significant than the change brought about by the arrival of television.

**SH: As creative director of Ogilvy's Brand Integration Group, what is your overall responsibility?**

**BC:** To find startling ways to bring our client's products and brands to life—in three hundred and sixty degrees, so to speak: in a package, on the street, in a store, at a skate park, or even in a film. We look at the most broad experience of a client's problem first—and then we design ideas against the stream of those experiences. We will build ideas for products, identity design, the Web, store design, or even films. We often partner with the general agency on the design part of a brand—while they might focus on TV advertising. But sometimes we'll handle a whole campaign when it makes sense. Either way, we love telling stories. But we do not suffer from a thirty-second commercial fetish

in our group, although we love to work on television when it makes sense. But no one on my team would come to me with a TV idea as their first and only solution. That's lunacy.

The other part of my job is to develop new ways for our clients to adapt to the problems of media splinterization—which has completely fragmented our audiences. With so many new information options available today, it's harder to pin down an audience. They are moving from traditional television to video on demand, computers, stores, events, movies, the Web, mobile phones, and gaming, among other places.

Occasionally, I fear that many people in the advertising industry are as complacent as the French Cavalry in 1914. The French had great horses, certainly. But they were blissfully unaware that a few Germans were building the first armored tank just a few hundred miles away. So we have to keep innovating. The "tanks" are everywhere now.

*SH: Aside from the military metaphor, what is the single most important aspect of your role?*

**BC:** There are three, really. And they overlap.

First, to recruit, and build the best creative and strategic team in the world.

Second, to work with people and companies who value what our team's imagination and intelligence can do for them. We get to work with some of the greatest companies and brands in the world. Coca-Cola, IBM, American Express, Kodak, Motorola, The Olympic Games. People see what we do.

Third, to build trust between our people and our clients. Without trust you have nothing.

*SH: In working with your "clients," how do you fulfill their needs while retaining your own creative integrity and that of your designers?*

**BC:** This is the best question, and the central one for creative people.

Developing good creative work is, I think, about reconciling two opposing forces: cultural congruency and personal authenticity. Congruency faces the outside world. It's about being responsive to the demands of the society, the marketplace, and understanding the business puzzle you are trying to solve. I always ask my partners, "What are we really inviting people to do, here?"

Authenticity, on the other hand, faces internally: it's understanding who you are and what makes you passionate—and remaining connected to that so you can bring it into your work. What we try to do is connect the creative, personal ambitions of our people with the problems that our clients bring us to help them build cultural relevancy. We try to make their goals ours. And our goals theirs.

But we don't spend much time talking with our clients about our own "personal visions," either. We'd get laughed out of the room. What we do talk

about is whether an idea is big enough—or interesting enough, or sharp enough. My experience has been that the most remarkable creative ideas come from someone's unique point of view. My job is to protect the power of that individual voice within this collective endeavor. Personal voice is really the only thing that cuts through in the end. The only thing that is really worth listening to, anyway. As a result I hire people with buckets of talents and strong, articulate points of view. I then put them in the line of fire to create their own work. If I hired dull wallflowers, we'd just see the notes of a committee meeting—which is how design and advertising is created these days.

Also, art directors should be involved not only in communicating others' business ideas, but in creating their own business ideas as well. Take the Hershey's chocolate factory we designed in Times Square. Rather than churning out a bunch of normal billboard layouts, we came to Hershey's with a much bigger visual story that was tied to their unique history. We showed them how they could open a wonderful store in New York by leveraging the powerful iconic legacy of their famous brands over the last hundred years—Reese's, Kisses, Twizzlers, Jolly Ranchers, etc. Once they saw the idea visually expressed, they got it. Then we built it over fifteen stories tall with a gazillion twinkling lights, steaming cocoa cups, flashing neon signs, and spinning letters. The art direction solution created the business solution.

### SH: Would you say that you have an art directorial style?

**BC:** The way I see it, style is just a search for accuracy. It is a tool to make a point memorable, to make someone feel something meaningful, to make the communication clear and understandable. In the end, I will employ whatever style I need to move a story forward.

### SH: Okay then, what is that style or styles?

**BC:** In the end, I'd call it ruthlessness. If an unfolding style doesn't help to move the story along, I'll cut and run and we look for something better.

### SH: Is there room in your environ for true creative experimentation?

**BC:** Often, but sometimes no. Some projects come flying in like an out-of-control 757 with two engines on fire, a mother giving birth to triplets in business class, and an unconscious flight crew. We've got to land the plane fast, so there's little time for experimentation. That's when you have to depend on your personal understanding of your craft. Sometimes good work has come out of those dire situations. Instant intuitive judgments are sometimes the best ones. But you can't plan on this as a reliable way to do good work. It burns people out.

### SH: So what is your ultimate art directorial goal?

**BC:** I have four. Two face inwards. Two out.

First, to create the kind of working environment that did not exist when I was starting out as a designer in the 1980s. A place where talented young people can learn from a range of gifted, articulate pros who love to teach. Not a place where you'll choke on the leash of a famous creative guru or be suffocated by a pervasive house style; at its best, a place that might feel like the best part of college. And, as I think work should be a place of discovery and invention, BIG should always feel like a kindergarten for grown-ups. So all of our creative leaders at both BIG, New York, and Los Angeles teach. I teach in the graduate program at the School of Visual Arts here in New York City. Other members of our team have taught at Parsons, Yale, Cooper Union, and Art Center. And we invite great people to speak with our teams. We've had Malcom McLaren, Helene Silverman, Ed Fella, and James Victore speak.

Second, BIG should be a place where you can do good work with extraordinary clients on big projects. Sure, it's great to do a slick brochure for a small Slavic furniture company using photographs of skinny blond bisexuals drinking Evian while cavorting on neo-modernist couches. It is fun, and you can show it to your other designer friends, and twenty-six people in Basel will really like it. But it's a different sort of problem—and an even more interesting creative opportunity—to develop a great global campaign for Motorola that has to respect so many different cultures around the world. That's a big stage to play on.

Third, to be a place where clients can enjoy the working creative process as much as we do. We sell a process of thinking as much as the output itself. We bring our clients right inside so they can see how the sausage is made. We make them co-conspirators. This can be frustrating for clients who are used to getting pitched by account managers. But they come to understand that their engagement in our development can make the work stronger.

Fourth, to show how art directors and designers can have a tangible impact on the culture we live in. We're surrounded by the artifacts of design and advertising everywhere we look. I want us to bring our imagination, taste, and richness to these experiences so they can really inform how our world looks and feels. Otherwise, we should just give up, go home at five, and leave this kind of work in the hands of those firms that really just don't give a damn. They're too happy to challenge anything as they count their paydays while slapping the same generic blandness on everything. I want to maintain a team that will create dazzling, different, unexpected work—or just more informative and helpful work—everywhere we turn.

# 04: Is an Art
# Director an Editor?

## Make It *Big*—and Fill 140 Uninterrupted Pages
### Rhonda Rubinstein

Recently, I was given a chance to create a beautifully produced, large-format publication of high reputation, working with the best photographers, total editorial independence, elastic deadlines, and a willing client. Yet along with this promising situation came some unexpected discoveries.

*Big*, by its own admission, refuses to be categorized. The magazine finds itself in the art/photography/design sections of international newsstands—though not very easily—for those who are so inclined to go looking. The cover contains the word *Big* in varying degrees of size and legibility, usually accompanied by a photograph. Inside, a few pages of lovely luscious products surrounded by lovely luscious people announce that this is in fact a magazine that is believed in by those who work in advertising agencies representing luxury items. After these few pages comes what is commonly referred to as an editorial well, which in this case runs very deep—a hundred and forty pages or so—and is entirely visual.

Two of the quarterly issues are produced by a different creative director in a different location on a different theme. Sound interesting? "Sign me up!" I tell Marcelo Junemann, the founder of *Big* magazine. "What are you looking for?" I ask in the less-jaded San Francisco voice that is mine after seven years of not living in New York City.

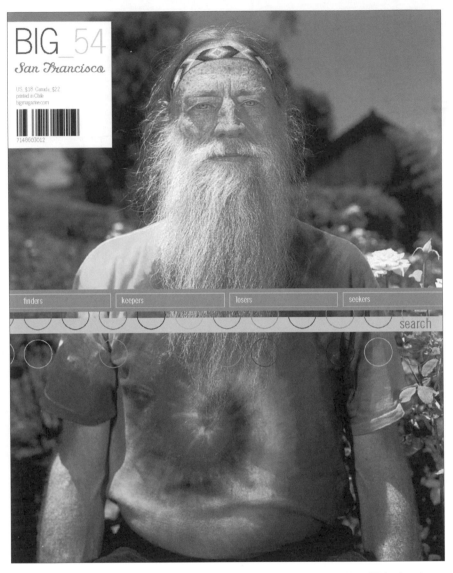

*Big 54* cover; art director/typography: Rhonda Rubinstein; photographer: Olivier Laude; Fall 2004.

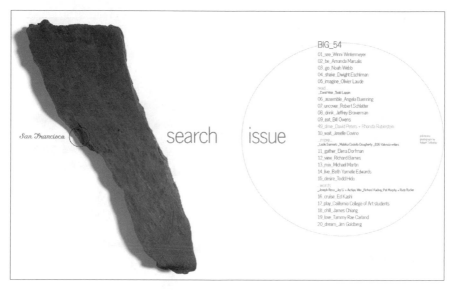

San Francisco    search    issue

Big 54 table of contents spread; art director: David Peters; typographer: Rhonda Rubinstein; photographer: Robert Schlatter; Fall 2004.

"Send me a proposal. We're looking for outstanding concepts, where people get fully inspired," he replies from his tiny office on the third floor of a Tribeca walkup. Not much to go on as a Request for Proposals, but this is the guy who started the magazine in Madrid about a dozen years ago, and brought it with him to New York, persisting in producing issues despite the particular publishing climate, which puts so much emphasis on such wearisome ideas as profitability and popularity.

It's March 2003 and antiwar protests fill the streets. A San Francisco issue of *Big* . . . clearly SF is really where it's at now. Okay, these may not be the freewheeling days of free love and hard drugs when everyone's got a rock 'n' roll band. And these may not be the free-dealing dot-com days when everyone's got a business plan and a lead to venture capital and you have to sign an NDA to attend dinner parties. But it's far more interesting now. After the future. When you think about it, the origins of how we live and work today pretty much started here. New age, new technology, nouvelle cuisine, vintage jeans.

I get details. "You pay photographers how much to shoot a six-page story?" Stop the presses. How can we ask the likes of Bill Owens or Richard Barnes to pick up a camera for two hundred and fifty dollars? And no film expenses. Given the collapse of many SF publications and thus of paying work, how could we ask photographers to shoot for no money? On the other hand, they might have some free time. We test our theory. The photographers respond, "Sign me up! What are you looking for?"

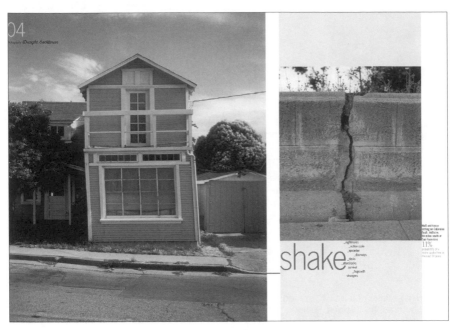

Spread; art director/typographer: Rhonda Rubinstein; photographer: Dwight Eschliman; Fall 2004.

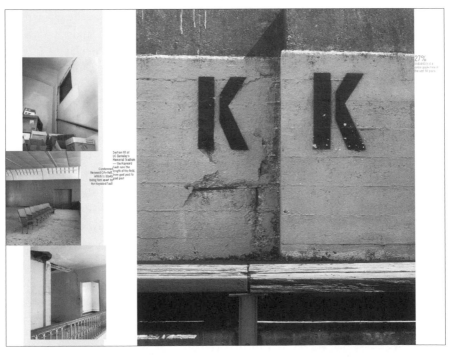

Spread; art director/typographer: Rhonda Rubinstein; photographer: Dwight Eschliman; Fall 2004.

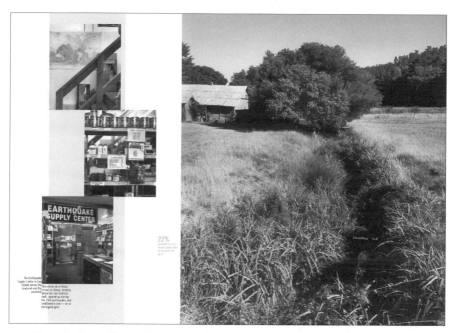

Spread with small photo (among three) of Earthquake Supply Center and photo of a field; art director/typographer: Rhonda Rubinstein; photographer: Dwight Eschliman; Fall 2004.

Spread with house and garage (left) and skateboarders (right); art director/typographer: Rhonda Rubinstein; photographer: Dwight Eschliman; Fall 2004.

In past issues of *Big*, New Jersey dignified its suburbs anthropologically, LA upped the sleaze factor on its character actors, and Detroit turned into a hip motor city. Capturing San Francisco requires serious help. First recruit: my partner at Exbrook, David Peters, who offers a thoughtful stream of ideas, both logical and absurd. Next, a photographer wrangler, Maren Levinson, photo editor of a successful SF shelter magazine, who knows every photographer this town has to claim. And Mary Spicer, who knows everyone else in this town, from political socialite to outlaw artist, and can locate any person, place, or thing required within twenty-four hours.

San Francisco takes pride in its diversity. So we couldn't be as single-minded as to do the issue on, say, technology. Well, we could, but we'd had enough of that. Or, more compellingly, an issue on dissent, since Berkeley is shorthand for protest and our congressional rep was the sole vote against Bush's war in the post-9/11, pre-Abu Ghraib days. Why do San Franciscans feel compelled to save the world?

We hone in on the more open-ended theme of "search." After all, San Francisco is where people end up in their search for love, for money, for meaning, for change, for inspiration, for sex. Or, in a less touchy-feely, but perhaps even scarier, way, "search" is the fastest growing medium of all time, with thousands of Web sites and conferences devoted to it.

In no time, search translates into a proposal that includes some of my favorite idiosyncrasies: a visit to the Este Noche, a Hispanic transvestite cowboy bar; the houses propped on the San Andreas fault line; a sweat lodge in Sonoma; the writer's grotto at the Dog and Cat Hospital; and Susie Tompkins Buell's mid-century modern apartment. We attach the names of some great photographers who live here and send off the 1,500-word proposal to Marcelo. It's mid-April 2003. San Francisco's average temperature of 54.1 degrees is the coolest April since 1975. Bush is preparing to announce Mission Accomplished in Iraq. And Marcelo stuns us with a quick and definitive missive: "Looks great. Go ahead."

In an age of predictable magazine formats, it is refreshing and daunting to have 140 uninterrupted pages. The electronic template I receive from *Big* is absolutely blank.

We begin. At the new Four Seasons Hotel, which, during its construction next to my former office, inured me to enough jolting that I ignored an earthquake tremor, believing it to be a boom dropping. The Seasons Bar, built for those now-scarce dot-com execs, is the perfect undisturbed room for meeting photographers at forty-five-minute intervals every Thursday evening over cocktails and wasabi peas. In these meetings we discover photographers' personal projects and propose ideas from our ever-increasing list.

Marcelo schedules SF for the May/June 2004 issue. What stories will be compelling in a year? By definition, anything new today will be dated tomorrow. Up-and-comers could be doing hard time by the on-sale date. We want to be timely and timeless.

Art director/typographer: Rhonda Rubinstein; photographer: Bill Owens; Fall 2004.

We search for what makes San Francisco such a singular place to live, work, create, and instigate. Which brings us to fog and earthquakes. When I moved to SF, I had a map of each to guide my apartment search. The first, drawn by a friend, delineated the city into two essential categories: sunny and foggy. We discover Jenelle Covino, a young photographer who has found a 1946 diary in which the writer's most pressing concern is the weather. Thus inspired, Jenelle takes on the fog with spectacular perspectives of visible moisture.

The second map revealed what was beneath the surface, from bedrock to landfill, particularly useful for earthquake probability calculations. We send Dwight Eschliman, a photographer whose eye for symmetry and parallelism has been well-appreciated by the commercial magazines, to search out life along the fault lines, where cracks run through football stadiums and houses slowly sink into the ground.

Some photographers are working on concepts that dovetail with ours. The city is known for its tourist-pleasing cable cars and streetcars, but Noah Webb, a recent Cal Arts graduate, elevates the idea of transportation into perfectly composed images of solitary figures caught in the web of recurrent motion. We green light his "Teleport" project, and Noah transforms the much-maligned public transit system into dramatic spaces worthy of New York's Grand Central Station.

On a good day, the city's more charming physical qualities include 29.5 miles of coast: blue sky, ocean waves, sand beaches. We talk to Jim Goldberg, of

Art director/typographer: Rhonda Rubinstein; photographer: Bill Owens; Fall 2004.

Art director/typographer: Rhonda Rubinstein; photographer: Bill Owens; Fall 2004.

Raised By Wolves fame, who has the idea of capturing the great outdoors in the lush color stills of *Vertigo*, *The Rock*, and other classic films set in San Francisco. Jim eventually agrees to venture from his Haight Street studio and returns with sensational fuzzy black-and-white Polaroids with the soft edges of aged film and an unexpected textural bonus of chemical fixative. Disasters have their own inherent beauty; it's simply a matter of helping people see it. Besides, reshoots are not polite on a $250 budget.

At the focal opposite is Olivier Laude. Perhaps his *National Geographic* work inspired his crisp, allegorical way of portraying visual identity. He grabs people off the street, covers them in thrift-store clothing, takes them out to the edges of town, and shoots photo after photo of them. The violent undercurrents in his color-saturated tableaus reflect his particular dark and comic worldview. Olivier confronts us with a portrait of the quintessential SF stereotype: a gay software engineer hippie. Dare we put something so disturbing, so unhip, so wrinkled on the cover?

Marcelo insists we produce word-based stories. Ten to fifteen pages, according to the agreement. We bring in more help: veteran magazine editor David Weir who spills more local knowledge at lunch than most writers know, and Marc Weidenbaum, an editor who just returned to the city and remains undeterred by our onslaught of research challenges. We track down writers to comment on less visible ideas: the search for self, for a Bay Area architectural style, the searches of the Gold Rush past and the sci-fi future. Our September photography deadline quietly slides, as do George Bush's approval ratings.

On December 12, a bar called Home is the setting for seasonal beverages enjoyed by the crew of seven, which now includes our dutiful photo assistant, Aya, whose day job we wouldn't want to risk by divulging her full name. At the Exbrook office, two precarious piles of boxes and envelopes full of 11 × 14 prints perch on a filing cabinet. And somewhere on the other side of the world, Saddam Hussein is pulled out from the bottom of a deep dark hole.

After nine months, Marcelo good-naturedly asks for a look at *Big SF*. I send layouts via e-mail, expecting questions. The reply: "The issue looks great! I'm really happy." So, on March 25, a twenty-one-pound box of plastic-wrapped and sealed art containing seventy-seven 11 × 14 prints, thirty-seven 8 × 10 prints, fifteen Polaroids, five 4 × 5 transparencies, one 6 × 6 print, one film negative and three CD-ROMs travels uninsurably via FedEx to New York, to be taken by Marcelo to Chile for color separation by the aptly named Cristobal.

Then comes the challenge of putting it all together. Though we began with a vision of a San Francisco search, we had offered a fair amount of creative freedom to the photographers (which was, of course, their reason for engaging in the project). Unifying the work of twenty different photographers within our theme became a design opportunity. Our resolution was a narrative that takes the viewer from dawn to after-dark, where the headlines are the actions. The simplicity of the search engine inspires the design. Keywords convey the intent,

content, or mood of the stories and underscores connect the ideas. Captions resemble search results in the form of statistics and prices that, through juxtaposition, offer surprising conclusions. The "you are here" circle highlights relevant information. Occasionally, typography happens, as when the circle goes bust in the Silicon Valley story. Color is inspired by a San Francisco day: International Orange (the color of the continuously repainted Golden Gate Bridge), the bright blue of sky and water, the occasional spot of yellow sun, and of course, nine shades of gray fog.

Finally, on June 17, 2004, in New York, the 9/11 Commission publishes a much-anticipated report declaring no evidence of a collaborative relationship between Saddam Hussein and Al Qaeda. With equal, if not greater anticipation in Chile, Marcelo receives the upload of final design files for *Big San Francisco*.

There it is, 140 pages now. Reviewing page proofs, Maren and I observe how the issue represents a distinct kind of photography. Gone is the cross-processed, wide-angle exuberance of the dot-com era. Contemporary SF photography has a big perspective: big sky, big space, and formal compositions, as exemplified by the transit story. It is direct, not as self-conscious as New York or as artificial as LA, and decidedly not as ironic. Perhaps these photos convey the opening up of creative space that can now be found in San Francisco, while the big money is away.

It is that space, that precious momentary pause, that the issue represents. The coverline begins the search on San Francisco. The issue of *Big* is the result. It is then and there—after the five-year rush and before the next gold mine is discovered—in this economic vacuum that will not be in the history books, that the reflection, the regrouping, and the invention are happening. Confronted with that great nothingness in the form of a blank template and inspired by the state of mind that is San Francisco, we were somehow able to distill this lull into printed pages. We searched on San Francisco and found ourselves. It was a lot of work.

## Véronique Vienne

Alexander Liberman, the legendary editorial director of Condé Nast Publications (CNP), always insisted that magazines had to be readable. Readable? The magazines he supervised during his fifty-plus-year career at CNP—*Vogue, Glamour, House & Garden, Vanity Fair,* and others—had distinctively crowded, messy layouts; page after page incorporated jumbled-up montages of text and images. Forget about quietly curling up to read the articles. Liberman's signature look was much too lively to invite contemplation.

Liberman, who retired in 1994, never bothered reading a manuscript before laying out a story. Once, when I was art director of *Self* magazine, he caught me reading a piece I was working on. With the authority of a man thirty years my senior, he reprimanded me severely for wasting time on the job. Magazine readers must get a feel for a story *before* reading it, he explained. It's best if art directors don't get involved with the text. My role, he said, was to communicate ideas—not illustrate words.

He summoned to my office the senior editor in charge. She scurried in, a hard copy of the edited manuscript pressed against her chest, like a shield. She was asked to put it aside at once and pitch her story aloud to Liberman. Always polite and suave, Mr. Liberman, as we called him, rebuked her whenever she looked at her notes. He was not about to be text-driven. Whether dealing with fashion, beauty, health, food, or travel, articles in CNP magazines were scripted to have a dramatic plot line. With a series of questions, he tried to unveil the reader's emotional relationship with the article. "Are you saying that vitamins are bad for you?" he asked. "If that's so, rewrite the headline."

While listening to the editor, Liberman began to build a new layout from scratch, his hands moving as if on automatic pilot over the drawing board. "I don't search, I find," he liked to say, paraphrasing Picasso. Headlines, quotes, sidebars, photographs, dummy text, and pieces of colored paper would come together in less than three minutes. I had to hold my breath, literally, not to disturb this impromptu collage. As soon as Liberman declared that he was done, he made it clear that my responsibility was to hold the elements in place with tiny bits of transparent tape—and God help me if I straightened anything in the process.

David Carson, the now-famous graphic design iconoclast whom I hired at *Self* in 1990 as a mere paste-up assistant, remembers trying to copy fit Liberman's montages with the final text—not an easy task. "It was surreal," he now says. He had to treat Liberman's fragile piles of scrap paper as if they were works of art. He thought it was all pretty silly. "At the time I didn't know who this guy was. Now, looking back, I get the feeling that he has been undervalued

and underappreciated as a graphic designer." Although the two never spoke, I can't help but wonder if Carson was not influenced by the old man's serendipitous approach to the page.

Though Liberman's layouts were at times deliberately messy, they were never confusing. He would strive to shock readers, but never intimidate them. As a result, the magazines he designed were approachable and thus "readable." He made sure the Condé Nast publications triggered in readers an instant sense of identification with what was presented on the page. A glance is all one needed to grasp the sum total of what the editors were thinking about. These were magazines one didn't need to decipher in order to *read*. "Clarity and strength of communication is what interest me," said Liberman. "I hate white space because white space is an old album tradition. I need to be immersed in the subject matter."

Unfortunately, few of Liberman's collaborators were ever able to "read" him as effortlessly as readers were able to decipher his layouts. From 1942, when Liberman, then thirty, was named art director of *Vogue* magazine, replacing the formidable Mehemed Fehmy Agha, to 1994, when he announced that James Truman, thirty-five, the young editor of *Details*, would be his successor as editorial director, he kept everybody mystified with abrupt decisions and unexpected turnarounds. "The creative process is a series of destructions," he was fond of saying. For him, the creative process was also a series of dramatic dismissals. Great editors got the ax on Liberman's watch: Diana Vreeland, Grace Mirabella, Louis Oliver Gropp, just to name a few. And countless great art directors as well: Priscilla Peck, Lloyd Ziff, Dereck Ungless, Ruth Ansel, Rip George.

To this day, the mere mention of Liberman, who died in 1998, can set off a heated discussion between designers and editors who have worked with him. People who have been fired by him sometimes break into hives. Others relish the opportunity to tell some particularly funny story. Because of him, there is an instant sense of community among ex-CNP employees. Commenting on Liberman's "absurdly hip" collage-approach, design critic Owen Edwards today says: "When I worked with him, I always thought he was dead wrong—which only shows how dead wrong I was."

Liberman had a knack for astounding and confusing people around him—and his attempts to explain his design philosophy were more alienating than reassuring. "Consistency is the sign of a small mind," he told me for openers. "Don't be stylish, you'll be dated," he would then admonish. And he kept after me: *"Un peu plus de brutalité, s'il vous plaît, ma chère amie"* ("a little more brutality, please, my dear friend"), he insisted when my fashion layouts looked too "nice" to him. And each time my heart would sink. But eager to please—no one was ever immune to his old-world charm—I presented the next day a revised, Fleet Street-inspired layout. Such a look of contempt I had never endured. "Simply lurid," he said, before walking out of the room.

He was not a teacher. Although very articulate, he could never find the appropriate words to share his vision with others. Looking back, I believe that his inability to communicate with his design associates was due to the fact that his ideas were so radical, he couldn't begin to describe them. He used an antiquated vocabulary that dated from the days of Gutenberg to introduce a way of thinking that foreshadowed the revolution of the information age. He asked for "vulgarity" when what he was after was impact. He talked of "charm" to describe a sense of ease. He called "provincial" layouts that were too rigid. Although Liberman dismissed computers as "too slow," ten years before the introduction of the Macintosh, he was already designing pages as if they were interactive screens, with layered rather than linear narratives.

A man employees loved to describe as suave, urbane, and aristocratic, Liberman was no stranger to revolutions, cultural or otherwise. Born in Kiev, Russia, in 1912, he remembers the first days of the Bolshevik upheaval. His father, a powerful forestry and timber manager, prospered under Lenin's regime. His mother, an out-of-work actress, created a children's theater to keep starving urchins off the street. But in this climate of anarchy and social chaos, the young Liberman, a sensitive and difficult child, was displaying troubling behavioral symptoms. His parents were afraid he was turning into a delinquent. In 1921, apparently with Lenin's personal consent, he was shipped to school in England where he was forced to learn manners. A quick study, he acquired there, by age ten, the genteel demeanor and slight British accent that would later become his trademark.

After Lenin's death in 1924, the Libermans left Russia and settled in Paris. Alex was transferred to a chic French private school where he made valuable friends among the sons of the aristocracy. But the turning point for him was visiting the 1925 Paris Arts Décoratifs exhibition. He was only a teenager, yet the discovery of Art Deco, then called *art moderne*, was "one of the most important events in my life," he said later.

From then on, the concept of modernity became something of an obsession with him: "Alex tried and tried to get everyone to be modern—his idea of modern," notes Lloyd Ziff, who was art director at *House & Garden*, *Vanity Fair*, and *Traveler* in the 1980s. But he notes that the way Liberman worked, juxtaposing photographic and typographical elements, was more reminiscent of Russian Constructivism than of French Art Deco.

Liberman's early career in design was somewhat erratic. A bleeding ulcer kept interrupting his attempts to find a line of work he would enjoy. He studied painting with André Lhote, architecture with Auguste Perret, and was briefly employed by Cassandre. In 1933, he got a job at *VU*, a Parisian weekly, and one of the very first news magazines to use reportage photography. There, he befriended Lucien Vogel, the editor, and met photographers who would help him define his taste for photojournalism: André Kertez, Robert Capa, and Brassai.

In the late 1930s, after a brief marriage with Hilda Sturm, a German ski champion, Liberman fell deeply in love with a married woman, Tatiana du Plessis, a striking beauty who was a niece of famous Russian actor and director Konstantin Stanislavsky (inventor of The Method acting). The invasion of France by Hitler's army in 1940 forced their fate: Tatiana's French aristocratic husband was killed while trying to join exiled general Charles de Gaulle in England. Alex escaped to New York with Tatiana, soon to be his wife, and her daughter, Francine.

In New York, Liberman was quickly hired by Condé Nast, the founder of the company that still bears his name. The old man was impressed with Liberman's experience with photojournalism at *VU*. Back in 1931, Clare Booth Luce had submitted to Nast, her boss at the time, the prototype for a weekly picture magazine called *Life*. He had rejected it. Now *Life*, launched in the late thirties by Henry Luce, Clare's husband, was a success—and Nast was sorry he had missed the opportunity to start a breakthrough publication. When Liberman proposed, during his job interview, to inject some reportage in *Vogue*, Nast loved it. From that day on, Alex Liberman thought of himself as a journalist—a super editor with visual understanding. He never liked the title of art director and was relieved when, in 1962, he was appointed editorial director of all Condé Nast magazines.

During his career at CNP, Liberman actually carried a grudge against art directors. Their title, he felt, was misleading. He didn't want them to be artists, but managers of the image of the magazine. He understood his role, and the role of all editorial designers, to be what we call today "brand managers." Unfortunately, the notion of branding was still in its infancy, and Liberman never came across the use of that term. What a pity. He would have loved to wrestle with concepts such as "perceived quality," "brand equity," and "visual territory."

Instead of rewriting the art director's job description, Liberman spent five decades fighting the idea that editorial design was an artistic endeavor. He went out of his way to undermine art directors in front of editors. With remarks like "This layout is utterly banal, wouldn't you say?" or "Remember: You are not a scarf designer, you are a journalist," he could reduce some of the most talented designers to tears. In the hallways of CNP, you could easily spot art directors: they were the walking wounded, the folks wearing neck braces. While at *Self*, I too became partially disabled with a frozen shoulder, tension migraines, and lower-back problems.

Editors who attended the daily public floggings of art directors would look at their shoes in embarrassment—but internally, they were rubbing their hands. Liberman can be credited with weakening the authority of editorial art directors in the USA. He trained three generations of editors to belittle the opinion of their visually oriented co-workers. Today, every publication in America has at least one editor who once worked at CNP and refers to QuarkXPress and Photoshop users as "my art people."

Liberman considered art direction a profession, not an "art." As far as he was concerned, art was something one did in a studio, not an office. In fact, in his spare time, during weekends, he managed to become a prolific artist—furiously painting huge canvases or making large-scale environmental sculptures that won critical acclaim in the New York art world. As such, Liberman led two distinct lives. Careful to cultivate a Clark Kent, charcoal-gray-suit persona by day, he would become an ambitious abstract expressionist by night. His wife, Tatiana, called him Superman. "Art is the violent expression of resentment against the human condition," he told Barbara Rose, the author of a monograph on his work as an artist. Rose was under the impression that Liberman kept that resentment a private matter. "Alexander Liberman, the artist, is deeply suspicious of taste," she wrote in 1981. "Alexander Liberman, the editorial director of CNP, is, above all, a man of taste."

Rose was misinformed. With each passing year at CNP, Liberman showed less and less patience with issues of taste, letting his growing resentment show through. He became committed to banishing forever the "vision of loveliness" he had endured at the beginning of his tenure at Condé Nast from the very proper ladies who were *Vogue*'s early editors: Josephine Redding, Marie Harrison, Edna Woolman Chase, and Jessica Daves. At long last, in the 1960s, Diana Vreeland set him free. "Laying out a beautiful picture in a beautiful way is a bloody bore," she once said. Like him, she treated the magazine as a series of collages, wantonly pasting together her models' body parts to get the "perfect whole." Liberman was impressed. "I put legs and arms and heads together," she said. "I never took out fewer than two ribs."

When I first encountered Liberman, in the late 1970s, Diana Vreeland had been replaced by Grace Mirabella, and the *Vogue* art department, where I worked as a paste-up assistant, was run by Rochelle Udell. The magazine layouts were deliberately untidy, to differentiate *Vogue* from its competition, *Harper's Bazaar*, the absolute leader in terms of design and visual innovation. Still under the influence of its legendary art director, Alexey Brodovitch, *Bazaar* was a thorn in Liberman's side. But he did what a good brand manager would do: instead of trying to play catch-up with *Bazaar*, he carved out a new, younger niche for *Vogue*. As soon as he did that, circulation began to rise dramatically. And advertisers loved being associated with a smart fashion publication that embraced the spirit of the Pepsi generation.

Like Carson would do fifteen years later, I spent long hours in the *Vogue* art department, painstakingly trying to fit type around Liberman's complex photomontages. Meanwhile, in his studio at home, the "Silver Fox," as some editors now called him, was throwing paint by the bucketful on oversized canvases, working as fast as possible to try to bypass the mental process, a process he believed could only produce preconceived and banal solutions.

In 1989, I jumped at the opportunity to work with him again, this time at *Self*. By now, Liberman had dropped all pretense of good taste. Although he had

retained his suave, David-Niven look, I was told that he was fiercer than ever. And indeed, soon after I joined CNP, Anthea Disney, the editor who had hired me, was fired unceremoniously for not following Liberman's directions. In no position to assert myself with the new editor, Alexandra Penney, I decided to look at the situation as a chance to resolve the Liberman mystery once and for all. I galvanized my staff and made it clear to Liberman that my entire art department was at his service. For the next six months, we were on a roll.

As soon as the great man walked into the room, we were ready in battle formation: One assistant was at my side with scissors, knife, and loupe; another was posted next to the color copier; a third was assigned to the phones to keep the lines open in case Liberman got a call. I had two "runners" ready to spring to action to fetch an editor, find a color swatch, or alert the photo department. Helen Maryles, the youngest designer, was on tape duty. I will never forget the sight of her, standing next to Liberman, palms open, finger extended, with tiny pieces of transparent tape stuck at the end of her ten digits.

In his biography, *Alex*, written by Dodie Kazanjian and Calvin Tomkins, Liberman says: "If ever I have done what I'd call my own layouts, it's at *Self*." The pages he designed then and there were a debauch of bold type and cut-paper blocks of color, a look reminiscent of the *papiers découpés* technique Matisse favored at the end of his career. Liberman had met him briefly in 1949, when the painter was in his late seventies—still mentally alert and youthful in spite of age and poor health. Now, Liberman had a chance to emulate his favorite artist. The *Self* layouts were an unmitigated homage to the author of "The Dance."

For the first time ever, Liberman was doing "art" at the office. He did concede to his biographers that at *Self* there was "not much difference in the psychological process between a composition on canvas and arranging material like this on a page." So this was it. In a long career dedicated to overcoming aesthetic considerations, the *Self* experiment represented a brief moment of reconciliation between Clark Kent and Superman—between the editorial director and the artist.

It was a commercial disaster. The advertisers hated the "new" *Self,* with its whimsical color-blocks and elegant yet topsy-turvy typography. The readers didn't get it either. The newsstand circulation took a nosedive. The magazine had lost its sacro-saint "readability." Liberman, in collaboration with me and my staff, had been breaking his own rules—having fun and doing "art" at the office instead of striving to keep the layouts upbeat yet accessible. I was fired—and rightly so—for encouraging a seventy-eight-year-old man to be creative on the job. I should have known better: at Condé Nast, art direction is not supposed to be an artistic endeavor.

## Creating Content: Giving Design a "Voice"

## A Conversation with Drew Hodges and Gail Anderson
## Creative Director/Principal and Senior Art Director, SpotCo, New York

*Steven Heller: You were classmates at the School of Visual Arts. Drew went on to found a successful advertising and design firm dedicated to Broadway and entertainment; Gail is currently the senior art director at the firm.*

*Gail, after being an art director for* Rolling Stone, *what made you decide to work on theater posters?*

**Gail Anderson:** I was always aware of what Drew was doing and was continually impressed with Spot's work. Every time I'd run into Drew, he'd either just moved to a bigger space or had expanded the business. Of my peers, Drew's was the job that was most enviable and exciting. I mean, what designer wouldn't want to create theater posters? The opening spreads we did at *Rolling Stone* were very much like mini posters, so it felt like a natural transition. I welcomed the opportunity to continue to work with a galaxy of typefaces, to continue to assign art, and most importantly, to work with young and enthusiastic people. Ironically, I'd always thought I'd like to work with Drew at some point, so really, the stars were in alignment. The timing was perfect, so I couldn't pass it up. Ultimately, Drew was taking a bigger chance on me, since I'd never really worked with a variety of clients and could, at first, only see things from a design perspective.

*SH: Drew, knowing that Gail did not have advertising experience, what made you hire her to be your lead designer/art director?*

**Drew Hodges:** What we do is a combination of advertising and that dreaded word—*branding*. Basically, since we are selling the arts, if you have a play that is funny then you make a funny poster, and half of what that play needs to achieve in the way of advertising is done: giving a voice and personality to something that is unknown. We are the "coming attractions" for that piece of theater, so we carry a large part of giving that project a look and feel, as well as a literal voice (we do print, radio, and television). For many years before, I had been in the position Gail was going to occupy (senior art director), and the reason the position opened up was I had come to realize there was a lot more my firm needed to be doing beyond design, which I can only call "communicating," for lack of a better term. This has to do with anything from how budgets are spent, for which I have an extraordinarily knowledgeable director named Jim Edwards, to creating new programs to help position a show in the market—radio, TV, of course, but also a new initiative with the

Internet—working with sponsors, press, even the creation of new content to carry advertising to help the success of these shows. And I realized I was the only one in my office who could lead that charge. So basically I needed to replace myself, and it needed to be with someone with whom I never would worry about the quality of the design and the voice that design took. I had known Gail for years, since SVA, and no one has a better hand, and I always thought our work shared a kind of exuberance. Entertainment is unusual in that people are looking for your graphics to be in their own way entertaining. I love work that is quietly beautiful, or coolly minimal, but it really is not a good fit with the kinds of projects we are on. Also, I decided to hire two art directors to replace me—one overseeing all work until the launch of that project—usually the first ad in the *New York Times*—and then another art director to oversee that brand and interpret it going forward through the life of the show, which can be ten months to ten years. So to put it simply, none of us has formal advertising training. My position is now the one that leads the advertising work most directly in the broad sense, while my two art directors split my old role—Gail takes leadership in design, while the advertising art director takes a leadership role in the selling aspect once a brand has been launched, and hopefully we all are learning and gaining in strength from each other in whatever we know less well. To be fair, I didn't want a true advertising art director. Part of what I hope makes our work unique is that it succeeds as design as well as advertising, and we were lucky enough to find project work that suits that duality.

**SH: How much of your work is devoted to designing and how much is devoted to overseeing design?**
**Gail, do you have the luxury to spend the majority of your time designing?**
**GA:** I do a lot of rough sketches on paper and spend a healthy chunk of my day with the designers, which I really enjoy. It's important to talk through ideas before people get too enmeshed in what can sometimes turn into fairly elaborate comps. There aren't a lot of pieces that I sit at my desk and work on alone at this point, but I'm very involved in all of the work that comes from my department. Drew's involved too; whether he makes a comment in passing, or has a clear idea of a particular direction that should be explored. As the client meeting for a show approaches, there's a more formal internal meeting where we get feedback from Drew, Vinny Sainato, the advertising art director, the writers, and account managers. That's become a critical and extremely helpful addition to the process.

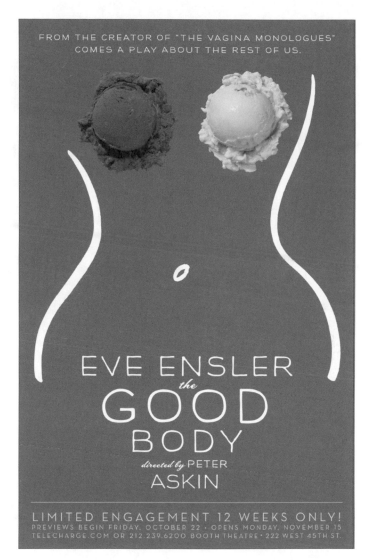

*The Good Body*; creative director: Drew Hodges; designers: Gail Anderson and Jessica Disbrow; illustrator: Isabelle Derveaux; 2004.

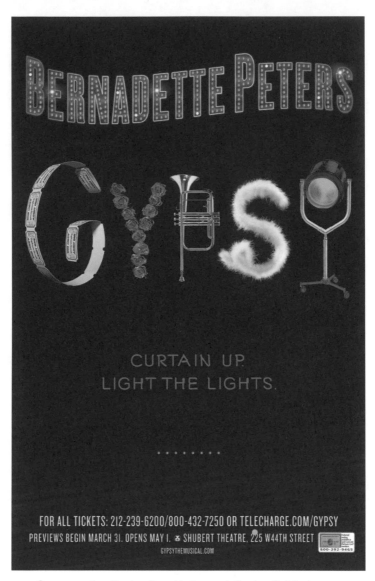

*Gypsy*; creative director: Drew Hodges; art director: Gail Anderson; designers: Drew Hodges and Darren Cox; 2003.

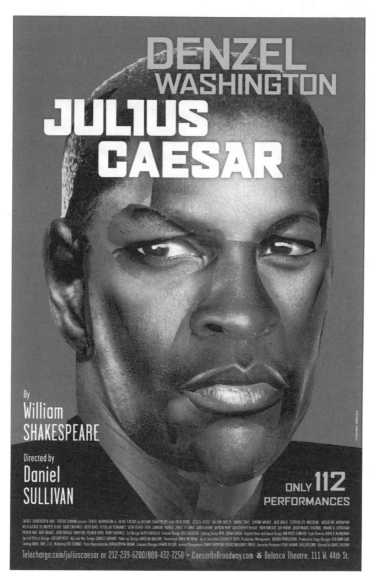

*Julius Caesar*; creative director: Drew Hodges; art director:
Gail Anderson; designers: Sam Eckersley and Darren Cox; 2005.

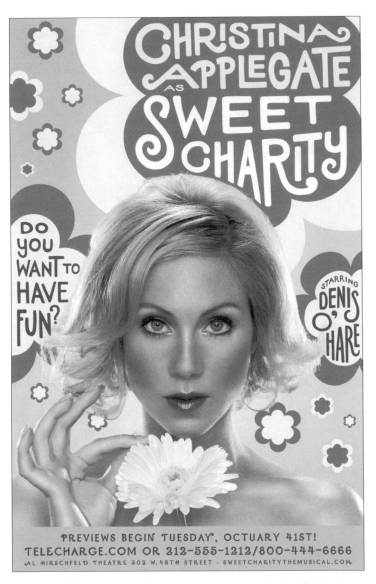

*Sweet Charity*; creative director: Drew Hodges; art director: Gail Anderson; designer: Jessica Disbrow; photographer: Jill Greenberg; typographer: Anthony Bloch; 2005.

**SH: Drew, do you have any time to focus on the design of things?**

**DH:** I occasionally design something altogether, but that is rare these days. My largest strength now is in interpreting what I think the client is looking for, and passing that on to Gail. I really believe making a powerful design is only the beginning of the equation. Making a powerful design that: a) really does the job, b) convinces the client it will really do the job, c) maybe even convinces the client that they thought of it themselves (and you have to be able to accept that maybe they really did think of the idea and be OK with that), d) is the exact visual solution that will accomplish all of this while remaining of design quality, and e) finally, becomes more than just a design, but something that will inspire a true campaign, a unique personality that will drive ideas for television, radio, subway platforms, and even recently set elements. I try to guide Gail on the journey from great design to great design we can get the client to buy to great design that can keep growing and surprising once it becomes an entire identity. And I try to keep them from self-induced physical harm when clients just don't, or won't, get it.

**SH: How do you creative or art direct for a Broadway show that must also pass the muster of producers, directors, and stars?**
**Gail, can your vision for a campaign be fulfilled without changes or must there be a modicum of compromise in each case?**

**GA:** I've come to embrace the compromise now, since it's a given in what we do. Each show has a team of players whose needs must be addressed, and while there are certainly times that the bravest work is eliminated, there are also instances where the suggestions made at the table are completely valid and even good. It's all about figuring out how to make those adjustments more than something we can merely live with, but rather something that's great and just a little different from where we'd started out.

**SH: Drew, how much of the overall vision for a campaign can you retain?**

**DH:** If you mean how much of it can we affect, then all of it. The beauty of this industry is that those who say yes or no to all aspects of the campaign are right in front of you (with the exception of the occasional huge movie star, and even some of those you might get your audience with). So if you can convince them, it goes. However, these are often people who are less used to doing design or marketing than you are, and you need to overcome that. Paula Scher taught me a long time ago: make a lot of work and pick your battles; know when you can make a difference and work as hard as you can to get that work through; and the rest, take a deep breath and let go.

**SH: You are both seasoned designers. It is axiomatic there will be differences given the client's preferences, but do you have differences over matters of style and taste?**

**Gail, are you in sync with Drew's concerns?**

*GA:* I've come to understand Drew's concerns more and more, since I attend the initial meetings where the art is presented and I see firsthand how demanding people can be. I sometimes read the reactions a little differently because I have less history with the producers, but I try to respond to Drew's interpretation as well as my own if in doubt. Our aesthetic is similar, so it's not a big deal. And it's all done in good humor, so I can take it if he's delivering bad news.

**SH: Drew, are you in sync with Gail's?**

*DH:* As far as I am concerned, taste issues never really come up—if I did not believe in her taste I don't know why I would have hired her from the get-go. She has better taste than me, frankly. Mainly, I am playing the role of the client's needs, or what I am guessing they will be, and trying to put that problem or concern forward early so Gail has the time to respond to it and solve it in a way that maintains the beauty the work had when first conceived. It is very common for me to say, "That type looks beautiful, but I know the client is going to want it larger." Sometimes Gail argues it is better this way and it should stay—at least then we both get a chance to refine our arguments before we meet with the client. Sometimes Gail will argue that a piece should stay as is, and I will accept that but ask for another option to cover a need I foresee the client will have. A good day is when the work is beautiful but we know the client will have trouble with it and we are able to predict that well enough so that we can show the work for its quality and solve client concerns as they voice them, because we have anticipated them. This gives clients the assurance to take the risk and go with the stronger work. This just happened on Wednesday with Denzel Washington.

**SH: At SpotCo, is there room for all the designers on staff to have a shot at a campaign?**

**Gail, how much freedom do you offer designers?**

*GA:* I like to think that the designers have a good deal of freedom to experiment, and certainly to try as many ideas as they can generate. I can be pretty blunt about asking them to kill the ones that just don't have a chance after a while, and I offer the first dose of real-world concerns on the experimental stuff. It's important that the designers develop their own voice and not just execute my (or Drew's) vision. The variety of styles is key even when I know I would have done it differently. But admittedly, there are also times when my voice is the loudest.

**SH: Drew, How much freedom do you offer Gail that she can pass on to designers?**

**DH:** I let them make what they feel is right, after an initial briefing from me to Gail—however, once the work is well on its way, I may ask for something that is not there to be tried and put into the presentation. Gail assigns the designers (there are five) the projects. Sometimes I respond to their work directly as I am walking through their area, but I have tried to avoid that—it ultimately undermines Gail's voice and can confuse the designers. I rarely edit existing work. Gail knows what is strongest and puts that forward. I just add to what is there.

**SH: What are your mutual expectations? What do you want and what can you learn from each other?**

**GA:** Being on the senior management tier of a company is a new experience and I'm enjoying expanding my little world beyond design. There's so much room for growth at Spot that I expect to be challenged for a good long time. Part of my strengths lie in being a good art director of illustration, while Drew's lie more in photography, so we're able to tap each other's resources as needed. Vinny looks at design solutions from a completely different perspective, sometimes more nuts and bolts, where I can get bogged down in minutia. That's made me sometimes question my approach to problem solving—not a bad thing for a jaded old designer. And Drew's abundant energy divided by my "Is she still breathing?" calm plus Vinny's razor-sharp wit probably equals one normal person between the three of us.

**DH:** Oy. Way too much, I suppose. I expect the art directors to create beautiful work. That is a given, and they always do. I expect them to try and have a larger idea beyond the comp itself so the work can become an advertising campaign rather than just a poster. I expect them to try and give a client what they have asked for, even when it is ridiculous, but not without having what we consider to be a better option presented right alongside it. I expect them to manage their departments, make sure their staff feels listened to, respected, and considered. I expect them to be on budget and on time, and when neither happens I expect them to tell me early so we can do whatever needs to be done to minimize the concern on the client's part. I expect them to work very hard, and keep good hours. I hope for them to learn the ability to lead a room of clients, when leading that room is akin to herding cats. That one we are all working on. I expect them to laugh as much as is humanly possible— if only to drown our sorrows. And I expect them to treat me with respect, hopefully as a friend, which they always do.

# 05: Is Art Direction Design?

## Design vs. Art Direction: A Question of Character More Than Training

### A Conversation with Dimitri Jeurissen
### Art Director/Partner, BASE, Brussels, Barcelona, New York

***Véronique Vienne: In your brochure, under the title "What Base does," you list art direction on the top. How do you define it?***

**Dimitri Jeurissen:** Here, the art director/graphic designer relationship is critical. This is the difference between us and a traditional advertising agency, where the emphasis is on the copywriter/art director relationship. Our main expertise is image-creation, graphic identity, advertising images, and branding images.

We are not in a traditional hard-core advertising business. The advertising work we do is not aggressive or bottom-line oriented. We get involved in image campaigns—we are never asked to solve short-term problems. We follow the same pattern as a studio like Baron & Baron. Fabien Baron started as an editorial art director, but then went into advertising, opened a design studio, became a photographer, a product designer, a furniture designer, and did some fashion branding as well. He is an excellent example of the way art direction cuts across definitions.

**VV: What is the difference between an art director and a graphic designer?**

**DJ:** Physically, it is very different. A graphic designer designs with type and does layouts. An art director is someone who puts together teams of photographers, graphic designers, stylists, etc., in order to convey the right message. An art director is like an orchestra conductor.

**VV: How can someone who is trained as a graphic designer become an art director?**

**DJ:** It is a question of character perhaps, more than training. Art direction is between creation and commerce. To succeed in this position, you need to have a lot of energy. You can't be lazy. You also need to be somewhat charismatic in order to lead a team. I became an art director because I was entrepreneurial. I liked having people around me and I liked looking at all aspects of a project. It was also what I was good at. I had a knack for getting things done. At the beginning of my career, I was doing design work, like everyone else. Little by little, though, I realized that I was better at some things than others.

**VV: If you had advice to give a young art director, what would it be?**

**DJ:** Be open. Look around, that's the most important thing. Go to exhibitions, to plays, to gallery openings, to magazine parties, whatever. You have to absorb a lot of things. And not just things having to do with the art scene. I am open all the time, even when I pick up my son from school. I listen to what the kids say, notice how they dress, and watch how they interact with each other. This attitude is what you have to bring to a project. Graphic designers focus on the page. In contrast, art directors must look around beyond what's in front of them.

**VV: So the expression "art director" is a good one. The word "director" not only suggests that you are "directing," it also suggests that you are looking in many "directions."**

**DJ:** Yes, you need people skills and you need to be curious and adaptable. Being an art director is a very social function.

**VV: What gives you the authority to direct others?**

**DJ:** You have to be sure of yourself. For example, I never bring three design solutions to a client's presentation. I only show them the one I believe in. There is always one that's better than the two others. It's an error to try to cover all the possibilities. You don't go to the doctor and say, "What's wrong with me? Give me three options."

If there are some problems with the design solutions you propose, of course you work on it further. There is always a conversation—obviously, as a designer, there are a lot of things you don't know about your clients' products or services. But what you try to establish is an exchange of rational ideas rather than subjective reactions.

**VV: You also list "brand positioning" as an expertise. How did you learn about branding?**

**DJ:** Most advertising agencies build up branding as an exact science. But I never felt I had to study marketing in order to understand branding. Instead, I try to use common sense to solve branding issues. I try to anticipate what is right and appropriate, and try to check my gut feelings against others who have a different expertise. You can do all the studies you want with a brand agency and follow historic examples and still fail. I remember when Dr. Pepper was trying to launch its soda on the European market. They did everything by the book to make it successful. But no one liked the taste of the stuff. It was a total failure. You can't solve every problem with branding!

Branding happened naturally for us. We started doing corporate identity for galleries, books, and so on. And now we are doing branding for a fashion sportswear company, for a television station, for a political party, for a number of cultural institutions, for a lingerie brand, and for a car wash in New York's Chelsea.

**VV: Why do clients come to you? In other words, what's your brand?**

**DJ:** Our design solutions are always pretty direct and evident. Honest too. I like the word *honest* to describe what we do. With the result that sometimes we are asking ourselves: "Is it enough?" But I think that simplicity is what makes us different.

Our Web site is an example. We used to have this flashy Web site but eventually got fed up with it. Truth be told, my partners Thierry Brunfaut, Marc Panero, and I are not of the generation of Web designers, so we were a little overwhelmed with all the technological aspects of our first Web site. We simplified it and designed it as a series of simple buttons. Just click and go where you want to go.

**VV: Your main office is in Brussels. You also have an office in Barcelona. Why did you open an outpost in New York when so many of your clients are in Europe?**

**DJ:** Art direction is about making all the right connections and about knowing all the right people—and New York is where all the talent is. It is the international crossroad for all the professionals we work with: the photographers, the models, the agencies, the designers. We quickly realized that

someone had to go open a New York office. And it was more appropriate for me to come here since I am the art director for Base and I deal with talent all the time, whereas Thierry and Marc are more graphic design oriented.

**VV: Can you tell me about BEople, "a magazine about a certain Belgium," as it was called? It received quite a lot of press and some design awards here in this country.**

**DJ:** Unfortunately, *BEople* is no longer on the newsstand! The cover, with its distinctive white circle that systematically obliterated the face of the model, evolved from the realization that we had no celebrities in Belgium—no native actresses or movie stars to put on the cover of the magazine. Instead of apologizing for it, we made this lack of celebrities central to our brand.

This type of magazine was in our head for a while. So we were very enthusiastic when the opportunity came up to get involved with this new concept. We did seven issues—on the kitchen table, so to speak—with little financial support. But eventually, the editor/publisher ran out of money. Advertising was fine, we were a healthy magazine in that way, but we, at Base, were not making any profit, and so we had to stop—even though we loved the collaboration and the experience we gained from it.

## Less Is More:
## Art Directing a Magazine about Design

## A Conversation with Emily Potts and Michael Ulrich
## Editor and Art Director, *Step Inside Design*

**A design magazine is difficult to design because it is about design.**

*Steven Heller: Emily, what is the most important visual concern you impart to your art director?*

**Emily Potts:** My main concern (which really isn't a concern, because I trust Mike's direction) is that the layout doesn't override the pieces we're featuring, and that everything is readable and easily accessible.

*SH: Michael, how do you address these concerns and still produce a magazine with a visual personality?*

**Michael Ulrich:** I try not to over-design the stories; I use simple layouts and plenty of white space to create a visual atmosphere that allows the designer's personality to show through. The design of the magazine should add to—not take away from—the reader's experience of looking inside the head of whomever we feature.

**The balance between text content and visual content always has to be negotiated between editor and art director.**

*SH: Emily, how much latitude do you give your art director at the expense of the word (if any)?*

**EP:** I don't really give Mike any visual direction when I hand over a story. I know he reads it, looks at the images provided, and decides what to show. There are occasions when I go back to him and ask him to put a different image in or rearrange images to make better sense with the order of the text, or if I feel one image is more important to the story than another.

*SH: Michael, how much compromise is there in the overall relationship of text to image?*

**MU:** Emily gives more direction than she gives herself credit: when I'm given a fifteen-hundred-word story for a six-page feature, there isn't any compromise; when I'm given a fifteen-hundred-word story for a two-page feature, there's a lot. She has a clear understanding of our audience, so she rarely over-writes. She also has a clear hierarchy for each issue, so she edits accordingly, which makes my job easier.

**Some editors get very involved in the typographical scheme of their magazines; others are more laissez faire.**

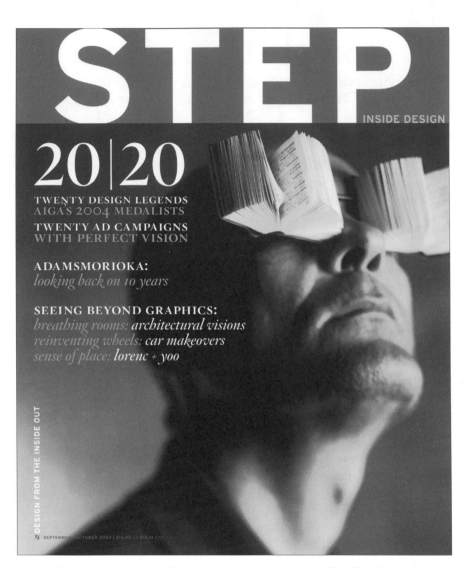

"20/20" cover; art director: Michael Ulrich; photography: Leon Bird, PhotoLibrary, PictureQuest.

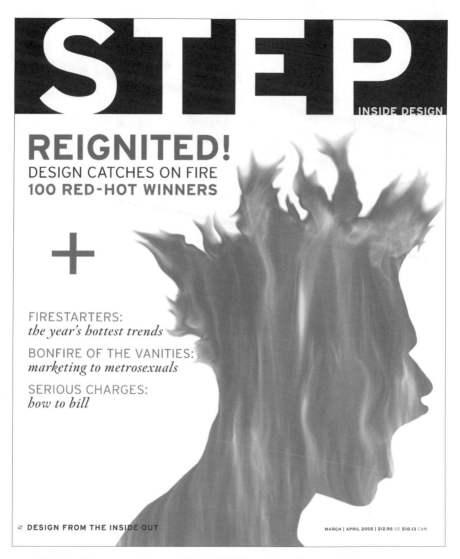

"Reignited" cover; art directors: Michael Ulrich and Greg Samata; designer: Michael Ulrich.

# DESIGN AT WARP SPEED

BY TIFFANY MEYERS

FLIGHT-JUNKIE (AND INDUSTRIAL DESIGNER) **DARIO ANTONIONI** HARNESSES HIS BACKGROUND IN AEROSPACE ENGINEERING TO CREATE FURNITURE FOR THE FUTURE.

"Design at Warp Speed" spread; art director: Michael Ulrich; photography: Brigham Field.

***SH: Emily, how hands-on are you when it comes to the typographic (and indeed the pictorial) layouts?***

**EP:** I'm not very hands-on at all, except when it comes to pull quotes. I choose which portions of the text deserve more attention if we're using pull quotes on a page.

***SH: Michael, how much freedom do you feel you have to achieve the most integral typographic result?***

**MU:** Complete. Sometimes Emily comes back with concerns about readability or flow, but I've found that if I take her suggestions ninety-nine percent of the time we create a better story.

**Covers are the most difficult entity of a magazine. So many people get involved.**

***SH: Emily, you have a cover personality, but how much direction do you give to the art director on a cover?***

**EP:** I decide the most important stories/themes for the issue, which are represented in the coverlines. Obviously, the cover images need to relate to the coverlines and content within. Mike chooses several images/concepts that he feels relate to the theme and the two of us make a decision as far as which image to use. He usually has the concept nailed, so it's more an exercise to see if we are in agreement.

*SH: Michael, what determines how you design this important piece of editorial real estate?*

**MU:** We have guidelines that were set down at the redesign stage, and my goal is to meet each guide as best I can. If I nail the cover, there isn't much discussion; if I don't, I start all over. The cover is by far the hardest page in the book for me to design.

**The overall relationship between editor and art director is critical to making a viable end product. Sometimes personalities grate, other times the two principals are yin and yang.**

*SH: Emily, how would you define your relationship to your art director?*

**EP:** Mike and I have worked together for several years, so we're very compatible—we understand where the other one is coming from. We're both very opinionated, which can be good and bad. We don't always agree, but we respect each other enough to rely on each other's strengths when it's time to make a decision.

*SH: Michael, how would you define your relationship to your editor?*

**MU:** We have the same hidden agenda: to create the best design magazine on the planet. Everything else is just details.

# The Philosophical Approach: Turning No into Yes

## A Conversation with Ken Carbone
## Principal, Carbone Smolan Agency, New York

**Steven Heller: What does the term art director mean to you?**

**Ken Carbone:** An *art director* is someone who does just that, takes all of the emotional and persuasive power of art and directs it toward a design solution that works for business. An AD has to be part navigator, part coach, part diplomat in finding the essential balance between art and commerce. He or she must know how to motivate a design team to do their best to meet the functional goals of a project, and negotiate with a client when necessary to go beyond convention for exceptional results.

**SH: Does an art director have to be a designer?**

**KC:** It helps but is not essential. Great art direction is first and foremost about ideas. This can come from someone with a highly developed aesthetic sensibility but no formal training. It can be a writer who knows how words and images combine to express an idea. Sometimes it's a client with great vision who clearly articulates a creative path. As a designer, I believe you must fill the gap left in the absence of any of these. This is where it helps to develop a broad frame of reference and maintain a high level of intellectual curiosity that continuously fills your creative well.

**SH: As the co-principal of the Carbone Smolan Agency, what is your overall responsibility?**

**KC:** Running the business with my partner Leslie Smolan, creative direction, new business, client satisfaction, and the necessary R&D to improve our work and services. This last part is particularly important. I once got a fortune cookie message that read, "The road to success is always under construction." This is on a plaque in our office as a reminder that there is always room for improvement. Our work is never done.

**SH: Given all this, what is the single most important aspect of your role?**

**KC:** Turning no into yes.

**SH: In working with your "clients," how do you fulfill their needs while retaining your own creative integrity and that of your designers?**

**KC:** It starts with distinguishing what a client "needs" from what they say they "want." This for CSA often involves rewriting the "brief" and exposing

new opportunities that will benefit their business. This begins with our "evaluation and insight" phase of work. I believe half of the challenge of doing great design is having a clear and agreed-upon strategy. When our clients and we understand where we're going and what the outcome should be, there can be any number of possible creative paths to get there. Once this foundation is in place, a design team has a concrete target and is very motivated to do their best work.

**SH: Would you say that you have an art directorial style?**
**KC:** More of a philosophical approach.

**SH: What is that?**
**KC:** Simple is better. This principle can be translated into many different styles: cool, classic, or edgy. We often get complex problems for service businesses that have nothing tangible to show. These are tough assignments requiring strategic thinking, content management, and art direction. We have learned to be extremely nimble stylistically because our clientele is very diverse. On a given day, we can be working on projects involving art, law, finance, health, entertainment, or science. There's little room for a "signature" style but if there is any thread that runs through our work, it's a merger of strategy, content, and art delivered with simplicity and clarity.

**SH: How do you manage the design of others?**
**KC:** It is similar to my philosophy about teaching. I believe you can learn by experience and/or by example. The best creative results happen when a design team openly explores various directions through experimentation and discovery. However, because we are making design not art, there must be the acknowledgment that the work has a commercial end. If the work is too far off track creatively, I try to give an example with a sketch or suggest an idea that can direct a project toward the target solution. Both ways work equally well, but I prefer to be the coach on the sidelines.

**SH: Is there room for creative experimentation?**
**KC:** There is always room for experimentation, but not at the expense of a client's business. Greater creative opportunities often lie in the consumer-products field, where "persuasion" and emotional appeal can be translated into powerful visuals. For example, a single line of great copy and well-placed type on a sexy fashion photo is sometimes all that is needed. However, often the limitations of working in the service sector for conservative clients forces you to think more conceptually in order to forge tangible associations to the immaterial. We have found that there is a great deal of creative latitude for these businesses if the design is on strategy and the client is willing to set new standards.

***SH: What is your ultimate goal?***

***KC:*** Can I have three?

***SH: Sure.***

***KC:*** To have fewer clients, but ones with whom we have an exceptional relationship built on a mutual understanding of the risks and rewards of doing exceptional design. Where we are integral to their company, do a lot of business together, and where a social bond strengthens the work. I'd trade fifty clients for five of these.

Also, we have had success "productizing" our services to deliver high value for our clients. We have proven processes and fixed deliverables that can be replicated for a variety of business sectors. I see these services as "scale-able" and profitable ways of leveraging close to three decades of experience for a varied clientele. This is definitely a promising area of our business that I would like to expand.

Finally, my goal is to allow for the very talented group we now have to emerge as the stewards of CSA, to build on our legacy, and evolve the agency in exciting ways creatively and as a company.

# The Editor's Choice: Designer or Art Director?

## A Conversation with Robert Priest and Peggy Northrop
## Principal, Priest Media, and Editor-in-Chief, *More*

***Véronique Vienne: Peggy, how did you pick Robert to be your design director?***

**Peggy Northrop:** I interviewed six or seven designers and sat with them—some I knew, some I had never met before. I looked at their portfolios, talked about what they had done before. I figured that I would have to spend long hours with whomever I hired, so I had to like him or her. This is a silly thing to admit, but I remember that Robert wore a really great suit. "This is good," I thought. The way he looked—so sharp—matched the elegance of his work.

I wanted a bold and strong design—nothing silly and prissy like so many other women's magazines. In other portfolios, I had seen a lot of pink, italic type, girlish stuff, which I found offensive in terms of the kind of vision I was after for *More* magazine, a publication that is supposed to appeal to a grown-up woman with, let's face it, more testosterone.

***VV: Robert, before accepting a magazine redesign job, do you do any research to make sure that it's the right fit for you?***

**Robert Priest:** I don't have time for much research. The decision is more instinctual. This one anyway seemed like a perfect fit for me. I worked on men's magazines a lot, and I realized that there was a big gap in the women's magazine market—there was no magazine for "the thinking woman." I figured that I could take some of the design elements that had worked for a men's magazine and adapt them to *More*.

Let me add that I too was very impressed with Peggy's physical presence during our first encounter. I took my cues from the way she dressed. My idea was to design a magazine that she would like, respect, and buy.

**PN:** I was certainly attracted by the idea that Robert had designed men's magazines. I knew that my readers didn't want a handbook on how to live their lives. And they certainly didn't want to be told how to please their guy. Either they had figured it out, or decided that it wasn't worth figuring out. This magazine wasn't going to be about that.

**RP:** Some of the men's magazines are a little too earnest or their humor was too sophomoric. *More* had a warmer, grown-up personality, which I loved. Usually, I show a couple of different design directions to an editor, but I felt so in synch with Peggy's vision that I just presented her one approach and said, "This is it."

***VV: What did you show her, exactly?***

**RP:** Several covers, two features, some columns. Not to be arrogant, but I felt early on that I had nailed the problem and that it was only going to be a matter of refinement.

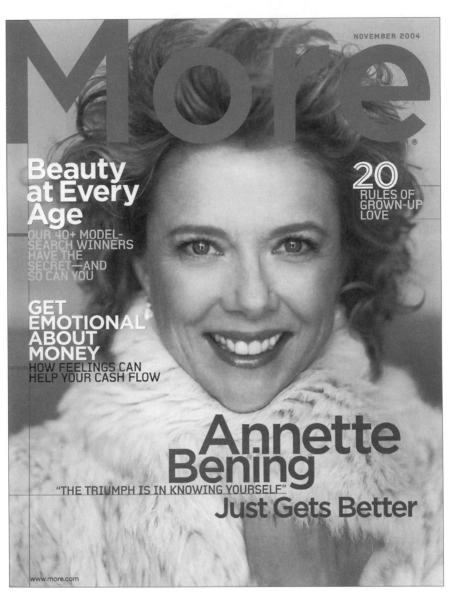

Annette Bening cover; *More* magazine; February 2005; design director: Robert Priest; creative director: Phyllis Cox; photographer: Frank Ockenfels 3; designers: Robert Priest and Grace Lee.

**PN:** I remember how the layouts were presented upside down on the table when I walked in, and I was feeling quite a lot of trepidation. But as soon as I started turning up the cards, I felt relieved. What I had envisioned in words was realized in design. Robert had taken this leap and created a format that allowed me to express my point of view and develop my ideas. I looked at it and thought: "This is really it."

**VV: Did you have someone else with you at that first presentation, or did you come alone?**

**PN:** I came alone. That is unusual, I now realize. I would have brought my art director, but she was on maternity leave.

**RP:** That's one of the issues I face every time I do a redesign: Editors come with art directors who are potentially threatened by my presence, even though I try to communicate to them that I don't want their job! Around an art director, the person who is doing a redesign has to do some tiptoeing. The fact that I had the freedom to explore the new format with the editor alone made the process very interesting.

**VV: How come art directors are seldom invited to do a major redesign?**

**RP:** Sometimes art directors are simply too busy. But when I was employed by a magazine, I would have felt slighted if I had not been asked to handle the redesign. I was able to do my own redesign while art directing the magazine. Admittedly, it was more of an evolution than a drastic change, but still . . .

Annette Bening spread; *More* magazine; February 2005; design director: Robert Priest; creative director: Phyllis Cox; photographer: Frank Ockenfels 3; designer: Robert Priest.

Paulina Porizkova cover; *More* magazine; March 2005; design director: Robert Priest; creative director: Phyllis Cox; photographer: Jason Bell; designer: Robert Priest and Grace Lee.

Paulina Porizkova spread; *More* magazine; March 2005; design director: Robert Priest; creative director: Phyllis Cox; photographer: Jason Bell; designer: Robert Priest and Angela Riechers.

Whether or not to involve the art director in a redesign is a tricky question. I do feel that I am trespassing on somebody else's turf. But I can't baby the art director. I have to assume that, whatever the situation, he or she can deal with it.

### VV: Do you take into account the sensibility or the skill level of the art director when approaching a redesign?

**RP:** I do. You have to design with the anticipation of what the politics of the art department are going to be. If you make the design too complicated, with too many bells and whistles, chances are it will not be able to pull it off. I am very careful about that during most redesigns. This was a different situation, though. Peggy gave me the opportunity to explore a wide range of possibilities.

### VV: Peggy, are you taking into account that a redesign usually costs more money than the previous format? Are you lobbying for a bigger design budget?

**PN:** I knew that I wanted to do a redesign before taking the job of editor. So, before I signed up, I said, "Whatever the current budget is, I want more money!" I had to have a bigger photography budget.

### VV: Do you get very involved with the art department?

**PN:** I am not the kind of editor who wants to be an art director. I just say, "I prefer the attitude of this model, she's got the expression I am looking for." At the same time, I expect an art director to push me out of my comfort zone.

**VV: Do you ask other editors on your staff to give their opinion regarding the design?**

*PN:* No, I don't believe in design by committee.

*RP:* You are a rarity in that way. Most editors like to look at layouts and kick it around with others for a while. There is no right way to do this. Whatever works for the person is what's best. I have been lucky—the editors I have worked for have been very appreciative.

**VV: Peggy, what did you tell Robert about the mandate for the cover?**

*PN:* I told him that the women's magazines covers were usually too busy, and there was a sameness about them. We wanted to communicate at a first glance that this wasn't your daughter's magazine. I asked him to give me a new logo—less squat—and also to pull the camera away from the model. My readers, I felt, didn't want the surgical close-up, but the whole package, with more of a sense of the environment.

*RP:* The early conversations about the cover were also about the color palette. And again I took my cues from Peggy, from the kind of colors she wore. Rich colors, strong-women colors—not soft pastels, but also not the dark, fierce colors of men's magazines.

*PN:* But celebrities covers, like the covers of *More*, are less controllable than you think. The best photographs are not always the ones you first intended for the cover. Sometimes you've got to go with what you have.

*RP:* It takes a while to figure out the covers of a magazine. Particularly if you try to do something that has not been done before. You have to try different things for at least a year before you find out what works for you.

**VV: Did you present the design to the rest of the editorial staff?**

*RP:* Casually, yes—but not in any formal way. I like people to have a chance to express their opinion about a redesign, so that they feel involved.

*PN:* I remember someone looking at some detail on a page and asking, "Do we really need this design element?" and Robert said, "Need?" and I looked at him, winked, and repeated after him, "Need?" No, we don't need it, I explained. Do I need a new pair of shoes? No, but I want it. It's the same thing with this magazine. Do we need another magazine? Probably not.

*More* is not about need; it's about want. About wanting *More*. Our name is more, not less. It's about pleasure, about exploring, about vibrancy. That's why I wanted that visual "crackle" in the design. Frankly, there are people who find the exuberance of the design too much.

**VV: Did you give Peggy some directives about the kind of photography you envisioned for the magazine?**

*RP:* I make sample layouts with photographs that I swipe from here and there, as a source of inspiration. These images are my expression of how the

magazine might look. The hardest part for me is to find the right swipes, photographs that express the right spirit. With *More*, it was very difficult to come across photographs that were perfect for our vision, because they did not necessarily exist. It was a challenge, for example, to find great photographs of women in their forties.

> **VV: It's hard to believe! I know so many women in their forties who are simply gorgeous!**

**PN:** The readers of *More* magazine expect to see "real" women, not models—yet we have to find a way to make their photographs look heroic. I recently realized that, more often than not, the problem is not the photography but the styling. We are trying to do too much, in too short a time, and we have not been paying enough attention to the crucial details that make the picture look sharp.

> **VV: Robert, is it hard, in the end, to let go of the magazine after you have completed the redesign? Is it hard to move on?**

**RP:** Yes, it's hard. You want it to become a magazine that interests people, that sells well, and that keeps evolving. I was briefly tempted to take the art director's job that was offered to me. The position was open and Peggy is a very inspiring person to be around. But in the end, I decided that my independence was too important.

**PN:** I miss the fun we had redesigning the magazine. Now, while Robert gets to go on and do his own thing, I have to deal with the daily reality of solving editorial, staff, budget, marketing, and advertising problems!

# What Matters: A Brain Full of Visual Images

## A Conversation with Vince Frost
## Art Director/Designer, *Zembla Magazine*

*Steven Heller: You've designed a few magazines—Big, Zembla,* **Independent Saturday Magazine,** *and* **Financial Times/The Business.** *Do you consider yourself an art director or a designer?*

*Vince Frost:* I am a designer. Magazines have historically given titles to the people who put a magazine together. The person who has overall responsibility for what the magazine looks like is the art director. I have never been happy with this title. It sounds to me that all an AD does is point and others do. I am about doing. Therefore, I normally put my title as "Art Director/Designer" or "Creative Director/Designer." I also don't like the term *graphic design*, as it sounds old-fashioned and does not represent the versatility of what we do today.

*SH: What is the difference in your role as art director versus designer?*

*VF:* For me, there is no difference. (I suppose I have just contradicted myself.) As a designer, I am about solving problems and making things look good and engaging people to create an effective outcome or to entertain. The bigger picture and the big idea are what interest me as much as physically designing it.

*SH: Collaboration is essential, but what makes for a good one?*

*VF:* When other people's input makes it better.

*SH: In designing a magazine like* **Zembla***, at what point is the magazine "your own"? At what point do you have to relinquish, if ever, your ownership?*

*VF:* With *Zembla*, I created the look, the space, the face, the pace, the masthead, format, etc., etc. It was a two-month, painful experience. (I did this in my London studio before I moved here.) I must have done a couple of hundred mastheads alone. I now live in Australia (the other side of the earth) and so it was designed in London, Melbourne, and Sydney, with final artwork, corrections, and subbing being done in London with the editor and subs. I art direct and design it from here as well as overseeing it in London from here. It proves to me that I can control and art direct the look of it outside the "normal" "in house" environment. This is only made possible by having a great team and the incredible technology that we have today. I can work during the day here on designs and send pdfs while London sleeps and vice versa. We have a twenty-four-hour studio. Even the repro house now puts all the proofs of the whole magazine as pdfs online. (You can look at these if you wish at *www.i-base.co.uk*, password: zembla.)

**SH: How much say do you as art director have about overall content?**

**VF:** I have a lot of say. I question and suggest and edit with the editor. But I rely totally on the editor being good at what he or she does and they do on me.

**SH: What makes a good art director?**

**VF:** Someone who is confident, a team player, dedicated, a perfectionist, open-minded, passionate, inquisitive, a collaborator, nuts, playful, and who has a brain full of visual images.

# 06: Do You Want to Be an Art Department Manager?

## Reality Check: Managing an Art Department

### Ina Salz

To many art directors, *management* is a dirty word. They don't like to talk about it; they don't like to think about it; even if they are generally regarded as good managers, they often don't want to admit it. For art directors, there is little cachet in being a good manager.

The truth is that managing is what art directors spend most of their time doing. Relatively few of our working hours are purely creative. Most of our working hours are spent managing: managing our staff, managing pre-press, production, technology or legal issues, managing budgets, managing schedules, managing the creativity of others (designers, photographers, illustrators, information graphics artists). Whether we admit it or not, that is the reality of our job.

Management is not generally considered to be creative (although it can be); art directors don't win awards for good management. Their management skills aren't recognized or published in books or magazine articles; nor do they win the admiration of their peers for them. Most art directors received no management training in school. Art schools focus on creative work and creative thinking.

Is there an art school in this country with a course on how to manage an art department? And if there is, what self-respecting art student would sign up for it? Management is about the last thing they have on their minds.

So most art directors come to their jobs entirely unschooled in formal management techniques and with little inherent desire to think about or examine successful management techniques. Yet an art director who is a good manager has a far better chance at getting and keeping a good job. A good manager keeps his staff happy and creatively challenged, maintains good relations with the other staff entities, maximizes the budget, and successfully handles a myriad of noncreative tasks, including the all-important budgetary supervision.

On the other hand, the implications of poor management in the art department are enormous. Changes in technology and production have completely transformed the role of the art department. For most publications, the art department represents a fairly large cost center. A poorly managed art department can soak up budgets and waste resources that could be put to much better use. Poor management often means higher staff turnover, with the attendant search and training costs. And last but not least, the creative product suffers when there is disharmony and poor communication.

A great deal can be learned from those art directors who have thrived by taking their management role seriously. Their valuable advice, gleaned from hard-won experience, can make a huge difference in your success or failure as an art director. And your management skills play a large part in the success or failure of the publication.

## Hiring Well

Design Director Joe Dizney at the *Wall Street Journal* oversees a staff of fifty in the New York metro area, plus small staffs in Brussels and Hong Kong. "Hire good people, hire smart people, then be fair and honest with them," he says. "I see myself as an entertainer first, then a friend, then a boss. I never wanted to be a boss. You just have to be empathetic."

Robert Newman, now design director of *Fortune*, says his number-one rule is to never hire anyone unless he's worked with them before or freelanced for them for a while. Over the years, he has built a network of talented junior people whose careers he follows. He admits that his reluctance to hire someone he hasn't worked with stems from his experience that "at a big company it can be really hard to fire people."

*New York Times Magazine* creative director Janet Froelich likes to hire people from outside the magazine world, people from books and design studios, and then to mold them herself.

Longtime creative director of Warner Books Jackie Meyer always looked for people "who wanted my job" (this is the same thing my first art director, Judy Garlan, said when she hired me). Though Jackie had very low staff turnover

(always a sign of a good manager), she resigned herself to the fact that "most people who are great aren't going to stay too long."

Michael Grossman, who was art director of many large publications, including *Entertainment Weekly*, says he likes to hire people he knows he's not going to hang onto. Michael tries to "create an environment where people can come and work with me for a few years without friction and then move on." Michael asks candidates what magazines they read because it tells him not only about their interests but also whether they share a common design sensibility.

As art director of over half a dozen publications in my own career, I learned to look not only for those with typographic skills that were simpatico with my own level of taste and sensitivity, but also those who had certain personality traits. Most important: an ability to get along well in a team environment, to possess intelligence and curiosity but also the ability to be articulate. We are in a business that requires teamwork and communication. The one time I ignored my own rules to hire a spectacularly talented person, it resulted in a huge problem for me.

Mary Zisk, the former art director at *Art & Antiques*, wanted to share her one mistake in hiring. During the interview, the job candidate asked a lot of questions, which Mary took as a good sign of her interest and curiosity. But after hiring her, Mary discovered that her new designer was unable to think for herself or take on any responsibility without badgering Mary about every aspect of the work.

## Mentoring and Teaching

Steve Hoffman, who has been the creative director of *Sports Illustrated* for more than eighteen years (throughout many editorships), says that for him, the most interesting part of managing is teaching people. His personal style is "quite frank and informal," but he has learned that "you simply cannot communicate too much." He "had an epiphany" many years ago. "I used to assume that other people knew or understood my motivation, but in reality people were often left isolated and didn't understand what I wanted or needed." He realized that everything must be said, and that it is a two-way street. Weekly meetings provide "an opportunity for everyone to be physically together and shoot the breeze," to know that they are included in all the workings of the art department and not just stuck in their cubicles.

Most art directors learned mentoring by being well mentored early in their own careers. But Janet Froelich says that initially she was thrust into the position of art director and had to fend for herself. Subsequently, she learned how to manage well from two of her editors, Jack Rosenthal and Adam Moss.

Dan Josephs, art director at *Child*, learned good management skills from his father, who was a creative director in advertising. Dan visited his father's offices many times during his childhood and observed how things worked firsthand. Now that he is a parent himself, he feels that management skills are

akin to parenting skills, and that "how you were parented affects how you manage." From his father, he learned that "you must be very sensitive to the creative process but you must offer direction and be articulate."

My best mentoring skills were learned from Peter Blank at Ziff Davis. Peter oversaw the art directors of over thirty magazines at one point. What I remember most is that Peter often "ran interference" for us with our editors, with management, or with production. Peter simultaneously championed us and was a buffer for us, often using his own clout when we couldn't push something through ourselves. He always found time to make each of us feel special and valued. He kept us motivated and operating with a full head of steam with frequent but short staff meetings (and lavish praise). One of the smartest things that Peter did was to assign a "big brother" to each of us, someone who was responsible for showing us the ropes and answering all of our questions. This also had the effect of fostering creative collegiality within our group.

I also observed good mentoring at the *Economist* in London, where Aurobind Patel was the art director. There, everyone's workstation was in an open area, even Aurobind's. Everyone had a window. There were therefore no "secrets" and Aurobind could easily "keep his finger on the pulse." As at many magazines, there was a wall of covers. Aurobind proudly pointed out the staffers who were responsible for each cover. Every member of his staff had been given the opportunity to come up with ideas and design covers. In fact, some of them had even illustrated the covers. No wonder his staff loved him . . . he had given each of them the opportunity to think creatively, to think big, to think globally.

A good art director realizes that a good idea can come from anyone. This kind of openness fosters an environment in which everyone feels comfortable brainstorming. If everyone is thinking creatively, it's simply more likely that the choices will be better. Malcolm Frouman, art director of *BusinessWeek* for more than twenty-five years, says he'll take a good idea from anyone. He is a firm believer in a collegial approach to design and creativity. Many times, Malcolm says, he will be sitting in his office trying to come up with a solution when he will grab the first person walking by and pull him into the office to help. Or, having come up with an idea, he'll show it to a colleague immediately for feedback.

Malcolm looks for opportunities to stretch his staff. Although there is a hierarchy based on seniority, experience, and talent, Malcolm often assigns something tougher than what a particular staffer is accustomed to . . . a cover, a special project. The benefits of this technique are manifold: the magazine gets a fresh approach, the depth of experience of the staff increases, there's a little competition, which is healthy, and the individual grows and feels more fulfilled. And if a more senior person leaves, Malcolm can more easily move people up. Although this seldom happens; most of Malcolm's staff have been on board for many years.

Malcolm's job, among other things, is to see that the work of all the designers comes together as a cohesive magazine each week. He constantly gives feedback and suggestions, preferring to give constructive criticism on an individual basis in private. Even if there's a potential lesson for everyone in an individual's mistake, he doesn't believe in criticizing publicly. A generic memo or a general comment at a staff meeting is a better way of imparting the message.

Some of Malcolm's art directors went on to art direct their own magazines. Laura Baer, now art director of *Prevention*, says she learned good mentoring skills from Malcolm. "I bring in a lot more bagels, for one thing." But when she first left *BusinessWeek* to become art director of *PC Magazine*, she says, "I had a huge learning curve. The first thing I found in my desk was my predecessor's stash of Maalox." She had to become comfortable asserting herself and found it especially difficult to delegate.

Another *BusinessWeek* "graduate" is Francesca Messina, now design director of Guideposts Publications, who struck out on her own after ten years with Malcolm. "The funny thing is I think of Malcolm every day. I learned so much from him that was positive. And the things I thought were negative I now understand more. I used to wonder why Malcolm didn't want to give himself more design time. Now that I am in charge, I spend (at best) only twenty percent of my time being creative."

Not everyone is comfortable with the role of manager. Mark Ulricksen, now a successful award-winning illustrator, rose through the editorial ranks to become art director at *San Francisco Focus*, where he spent a total of eight years. "I thought I'd be a good manager . . . I was a lousy manager. I didn't want to deal with everybody's problems. I just wanted to be creative." The art director should be someone who embraces the responsibility of managing the department and enjoys mentoring and motivating their staff.

Janet Froelich says she spends most of her time "talking, planning, scheming, always looking out for the rhythms of the book, being a cheerleader, being a mother, trying to understand the human end, massaging egos, running interference between people with abrasive personalities and the editors. The hardest part is critiquing . . . getting their sensibilities to work for the magazine and directing my staff without their knowing it."

When Dan Josephs was hired as art director of *Child*, "it was as if I had walked into an autocratically managed department . . . everyone was afraid to make a decision. I needed to instill confidence to be creative and to trust." Fortunately, Dan had the opportunity (often available at large companies) of attending a management training session. "It makes you aware of your style and that you can evolve it and that we need to evolve it. You can have good intuition but there are skills to be learned."

David Armario, art director of J. Crew, feels strongly about teaching his staff everything he knows and is serious about taking them under his wing. He

tells his new hires that he intends to give them *respect* and *loyalty* (two old-fashioned words that we don't hear often enough) and that he expects the same from them. He tells his staff that he cares deeply about their careers, and hopes that when they feel it is time to move on that they will tell him so he can help them find their next jobs.

## Communication

Good communication skills are essential to good management. Don't underestimate the power of a well-written memo. There is no better way to earn an editor's respect than by dispelling the unfortunate stereotype that art directors don't write well and prefer pictures to words.

Lynn Staley, art director and assistant managing editor at *Newsweek*, says a good art director must know how to go to a meeting. "It sounds simple," she says, "but it's an art: how and when to respond, what not to respond to, how much of that message you should subsequently share, and with whom."

Joe Dizney says his staff knows that his door is always open. If someone does a good job he sends out a "hero-gram" to acknowledge his or her work. "I give credit to my staffers when thanks come to me." Dizney continues, "One of the things I'm proudest of is that I'm not afraid to admit it when I'm clueless . . . I don't know everything." To make sure his overseas staffs feel included in the loop, he teleconferences with them so there can be a wrap-up.

## Granting Responsibility

On larger staffs, it is possible to have a managing art director who reports to the art director. Robert Newman says that what has benefited him the most in his career is to have an internal structure where he can delegate as much as possible. He likes to have two Number Twos: a design manager and an administrative manager, who handles things like trafficking layouts and vacation schedules. Robert believes in layers of authority within the art department, where higher-ups have responsibility for those under them. "Managing the art department is really hard; to do it all you need help. At a magazine, the art director's job is the only one where you need to be a creative person and a manager."

Dan learned his "light" management touch from his art director at *Travel & Leisure*, Pam Berry. "She treated us maturely; she hired people who wanted to take responsibility and she allowed them to grow into art directors. My number two does some management and I encourage everyone to take full responsibility for their own work. I want to let them work out their own solutions."

Malcolm Frouman believes in giving his art directors plenty of autonomy. "Each art director 'emcees' all the acts that make up a layout, working with chart people, photo editors, and illustrators to make sure all the parts are compatible. I ask the art director to assume almost an editor's role in their work. Good people skills are essential. They must be able to forge strong

working relationships with editors as well as with colleagues and freelancers." Malcolm looks for people who are articulate and he regularly works with his staff to sharpen their interpersonal skills.

Francesca Messina thinks that, "The hardest thing to do is to find the best possible people to do the tasks that you can no longer take on even though you want to. And it is so important to be able to articulate your intent to designers so they are absolutely clear about your direction. Malcolm was very good at this." But even though you have granted your staff a great deal of responsibility, "it's hard to free yourself up to weigh in on their work, to be available to them when they need me."

## Wearing Many Hats

Art directors must get involved with so many areas; it is not uncommon for the art director to be asked to be "of counsel" on the company's Web site design, branding, and CD-ROM projects. Legal issues must be dealt with: I spent days working with lawyers to create new contracts for illustrators and photographers. I testified at an arbitration hearing about lost slides. When my company was suing another company for logo infringement, I educated our lawyers about fine points of typography, which might aid them in making their case. On several occasions I was involved in startups and had to develop budget and staffing plans as well as recommendations for office furniture and equipment.

And then there are the interpersonal skills: being a leader means being a decision maker, a diplomat, a teacher, a cheerleader, a psychologist, a strategist.

Managing budgets may be the art director's toughest task. Francesca Messina says that, "In addition to hiring good people and managing the workflow, the biggest challenge is being responsible for the bottom line, justifying to the company how you are spending their money. There's no guidebook for that. And every company is different; there are different cultures, different imperatives. The first thing I do on a new job is to find out who cuts the checks, who approves the budget items. I take the office manager to lunch."

No one said it was easy to be an art director, but it's worth the trouble. "You could end up losing sleep over these things," says Dan Josephs, "but it's one of the best-kept secrets in the world that this job can be a lot of fun."

## Publishing Headaches: Getting Everyone Onboard (Including Authors' Wives)
### A Conversation with John Gall
### Art Director, Vintage/Anchor Books

***Steven Heller: As art director and designer for a major publishing house, how do you balance both roles, or are they one and the same?***

***John Gall:*** I think art directing in publishing has changed a lot over the last fifteen years. When I started, most art directors were art directors only—totally hands off—and never did any design work themselves. You'd get handed an illustration and a "see what you can do with this." Things started to change as more designers began to be promoted into art directorial positions.

***SH: So there is a distinction?***

***JG:*** My formula of late, for what it's like to be an art director today: art director = designer + headaches. That's the designer in me talking.

***SH: Do you get a chance to design much anymore?***

***JG:*** Most of my day is taken up with talking to editors, freelancers, production, staff, answering e-mail, avoiding lawsuits, or hiding from the above. I may have thirty minutes at the end of the day to actually sit down and design something.

***SH: As a designer, do you have an art directorial approach that favors designers?***

***JG:*** My art directorial approach tends to be as hands off as possible. I like working with people who understand the parameters, who will take a project and an understanding about the direction and then run with it. I don't enjoy having to apply the heavy-handed approach (can you move this one-eighth of an inch this way? And make the sky six percent bluer?), even though it's occasionally necessary. I am not that interested in having covers that look like I did them. I like the variety.

***SH: What makes a good book jacket art director/designer?***

***JG:*** I think what makes a good jacket designer are the same things that make a good designer in general. Good typographic sense, inventive use of imagery, clarity of idea and intent. I also think being versatile and well versed in design history and style a good thing, since books come at you from all different periods.

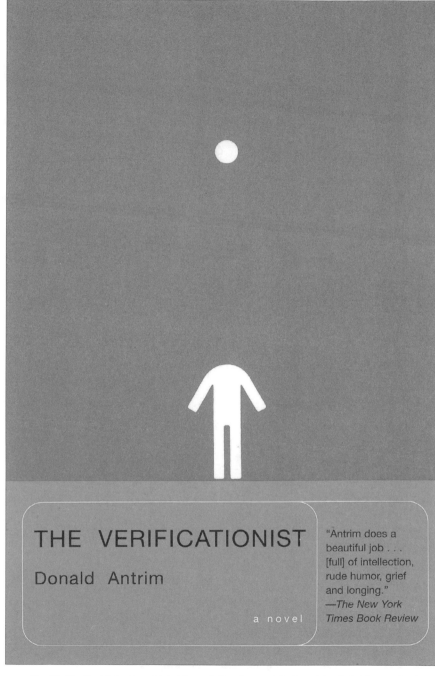

The Verificationist, by Donald Antrim; art direction and design: John Gall; Vintage Books, 2001.

**SH: How do you navigate the marketing departments while retaining your design integrity?**

*JG:* I work a majority of the time in the trade paperback format, a format already compromised by marketing needs. The whole concept is to create a less expensive version of a book for wider consumption. Trade paper is closer to hardcover but with more information (quote, maybe a best-seller line) presented in a smaller format.

The paperback does not have the fortune of being timed to the review attention a hardcover gets, so the cover—we're talking frontlist here—has to say something like "Remember me? You were waiting for me to come out in paperback? Remember? I'm the one the *New York Times* really liked, you know the one about the guy with narcolepsy who likes the girl in the plaid skirt?"

We have a pretty cool marketing group and I think they really respect what we do. But I still don't know how to deal with things like "brown covers don't sell."

**SH: Does this mean you have to follow some rigid set of guidelines?**

*JG:* My approach to design is fairly intuitive. I like to read the book, hear about the issues surrounding its publication, then try to put it all to the back of my mind while I let the creative stuff happen. Don't know how I end up with so many brown covers though. I must enjoy the torture.

**SH: Is there ever a conflict between art director, editor, and author?**

*JG:* There are frequently conflicts or differences of opinion but generally no fisticuffs. Getting a cover approved is no easy task anymore. There are editors, publishers, marketing people, agents, authors, authors' wives and friends . . . each trying to take a little bite. Since the authors are the ones creating the content that the entire company runs upon, we try not to force anything on anyone (unless we are running really late—which is usually).

**SH: How large is your list, and does this have an impact on how much or little you work with authors?**

*JG:* I oversee about two hundred and fifty covers a year. And yes, I want them all to be great, but my opinion has always been if an author has just spent, say, ten years writing a book and gives us a hard time, we may have to work with his or her demands. After all, it's his or her book and there's always another cover demanding my attention.

**SH: Do authors ever design their own covers?**

*JG:* With the advent of the home computer everyone can talk about layout and fonts and other design stuff. A lot of people have a little bit of knowledge in this area now. I've been seeing full-color printouts of covers designed by authors lately. Scary. Very clearly, not everyone is Dave Eggers.

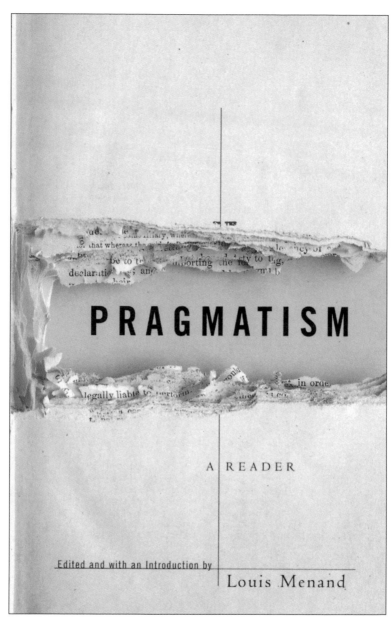

*Pragmatism*, edited by Louis Menand; art direction and design: John Gall; photography: Katerine McGlynn; Vintage Books, 1997.

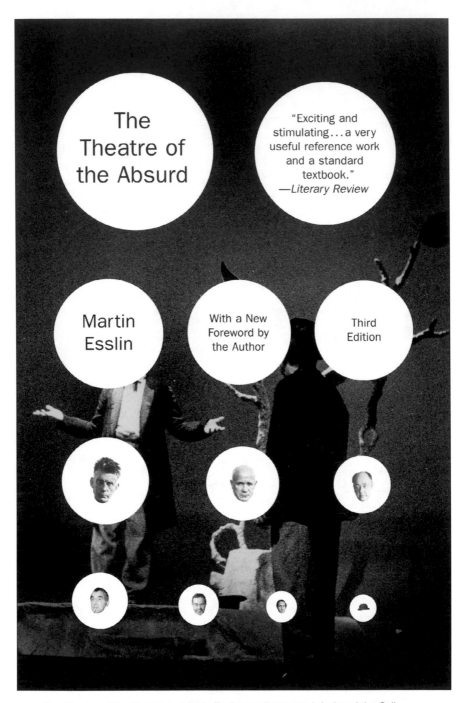

*The Theatre of the Absurd*, by Martin Esslin; art director and design: John Gall; photography (background): The Billy Rose Theatre Collection, The New York Public Library; photography (heads): © The Granger Collection, 2004.

**SH: Interaction with editors is key. How do you convey your best ideas across to them?**

*JG:* First of all, I work with some very smart people—people who are smarter about publishing a book than I, people who have also seen thousands of covers. I present very finished-looking comps, and very little explanation is needed. I mean, if they don't understand it, where does that leave the book buyer? No one will be standing next to them in the store trying to explain some half-baked idea.

On the other hand, when discussing a cover with editors, sometimes the only point of reference will be another cover that exists somewhere, and I may need to address why we should be looking at this problem in a different way. Mind-reading and decoding skills are also important in the job.

**SH: How do you art direct jackets and covers that represent your creative personality, and also reflect the publishing house's identity?**

*JG:* Before I arrived at Vintage, there was a fairly distinct house style. Books were slotted into three or four different formats and they were done beautifully. The amount of frontlist titles has grown since my arrival and the need to expand the "look" of the books has grown. We started ditching the old formats and started pursuing more of a frontlist/backlist plan, where backlist books by each individual author would have their own look and frontlist would be more distinct and "new" looking.

I'm not sure our house has a particular style at the moment; there are just too many and varied books to fit into a "look" without becoming tired over the long haul. I don't necessarily see the house style; then again, others have told me that they do. I just hope the covers can be recognized for their intelligent solutions, and are striking, witty, beautiful, weird, surprising, all that stuff, and have a clarity of idea that is true to the book.

Over any period of time a house is bound to develop some sort of look reflective of the designers working there.

**SH: What makes a successful jacket or cover?**

*JG:* There are really two distinct schools of thought regarding a successful cover. One comes from the design end and the other from the publishing end, and rarely do they intersect.

Different groups within the publishing company will each have different answers for this question. What an editor thinks is good, sales might not.

And as designers we have different sets of criteria, which must also address everyone else's criteria. How that gets resolved is always a bit tricky. A really great cover is going to convey the essence of the book in a unique and surprising way that maybe pushes the design envelope a bit. It might even add to and enhance the editorial content of the book. A cover that is seen and respected by other designers is a good thing too, though; one of the worst

things you can say when trying to sell the design is "the AIGA will really love this one." Probably the most famous book that I designed a cover for was *Cold Mountain*, by Charles Frazier, a cover that gets referred to in publishing circles as a "successful" cover, yet when I show it during a slide presentation of my work it gets a big yawn.

Luckily, I work with people who are willing to take a chance on something different every now and again. It's not like that everywhere.

**SH: Can you determine whether a cover actually sells a book?**

**JG:** Whether people actually buy books because of the cover is open for debate. I mean, even I don't, though I'm always checking the credit to see who's designing the interesting one. I designed a jacket once for a fairly modest book of a smallish print run. When the copies of the book arrived at the office, I heard people were stealing them from each other because they liked the cover so much. That seemed like some kind of success to me.

**SH: What makes an unsuccessful book cover?**

**JG:** At Vintage, at the start of a list, we'll have a meeting to discuss cover direction. Editorial will present a book and if it was already published in hardcover we'll look at the jacket and decide whether to adapt the design into paperback. My first experience was shocking. Here were all these beautiful Knopf jackets being held up and then the negative comments would fly. I thought these were "successful" covers, in the sense that they were amazing pieces of design. But if the book didn't sell, it's time for a new cover. I'm still trying to resolve this art versus commerce issue; maybe it's this friction that keeps us pushing ahead.

# The Grind and the Grid: Nothing Left to Chance

## A Conversation with Stéphane Bréabout
## Art Director, *Zurban*, Paris

**Véronique Vienne: What makes Zurban *such a unique magazine?***
**Stéphane Bréabout:** *Zurban* was launched four years ago. There was then, and still is, nothing like it in Paris. What's different is the design, which is contemporary and upbeat, and the editorial tone, sharp and irreverent—yet the readership is quite mature, a hundred thousand people between thirty- and sixty-five years old.

We never stray from our original goal, which is to do a Paris guide. We refrain from doing general news. For example, if a popular celebrity dies, unless he or she is strongly identified as Parisian, we don't mention it. Other magazines, in the same vein, have tried to find an audience in Paris and have failed because their focus was too broad.

Our approach is deliberately local, with a dense copy, more than a thousand words per page (and the format is small), and with about twenty different levels of entry points into the text! The difficulty for me, as the current art director, is to unify the look, while keeping the complex editorial structure.

At the beginning, the layout was messy, like that of a zine. So much so that it was almost impossible to publish it on a weekly basis. There was no grid, no format, no set rules. The magazine had to evolve in order to survive. When Hachette bought it, two years ago, the *Zurban* staff—about forty dysfunctional people running crazy—went into shock.

Four editors-in-chief and five art directors went through the magazine during the first year of the Hachette regime. Everyone on staff was trying to improve the magazine all the time—including making haphazard layout improvements. Even the best art directors hired by Hachette were unable to make a difference. None of them understood that the magazine was a weekly, and that it had to be on the newsstand every Wednesday, no matter what.

**VV: When did you come in?**
**SB:** I have been here eighteen months now. The first thing I did was to redesign the magazine with a very structured grid. I had worked on weeklies before, as well as on television—including *Love Story*, the first French reality-TV show. So I knew how to handle incredibly tight schedules.

To create a working format, I had to break down the existing design and start from scratch. One of the things I did was manage the white space, and use the page more efficiently. The way headlines were handled was very wasteful, for instance. The photographs never bled, the typography was too fancy and complicated. The cover was also broken into boxes, inserts, and coverlines.

Part of my responsibility was to sell Hachette on the changes I made. To this day, I do nothing without the prior approval of the company's CEO, Gerald de Roquemaurel, as well as our editorial director, Xavier Goupy. We don't meet, but I e-mail them all the layouts and cover suggestions. The trick is to satisfy the *Zurban* editor-in-chief as well as the Hachette executives. All the usual concerns have to be dealt with: branding issues, advertising issues, distribution issues, and so on.

**VV: In what way does the Hachette brand affect your work?**

**SB:** My covers cannot be controversial in any way. They cannot be highly conceptual either. At the same time, if the cover is bland, and the subject matter dull, the magazine doesn't sell. So it is the perpetual back and forth between taking risks and being conservative.

I always present my ideas to everyone with a tight rationale—and they challenge me not on the basis of my design, but on the basis of my rationale.

**VV: Practically, how do you present your rationale?**

**SB:** Fortunately, I get along with the editor-in-chief, and he trusts my judgment, so I don't have to fight an uphill battle there. He came to me because I know my stuff—I am a production expert—so I have a measure of authority in terms of what's possible and what's not. We sometimes disagree about my visual choices, but it is the exception.

With Hachette, things are a little more dicey. Particularly for the cover. The image I choose for the cover is scrutinized by Hachette editors and executives, who often don't "get" the concept of a photographic image. Sometimes, at the last minute, I have to find a replacement photograph. It's up to me to pull out something from a stock house or from our press archive.

**VV: One of the graphic characteristics of Zurban *is the modernity of the photographs.***

**SB:** Yes, the specificity of the magazine is the fact that all of the images are "credible." I don't want photographs of supermodels—even though Hachette would love it. One of the editors overlooking our magazine is the editor-in-chief of *ELLE*. So, of course, his vision is more fashion-oriented. I have to explain to him that if I put a gorgeous blond on the cover, I lose my credibility at once. In every single image, I show ordinary people. We use friends or acquaintances: the photographer's girlfriend, my wife, someone's daughter. It saves money, of course, but it is also a stylistic choice.

I go to photo shoots as much as possible. And I give photographers little sketches in advance. I tell them how to shoot, what angle, what specific result I want. At all times, I know who is shooting what subject. And if something goes wrong, I am the one who finds a solution. My job is to preserve *Zurban*'s specific visual point of view.

**VV: And in terms of graphic design, what are the visual characteristics that you must preserve?**

**SB:** Even though I reorganized the grid from scratch, I made sure I kept some of the typographic quirkiness of the original format, for consistency's sake. But these amusing stylistic gimmicks are integrated into a foolproof format. What I have designed is a template really, with a layout solution for every possible situation, about three dozen of them. Page layouts with or without sidebars. With horizontal or vertical photographs. With partial or full-bleed images. With reversed type or not. With headlines or without. With one, two, three, four, or five photographs. You name it. I worked it all out.

Admittedly, it's not much fun for designers, but it saves a lot of time, and it safeguards the visual integrity of the magazine. The reality is that on a weekly, with more than one hundred pages of compact editorial, you can't afford to experiment. With my system, it takes thirty seconds to decide which template to follow. Then it's just a question of execution.

The format, by the way, is constantly being perfected in its details. If we notice something that could be improved, we make a note of it and change the template accordingly.

**VV: And what are the editorial directives that preserve the personality of the magazine?**

**SB:** We are watchdogs, always ready to denounce corruption, expose crooks, debunk myths, make fun of self-promoters, scrutinize restaurant menus, find the latest bistros, and point out emerging cultural trends. Our readers expect that of us.

In terms of service—providing practical information—we are limited by the fact that, in France, if we give even one phone number at the bottom of a page, the entire page is rated as an ad, and we lose our editorial rate, tax-wise. We need a large percentage of "purely editorial" pages to keep our noncommercial status. That's why we have to send the readers to the back of the magazine, where we bunch together all our practical information on a single "advertorial" page.

**VV: What gives you the greatest pleasure as an art director?**

**SB:** It's seeing people in the street, in the subway, or in restaurants, with the magazine. I love watching my readers. There are a hundred thousand of them out there. Everything else pales in comparison. No design award, no pat on the back from an editor, compares with the pleasure of looking at people looking at my work. Every morning, on my subway commute, I see readers checking out their copy of *Zurban*. I watch over their shoulder to see if they notice particularly successful layouts, or if they skip over pages I spend hours trying to perfect.

Another source of satisfaction is the fact that my work is efficient. The magazine is not only successful, it also functions well. It comes out every week without catastrophic mistakes or horrendous deadlines.

**VV: Do you monitor newsstand sales on a weekly basis and react accordingly?**

**SB:** Of course, we try to evaluate the mistakes we make. But there are no fail-proof rules for covers, you know. Sometimes you do everything right, and still the magazine doesn't sell as it should. If our cover topic has to do with gardens and it rains all weekend, for example, our sales can be down by as much as twenty percent. So we do not angst over sales figures. We can't be on-edge every single week. No way. But when we do well—when we sell close to a hundred thousand copies—we celebrate with champagne.

**VV: If you had any advice to give a designer who is considering art direction as a profession, what would you tell him or her?**

**SB:** The best advice I could give a would-be art director is to learn everything about production, from beginning to end. It's liberating. It's what I did and it's a strength that has served me well.

Don't try to hold an art director position at the beginning of your career. Be a lowly assistant first. Spend time with printers, color separators, scanning technicians, copy editors, photographers, whatever. Once you understand what everyone does, you will be able to control the production cycle and design a magazine that is a coherent and functioning entity. You'll be both a trouble-shooter and a visuals editor. You can talk to an editor or a publisher. People will trust you and respect your authority.

Eventually, it's easier to develop an eye for the right aesthetic if you have a good understanding of the product itself.

# 07: How Do Art Directors Collaborate with Others?

## Art Directing Illustration: How to Astonish Me

### Steven Heller

Some art directors, like me, are only as good as the illustrators they hire. And I freely admit I could never do what they do. I cannot draw or paint; I cannot visually translate literal ideas into abstract symbols; I cannot transform my clichéd ideas into new concepts. But I do have a keen eye for illustration and a special flair for picking artists who have the knack it takes to do the job that makes me, *ahem*, look good.

This is actually the definition of what I call a "catalytic art director," who is not particularly endowed with innate artistic prowess but has instinctive matchmaking acumen. Eight out of ten times I can precisely match the right illustrator to the right project (a batting average of eight hundred would be pretty good in the MLB), and perhaps with a little tweaking here and there (an art director is a consummate tweaker) I could up that percentage.

#### Art Directors Are Frustrated Illustrators

Woody Allen once told this joke: "Those who can't do, teach. And those who can't teach, teach gym." Some art directors are indeed frustrated (or incompetent) illustrators, which is not to say that art direction is like teaching

gym, but it is about stretching and building creative muscles. An art director is part therapist, part father confessor, and part enabler. He is the conduit through which good art is published. He separates wheat from chaff (and usually keeps the former). An art director is also a talent scout. He or she may not be able to do what an illustrator does, but knows exactly what one is capable of doing.

When I look at an illustrator's work I can size up her strengths and weaknesses almost instantly based on a combination of interview and portfolio. Since neither one is enough of an indicator, I choose to meet face to face with illustrators to make a determination. I balk when the portfolio is a Chinese menu of options; I perk up if there is a singular vision. I am reticent if all I see is decoration; I am attracted when I see conceptual thinking—ideas. Of course, I respond to style, technique, and form but each must be "honest" in spirit and flawless in execution.

At this audition stage I exercise total control with the power to make or not make an assignment. But once I have committed to trusting the illustrator, during the time between making the assignment and seeing the sketch or final, I am curiously powerless. Since I believe it is counterproductive to interfere in the creative process, I stand aside. Sometimes I give minor direction (i.e., "no breasts, this is a family magazine," or "avoid drawing only white men," or "no flags, Uncle Sams, or dollar signs, please," etc.), and every so often (depending on the acuity of the illustrator) I actually suggest a possible idea that I'd like to see carried through (at least one valiant attempt), but this is rare. Most of the time, I prefer that the illustrator "astonish me," as the legendary art director Alexey Brodovitch said to his students. Which is not as easy as it sounds, although much of the time, since I have selected the right illustrators, I am indeed happily astonished.

## How to Astonish Me

Okay, I admit not every illustrator hits it right the first time. But the job of an art director is to pull an essence out of the illustrator. And when that initial artwork is submitted I know if it is a good fit for the article. If it is not, then I direct the illustrator to return to the drawing board (or computer nowadays), with sundry notions that might help him focus on the salient portions in the article. On occasion, when the result is presumably "a good fit for article," but the illustration is executed blandly, dryly, uninspiredly, or similar to other work previously done, it is then my responsibility to open a vein of inspiration that lies under the epidermal layers. The odds are, if I have selected the right illustrator, the best idea (and a new idea at that) is somewhere in the reservoir waiting to be tapped. Indeed, even the finest of the breed have their off moments and require frank critiques laced with paternalistic encouragement to get moving (i.e., "This really sucks, what did you do, spend all of six minutes? I'm paying you real money for this, so do something that won't embarrass yourself!"). In the end I usually get the sought-after result.

Art directing illustration is nothing like art directing photography, which entails more intense collaboration in a highly stressed environment where stylists, assistants, and others have something to say. Working with an illustrator is one on one (*mano a mano*). A photographer provides many variations on the theme. An illustrator is more parsimonious, which is not bad. Personally, I do not like looking at sketches, the artist's equivalent of photographers' contact sheets. To get the best results, I want the illustrator to focus attention on a single idea. This is not always the norm. Some illustrators prefer sketching out a few concepts to make sure the art director will be held accountable for the selection. Sometimes the art director doesn't trust the illustrator enough and also prefers to exercise more control. I prefer to see a finished piece. But if anything is wrong (if it has one too many breasts, or obscures the central point, or is clumsy, whatever), I ask for a redo, which eight out of ten times is unnecessary. While this is not exactly *laissez faire* art direction, the semi-hands-off policy usually allows for the best results.

When it does not, however, more direct intervention is necessary. Not all illustrators are born with the same atavistic talents (nor are all art directors). Being a good drawer or painter does not *a priori* mean they have the ability to conceptualize. I usually can weed these illustrators out from their portfolios, but if they get a job from me, their very first attempt is telling.

Occasionally, the craft or style of a decorative or narrative illustrator is so appealing that he or she has earned a chance to work conceptually. For this assignment, selecting the perfect article is the first hurdle, because even one that has visual potential can be fraught with difficulty. Given my *modus operandi*, I still do not want even the chancy illustrator to submit sketches, in the hope that going straight to finish might lessen "stage fright." Often they feel more comfortable showing lots of ideas, but if they are not up to par then I ratchet up the art direction. While I resist imposing an idea (which was historically the norm for magazine and newspaper illustration), I encourage the illustrator to recast elements of their own conceptual and pictorial elements. If this works out, everyone is happy. If it does not, there are two reasons why: the article was just not the right fit, or the illustrator does not have what it takes to do editorial work. In fact, another job of the art director is to determine who is ultimately best suited to what kind of assignment, and play to the illustrator's strengths.

## Over-Art Direction

Not all art directors can effectively mediate, because they are often in an unequal relationship with their editors (many of whom are predisposed to interfere more with illustration than, say, photography). The optimum way to art direct illustration is to have confidence that one's own art directorial decisions have authority. Conversely, art directors who must second-guess their editors will never make honest decisions, and will thus over-art direct artwork in order to please their higher-ups. Over-art direction is obstructionist, for it

imposes tacit roadblocks on the illustrator's ability to solve a problem. Over-art direction occurs when an art director is forced to show sketches for approval to an editor who is then unable to make constructive artistic judgments.

Like the dog that ate my homework, the mongrel editor may destroy an otherwise fine illustration, but even that is not a good enough excuse. Another art directorial responsibility is to effectively mediate between artist and editor without compromising or sacrificing the quality or integrity of the illustration. The common refrain, "My editor wants the illustration to look more like this or that, so can you add a figure here, and take out this, and move that over to the corner, and that color should change because his wife hates blue," should never be regurgitated back to the illustrator. Art directors should not be lap dogs. If changes are required, the art director must translate them into his or her voice, and impart them as constructive suggestions. Rather than over-art directing, this allows the illustrator to play with alternatives. Returning again to the dog metaphor, scared art directors (those who fear their editors) have a habit of chewing up illustration and illustrators, which yields terrible artwork.

## The Perfect Marriage

Art directors are usually designers, or at least they thoroughly understand the dynamics of graphic design. Some of the best illustrators are also fluent in design and typography, which must be seen as an asset. When art directing an illustrator, it is prudent to include them in the design process by showing them layouts and type treatments so that their work is not an isolated element in the larger composition. The marriage of type and image is the essence of design and the meat of art direction, but the illustration is the critical visual and conceptual component. The best overall work results when these are performed in harmony.

Sadly, art directors often view the illustrator as either a pair of hands, a mere adjunct to the design process, or otherwise a vendor of ideas that can be exploited without regard for the integrity of the creator. Fifty years ago, illustrators were at the top of the commercial-art totem pole before gradually sliding down thanks to the ascendancy of photographers and today's reliance on Photoshop illustration. While trends, fashions, and styles have helped unseat the illustrator, nonetheless this member of the creative team contributes significant value, and sometimes, if art directed well, carries the entire weight of a project. As stated above, some art directors, like me, are only as good as the illustrators they hire because they have created imagery that looks good, reads well, and expresses meaning through strong, smart, startling art.

# The Photo Shoot: How to Set the Stage

## Phyllis Cox
## Associate Creative Director, Bloomingdale's

The very first time I got to hire a photographer to create an image, I was hooked. This was going to be the love of my career, the passion of my creative life. The most exciting part of being an art director is literally to be allowed to direct art. What do I mean by "art"? Collaborating with photographers to create images that go beyond reporting to become their own message—photographs that are an act of pure imagination, the result of a vision shared by the art director and the photographer.

Finding great photographers to work with was the key to realizing the potential of the created photograph. I learned everything about the power of lighting from the legendary Horst P. Horst. It was 1990 and he was at the end of his career when mine was just beginning. His assistant had to focus the lens for him, but he controlled the composition and directed the lighting. He was the master, and his photographs were stunning.

In that same time period, I assigned another fashion story to Steven Klein, who was then early in his career. His photographs, as dramatically lighted as Horst's impeccable compositions, were very different yet just as memorable. These true talents were at opposite ends of the age/fame spectrum, and their work taught me to always consider new photographers—greatness is not a function of age or fame.

Over the years I used many emerging photographers before they became stars, which made me very popular with influential agents, who then would send me their best new talent. It was these mutually respectful relationships that kept the creative work fresh. When I couldn't get Irving Penn, I hired James Wojcek. Beyond getting clean, graphic images, I ended up with something whimsical and witty.

I was always especially pleased by discoveries that I made on my own. A college professor and art photographer showed me her work one day and I decided that her mystical and romantic images were something that I could use. I gave Joyce Tenneson her first editorial assignment. She shot a number of captivating fashion and beauty images for me and went on to great editorial and advertising success.

There is magic in great pictures, but there is also a process that helps the art director get from the vision to the final photograph. Whether for commercial, editorial, or purely artistic purposes, every photograph starts with an idea. The resulting image is dependent on the strength of this original thought, and I do not use the word *original* lightly. Creative people are constantly confronted with the annoying and unanswerable question, "Where do you get your ideas?"

## Ideas

Regardless of your creative resources or philosophy of creativity, in the end your ideas are just ideas and the real question becomes, "Are they good ideas?" Can they be turned into a compelling photograph? After years of analyzing ideas with editors, clients, and other collaborators, I have developed my own criteria for judging the merits of a visual idea.

1. Is it simple? Simplicity is the most overlooked and underrated characteristic of a successful image. A photograph that conveys a feeling or a concept directly and simply is powerful. One of the most arresting images I ever commissioned was a wooden bowl shot on the crosscut of a tree. Simple. Of course it helps to use a photographer who is a genius at lighting, composition, and texture.

2. Is it focused? And I am not talking about "in focus," but whether there is a single message in the concept. A common problem of many unsuccessful pictures is that they are trying to tell too many stories at the same time. One editor I worked with wanted to do a makeup story about new products for spring, the freshest flower-inspired colors, the benefits of the ingredients, how to apply them—plus final beauty shots. Yikes! Way too much ground to cover! When we narrowed the focus to the fresh colors emerging from their graphically portrayed flower origins and juxtaposed a beautifully made-up face, we created a dramatic and award-winning portfolio of photographs.

3. Is it a cliché? There is a fine line here. Clichés can sometimes be used to great or humorous advantage, but they can backfire if not handled very cleverly. One of my favorite pictures for a Hollywood style story used the sidewalk outside Grauman's Chinese Theater with its handprints and footprints of the stars—an old and tired icon to say the least. But when it was shot from an extreme angle featuring a foot wearing an amazing shoe and a hand with fabulous jewels placed in the prints, it was a striking and amusing image.

4. Where's the twist? Is there originality in the way that this story is going to be told? Would the crystal chandelier be more exciting if it was hung in a tree house? Could we shoot a runway story on a diving board? Unexpected locations, unlikely combinations, unusual backgrounds. When it comes to finding new points of view for the story, we can all use all the help we can get. It is time to take the idea and put it into group therapy in the form of the creative team meeting. But, first we need a team captain.

## The Photographer

Choosing the right photographer for the story is critical, and probably the truest test of any art director's skill. Finding the perfect fit of subject and photographer is not at all straightforward. You have done your research, reviewed endless portfolios, and called on the talents of your favorite and most-respected agents. The obvious choices are often just that—too obvious. You want excitement. Someone who will look at your project as the creative

challenge that will evoke the unexpected result. For instance, choosing an art photographer will bring a different point of view to a commercial project.

Study the "personal work" of established editorial and commercial photographers—it is often more inspired and usually quite different from the work they are famous for. One ironic series of black-and-white photographs grew out of a personal portfolio image of an old couple whose body language was exactly duplicated by a young couple in a billboard directly behind them. In reinterpreting his vision, the photographer was willing to research appropriate billboards and locations, and we built our fashion story around them.

Above all, in choosing a photographer, I trust my gut and have confidence in my judgment, which allows me to take chances. You have to believe in the creative energy of the photographer you have chosen. He is the leader of the team.

## The Creative Meeting

There is little that is more gratifying than a really good creative meeting. When the art director, photographer, and stylists sit down and start discussing the idea of the photographs, amazing things can and do happen. As art director, it is your job to provide an atmosphere of open discussion and the free flow of ideas. It is very important to maintain flexibility and to get input from all members of the team. Sometimes the smallest thought sparks a change in direction that refocuses the entire project.

It's difficult to believe, but one of the most memorable creative meetings was about shooting metallic leather shoes. The focusing factor was the metallic theme. The discussion was largely around what kind of backgrounds to use and the usual materials were mentioned. It was not until the photographer made reference to a shot he had done that involved using pure pigment that the story took off. Pigment was followed by paint. And that led to one of the best pictures that came out of this shoot, which was a gold pump immersed in a pool of gold paint in an ordinary paint pan, like the kind you use for paint rollers. It was stunning, one of my all-time favorite shots.

Look for the hook that brings excitement to the table. It is your job to clearly articulate the vision that emerges and get everyone on the same wavelength. The goal is to leave the room with each team member inspired, excited, and ready to carry out their part in the vision. The way you state the final goal can sometimes make all the difference. Some of my favorite photos have been on the subject of fragrance—a challenging subject for a visual medium. After deciding to create and shoot a fantasy fan made of leaves and flowers, my charge to the photographer was "I want to be able to smell this picture."

## Attending the Shoot

There are two schools of thought on whether the art director should show up at the shoot, and I switch back and forth between them. Sometimes I just like to be in the thick of things. On the other hand, I hope that I have provided the

inspiration necessary during the creative meetings and subsequent detail meetings to be confident in the result. A shoot is a delicate balance of creative energy that does not thrive if there are too many chiefs. One clear creative vision produces the strongest result.

Savor the surprising twists that occur on the set that take the idea to an unanticipated place. To that end, it is possibly wisest to give your team their creative freedom. Alexey Brodovitch, one of the greatest art directors of all time, used to send his photographers off with the famous admonition "Astonish me!" It worked for him.

# Common Vision: The Role of the Picture Editor

## A Conversation with Elisabeth Biondi
## Visuals Editor, the *New Yorker*

**Véronique Vienne: How did you become a picture editor?**

**Elisabeth Biondi:** When I came to New York from Germany years ago, my English wasn't that good, I had no art training, and no professional experience, but I needed a job. I found a position at a small photo agency as a "girl Friday," as entry-level secretaries were called back then. With half a dozen staff photographers, the studio functioned as both a production shop and a stock house.

I held a job there for about six or seven years, during which I got involved with a little bit of everything. Eventually, I decided that what I really wanted to do was become a magazine picture editor. One day, I heard that *Penthouse* magazine, *Playboy*'s competitor, was looking for a picture editor and that they were willing to take someone like me, someone without editorial experience. *Penthouse* is where I learned the trade—whatever the trade was! All along, I knew that I had to find a job at a good magazine. When at long last there was an opening at *Geo* magazine, I was ready for it.

**VV: As picture editor, how do you work with the art director?**

**EB:** In all the magazines where I worked—*Penthouse, Geo, Vanity Fair, Stern,* and the *New Yorker*—the art director would assign the illustrations while I assigned the photography. Of course we work together, as colleagues. Even though we are independent of each other, I consider that my job is to produce the kind of pictures that makes the art director's work easier—and more exciting.

At the *New Yorker*, for instance, I discuss with the art director whether we should have an illustration or a photograph—some stories clearly call for one or the other, while others can be either-or. Sharing a common vision is the only way to work productively.

Yet I insist on preserving the integrity of a picture. I make sure that it functions as an image, on its own. It isn't a flat piece of visual that can be cropped arbitrarily, for instance. At the same time, I am well aware that a photograph in a magazine isn't just "art." It has a job to do: to complement the written piece and entice the reader to spend more time with it.

**VV: Do most picture editors function as independent visuals editor, as you do?**

**EB:** At publications like the *New York Times*, picture editors have their independent voice. But in the majority of magazines, the picture editor does not function the way I was trained (or trained myself) to function. Unfortunately, now and then, you run into picture editors who are limited to producing photo shoots or doing picture research. But the best magazines give their picture editors a position of authority.

*VV: How would you describe your relationship with the
editor-in-chief?*

*EB:* As a picture editor, I am the bridge between the artist and the editorial intent of the magazine. I have to be able to verbalize what the magazine is all about and find the right match between a photographer's sensibility and that of the editor-in-chief, who has the overall responsibility for the publication.

I learned early on that I have to be able to explain to editors why a picture is appropriate or not for the article. My tool is my mouth. So is my brain. I come prepared to editorial meetings. I have read everything, researched the topic if need be, and made sure that I know all there is to know about the subject matter we are about to discuss. Rightfully so, editors expect me to know my stuff—and I do.

It is not so much my aesthetics that's critical in that relationship, but my ability to translate the magazine's point of view to others—editors and photographers. Even though my job is to reflect the editor's vision, I have to speak for the magazine in my own voice.

*VV: You said that you learned "the trade" at* Penthouse. *What did you learn at* Geo?

*EB:* At *Geo*, I learned to respect the integrity of a photograph. The person who was responsible for the visual part—the creative director in other words—was called the executive editor. He actually was a photographer. He followed the basic rules of Magum, and taught me to do the same. There, I not only learned how to treat a photograph, I also learned how to assign it and discuss the editing with the photographer afterward. As far as I am concerned, respecting these principles is the only way to create images that have a meaning.

*VV: Was the fact that* Geo *was originally a European magazine a factor in the way photography was handled there?*

*EB:* Even though *Geo* was first published in Germany, its U.S. edition, where I worked, was independent. There, I felt more American than German. My training was American, though my aesthetic was probably European. At the beginning of my career, I liked dark, somewhat surreal images. I quickly realized that I had to put that behind me. To do a successful magazine in America, you cannot publish too many dark and obscure images!

*VV: You came to the* New Yorker *after working at the weekly* Stern *in Germany for a couple of years. In your experience, what is the main difference between a European and an American magazine?*

*EB:* There is a great difference in terms of what you can show. In Germany, it's very direct; you can print almost everything and anything. We published

pictures of beheadings. Naked girls. The intent was to show the world "as it is," in all its cruelty—something no mainstream editor would do in America.

At *Vanity Fair*, Tina Brown, who is British, expressed a more European sensibility. If she felt that a picture was hot, she would generate the text to go with it. She deliberately used visuals to entice her readers. She knew how to edit the magazine visually, making sure the articles worked as images as well as stories. At *Vanity Fair*, she liked contrasts, energy, surprise—playing photographs against each other rather than striving for a perfectly smooth mix of images.

The *New Yorker* is more formatted, more traditional in its layout. Here, a story doesn't get scheduled because of an illustration or a photograph. It is a writer's magazine. And some things are set forever. No one, for example, would ever think of putting a photograph on the cover, as I agree.

**VV: What's the most challenging thing you do here at the New Yorker?**

*EB:* Convey to the photographer what sort of pictures I want. You can recognize a *New Yorker* photograph, but it is not defined by obvious standards. It's a very fine line that differentiates a *New Yorker* photograph from a *Vanity Fair* picture or a *New York Times* picture, for example.

**VV: What kinds of things do you tell photographers, for example?**

*EB:* I say, "Work in the classical mode—but with a twist." I tell them that I am looking for images that are both sophisticated and quite smart, yet always based on the editorial content. We start with what the story is all about, and the direction the article is taking.

Aesthetically, I try to give the photographers—whether they are photojournalists or portrait photographers—a visual parameter in which they can work. I want to make sure they understand the visual parameters. And I usually add, "If you are going to do something daring, please do it, but also shoot a more traditional picture so that we have a choice."

**VV: Finally, what's the most pleasurable part of your work?**

*EB:* I would have to say reading articles and then figuring out what sort of photograph would be best for them. I am never bored, always challenged.

# How to Talk to an Illustrator: Tips from Two Pros

## Vicki Morgan and Gail Gaynin

**Communicate clearly** . . . It's that basic. Say what you need and you will have the best chance of getting what you want.

*Tip:* First define "what you need" for yourself so you can explain it in plain English. If necessary, write it down.

**Communicate your visual needs to your group.** If the creative team has agreed that illustration is the best solution, identify your visual needs; i.e., a conceptual approach, a narrative one, a humorous treatment, etc. Then do your research to find a suitable collaborator. Be confident about your decision so that you can champion your choice to colleagues and clients.

*Tip:* If a particular artist inspired you, give him or her the opportunity to be considered for the job.

**Communicate why you chose your illustrator.** Let the artist know the specific samples to which you responded for this particular assignment. Unless the assignment calls for recreating art from a historical period, it would be counter-productive to make a comparison or reference to other artists' works. It is so appreciated when you tell an illustrator that you are looking forward to working together and welcome his or her creative involvement.

*Tip:* Your acknowledgement of the illustrator's talent and intelligence will go a long way toward making the entire project pleasant.

**Communicate the marketing or editorial directives.** Be clear about your product's specific positioning, restrictions, and deadlines so that you can convey the same objectives and information to your illustrator.

*Tip:* An idea is of no use if it is off the mark.

**Communicate what is in your mind's eye.** The illustrator is not a mind reader. Are you one who has said, "We love what you do . . . just be creative" only to look at the result and remark, "Oh . . . that's not quite what I had in mind!"?

*Tip:* Never relinquish responsibility with the comment, "I'll know it when I see it."

**Communication is necessary in collaboration.** Both you and your artist must know the job's pertinent information in order to make appropriate creative choices. Insufficient input does not get creativity flowing; too much can stifle it. If you see something going awry, speak up immediately.

*Tip:* Responsible teamwork prevents costly mistakes.

**Communicate respectfully.** Assume your illustrator is a pro and can handle art direction and commitments responsibly. As you both have busy schedules, honestly discuss your time considerations and arrive at a viable plan. It is important that you do not compromise an agreed-upon schedule by taking longer than necessary to respond to sketches, finishes, changes, and approvals.

*Tip:* Upon receipt of the artist's work, respond by saying, "Thanks. I'll show the rest of the team and get back to you by (a specific day)." If meeting schedules are delayed, keep the artist informed.

**Communicate all business aspects thoroughly.** Before work starts, make sure you are in accord on all contractual issues. Agree to due dates, contact information, work requirements, terms and uses, payment schedules, expense reimbursement, format of sketch, final art submissions, etc. If you are discussing fees and terms, be sure you have the authority to do so. And also be sure that contracts do not contradict your verbal agreements.

*Tip:* Have a written confirmation.

**Communicate with the rep,** if the artist has chosen to have an agent as part of his or her business structure. Circumventing the representative is unprofessional.

*Tip:* A good agent will be your ally, a useful liaison, and expeditor.

**Communicate your appreciation.** Most illustrators are working alone and without much feedback while creating the sketch and finish stages. Your communication means a lot to them . . . especially the call at the end when you tell them that you were happy with their work.

*Tip:* Thank the illustrator for making you look good.

# The Ideal Client: Letting Others Do Their Job

## A Conversation with Louise Fili and Chip Fleischer
## Designer, Louise Fili Ltd., and Publisher,
## Steerforth Press

***Steven Heller: Louise, what is the ideal publishing client?***
***Louise Fili:*** One who will do his or her job and let me do mine.

***SH: Chip, what is the ideal publishing art director?***
***Chip Fleischer:*** First and foremost, someone who is talented, capable, and knowledgeable, whose work will reflect favorably upon and add value to the books we publish. But also, especially for Steerforth's list, which is very general in its subject matter and tries to strike a balance between literary quality and commercial viability, someone who has a broad range and is flexible. And finally, someone who is comfortable with the idea that while each person involved in the publishing process has his or her own area of expertise, everyone, from the author to the publisher, editor, sales reps and publicists, needs to be listened to, and that more often than not the end result will represent a series of compromises.

**In books marketing issues enter into the jacket and cover design**

***SH: Louise, how have these factors helped or hindered your work?***
***LF:*** The higher the expectations for the book, the more the marketing people tend to intervene. I am open to suggestions, but what I always need to emphasize to every client is: Tell me what is not working for you, and let *us* decide how to remedy it.

***SH: Chip, how have these factors dictated how you work with your art director?***
***CF:*** More and more I have asked that our art director be open to feedback from sales and marketing professionals and do revisions as part of an evolving process. At the same time, I have found that the best approach is to convey what the s&m [sales and marketing] folks see as a problem or what feel or effect they'd like to try to achieve and let the art director propose possible solutions.

**Taste is subjective, and a lot of design is about the taste of the designer**

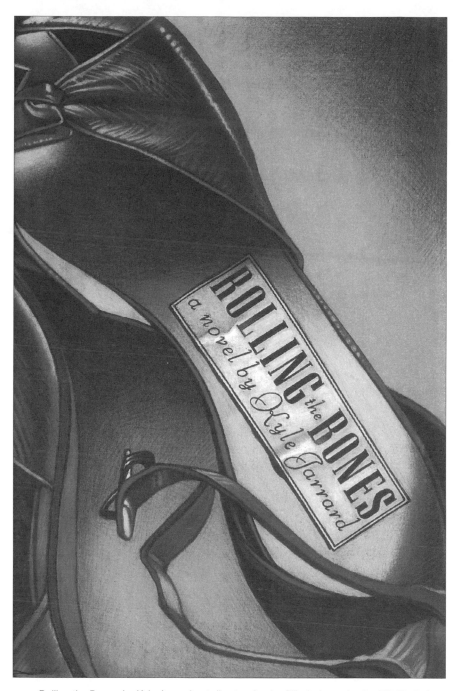

*Rolling the Bones*, by Kyle Jarrard; art director: Louise Fili; designer: Louise Fili; illustrator: Bill Nelson; Steerforth Press, 2001.

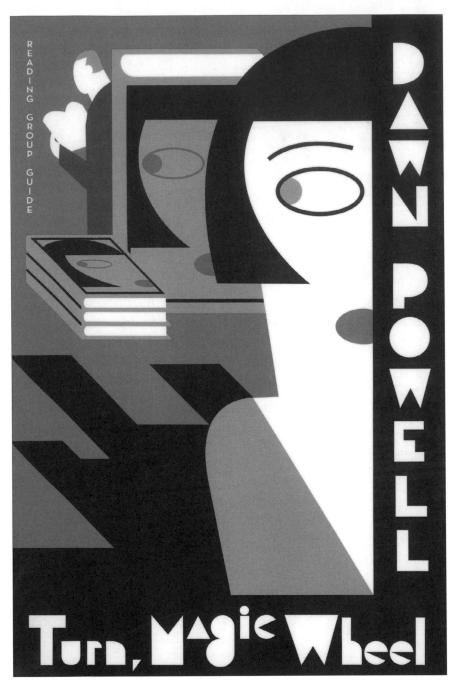

*Turn, Magic Wheel*, by Dawn Powell; Art director: Louise Fili; illustrator/designer: Richard McGuire; Steerforth Press, 2005.

Steerforth Italia; art director: Louise Fili; designer: Louise Fili; artists: various; Steerforth Press; 2000–2004.

***SH: Louise, how do you balance your preferences with the needs of your publisher?***

*LF:* I try to put my preferences aside and address what is really appropriate for the book. As Steerforth has such an eclectic list—from true crime to sophisticated fiction—it is imperative that each cover be designed to represent its contents.

***SH: Chip, how do you allow for your designer's tastes to meld with your publishing requisites?***

*CF:* By allowing the art director a free hand to take the lead as much as possible, so her tastes and original ideas can then establish the framework for the ongoing discussion about a certain project.

**Everyone has a different view of what makes a successful book jacket or cover**

***SH: Louise, what is your favorite Steerforth piece, and why?***

*LF:* I think it was *Whitman's Wild Children*. Instead of setting all the names in type, which would have made for a predictable (yawn) cover, I hand-lettered all of the text on blotter paper, giving it much more tactile appeal. Steerforth had the vision to accept (and appreciate) the direction.

***SH: Chip, what is your favorite, and did it work as you hoped to "sell" the book?***

*CF:* It's impossible to single out a true "favorite." Some of the most aesthetically beautiful jackets were not helpful to sales, and some of the less

beautiful reflected a book's content and tone so well that they helped to reach the target audience and clinch the deal. But to answer this question I think I'd single out the cover for the slim novel *HERO*. The book didn't sell all that well in hardcover or paperback, but it sold okay and was a positive experience for everyone. What I liked most about the cover design is that it was inspired, original, and very, very memorable. More than any other single title, people seem to associate that book with Steerforth, and in describing it they always remember what the cover design looked like. Simple as it was, I think it was a design that made people stop and drew them in. Also, it was the first time I experienced our art director saying "I know exactly what I want to do." She faxed a hand drawn rendition, which did not begin to do the finished product justice. But the end result was terrific, and the experience gave me something very important: the confidence to believe in her vision even when I have trouble seeing what the end result will look and feel like.

**SH: Louise, are there any standards or rules that you impose on your publisher?**
**LF:** Only that we have a conversation at the outset that clearly defines the book.

**SH: Chip, are there any standards or rules that you impose on your art director?**
**CF:** No hard and fast rules. But I have found it important to set clear parameters going into a project—from budget constraints to any strong feelings about the direction in which I'd like her to think about going.

# How to Be Hip: Surviving a Fashion Shoot

## Scott Hawley

*You're so hip.* You work in the fabulous world of fashion. Just minutes ago you were pasting the posters you designed for your friend's band into your portfolio. Now you've interviewed your way to a junior art director position at a company where you actually want the employee discount.

*You'll go to exciting places and stay in fancy rooms.* At first, you'll feel grateful just to go along and be quite humbled by all the work that goes into creating a picture of a guy in a white shirt standing next to a tree. But get wise, junior. There are things you'll need to know before you can just show up. Let's get you a little gumption—it's the only way you'll be invited back. I should know. I started out as you. I rose through the photoshoot ranks from dinner reject to the creative director that snags the duplex. I've shot countless flip-flops on endless beaches, snotty supermodels on hot rooftops, toddlers sunbathing in exotic locales, and golden retrievers wearing ties. I've worked with and for some famous designers and photographers. Fifteen years and a hundred mini-bars later, here is my best advice.

*Always love big or old doors.* Speak up: "I *love* that old door—it's too bad we couldn't shoot against that." "Did you *see* that *fabulous* door made of . . . wood? It's am-*az*-ing . . ."

*When something unexpected happens, try to be the first one to say, "We should just run that!"* Yell this immediately when a prop falls, or you can see the clips holding back a model's shirt, or when some item from the real world accidentally doesn't get removed from the set, like a Vuitton bag or an overweight stylist.

*Abbreviate clichés to keep them fresh.* "It looks fabulous!" becomes "Fabulous!" becomes "Fab!" becomes "Phhhf." Be the first to say "She's soooo phhhf!"

*Anyone young and cute is always correct.* If a model comes to the set and he's wearing a cut-up Hefty bag for pants, you should comment loudly that you *love* them, then quickly suggest that the pants should be in the picture, then be the first to have the new tailor create a pair for you to wear to the second shoot day. You have to move on this one, because everyone's watching the models at breakfast.

Also note: the title of whatever CD the model is listening to should be entered into your Palm Pilot to be purchased later and expensed—and remember to give more weight to whatever the models say—i.e., repeat everything they just said to a group of people—because, well, they're just soooo cute. Give them things.

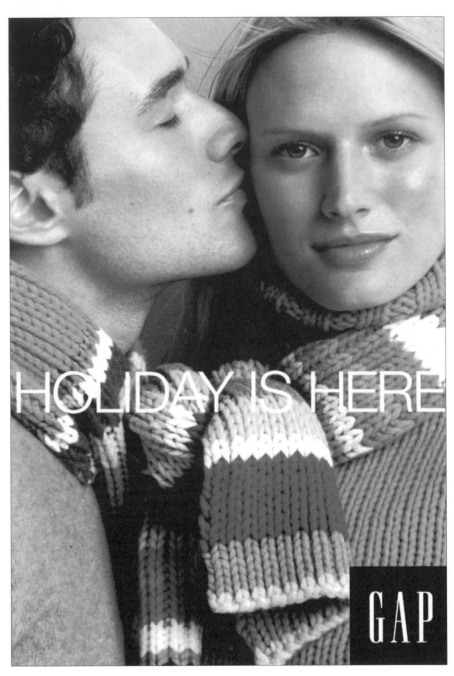

HOLIDAY IS HERE

GAP

An attempt to add a little humanity to a chilly brand. Models = People.

Polo Jeans Flag: While we were shooting against this flag on a NYC rooftop, the U.S. Navy sailed down the Hudson for Fleet Week.

Try to be the one that suggests that *any* young, even remotely cute assistant should be in the picture—your reasoning should be that, "They're as cute as the models but somehow more 'real.'"

*Hate the catering.* Tell the caterer how good everything looks, then when you get back to your table, act disgusted and say something in a pretend whisper like, "What *is* that?" or, "I'm *not* eating that," or, "How far are we from a McDonald's/Starbuck's?" *Ha!*

*Hate your room.* Just assume that someone on the call sheet has a better room with a better view and start complaining as soon as your bags are dropped. Make sure you have a list of other people's room numbers so you can get on the phone right away and join the bitch-chain. They'll have already called other rooms and this way you can gang up and get word back to your office on who has the best room. Also, embellish the cost of the best room by at least 50 percent for dramatic bonus. You should rotate a list of who is going to "walk out of the hotel" or who "moved rooms three times" so one person doesn't carry the burden of forcing the expensive upgrade. Be careful of exaggerating bug/pubic hair stories—they don't have the punch they used to have.

*Suggest that anyone with a higher title than yours should be one of the talent.* "Bob, *love* your cargo pants! *You* should be in this picture!" Or, "Why don't we use Bob's poodle, Giselle—she's sooo phhhf!"

*Be vague about dinner.* This is multipurposeful. First, you can hold out for the coolest combination of people that will be dining at the coolest place; if this happens, then your vagueness will also confirm to the people less cool than you that don't get invited that you are indeed cooler. Second, it gives you a mystique to exploit. If you hold out but then don't get invited *anywhere*, then you can stay in your room and make up your own story of elitist outrageousness, which you should embellish accordingly. One important note here: do *not* wander after 8 PM if this is your plan, because you might get caught wandering around with a handful of Snackwells by the tailor or a camera assistant, and this would be *disastrous*.

*Mention getting stoned, even if it's not something you do.* At the very least, the production assistants (PAs) will pay attention to you and treat you well, thinking that there's a chance you can score for them. Besides, if everyone thinks you have a substance problem, they're more inclined to invite you to dinner.

*Gray area is for common folk.* Remember to *love* or *hate* everything and especially everyone, but reserve your judgment until you hear everyone else's opinion. This ties into which group you'll want to dine with (see above) but does not include the tailor/PAs/camera assistants, who you should feel free to make fun of openly, even within their earshot. It's not only acceptable but encouraged to label all things/people with a loud, one-word declaration, which will be understood by anyone who matters; i.e., if you see a model in a prestige ad ala Versace, just hold up the magazine to everyone and say, "*Love*," or if you overhear someone discussing a star of a movie that's not making any money, just ask, "Who are you talking about?" and when they tell you, just roll your eyes and say, "*Hate!*" These declarations save you some much needed time, which you can use later in your room, when you're eating Rice Krispie Treats from your mini-bar and phoning everyone to ask if they've checked out the gym.

*Be the first to ask an "exotic person" where they're from.* By definition, an "exotic person" is anyone with an accent—not including Canada—or with questionable ethnicity. Play the geography game: you'll be competing with the others to see who has either lived or vacationed closest to the foreign hometown of the exotic person. The winner gets to "own" the exotic person for the remainder of the shoot. Note: It's the responsibility of the winner to repeat his winning story every time he overhears someone ask the exotic person where they're from.

*Get the fuck out of there.* There's a moment around 3:45 PM when you won't be able to down another diet Coke or manipulate a PA into leaving the set to

bring you back a $6 jumbo latte. This is the time you should choose someone to hate. It will help to pass the time dishing on them until the last, painful shot. Turn to someone freelance and comment, "Hey, at least we're not in the office—oh yeah, you don't *have* an office." It's funny, and it makes them feel bad. Tell a cohort about how you just made fun of someone to his face and kill another ten minutes. It's very cool to be "over" everything, including the people you're with and the actual shoot you're on.

# 08: Is There an Art to Art Direction?

## Aesthetics as Content: The Curse of the D Word

### Steven Heller

Do you make things look nice regardless of content? Do you spend more time worrying about aesthetics than meaning? Do you fiddle with style and ignore substance? If the answers are yes, yes, and yes, then you are a decorator.

But is there anything fundamentally wrong with being a decorator? While Architect Adolf Loos (1870–1933) proclaimed ornament is sin in his essay "Ornament and Crime," attacking late-nineteenth-century art nouveau, in truth decoration and ornamentation are no more sinful than austerity is virtuous.

Take, for example, the psychedelic style of the late 1960s, which, while smothered in flamboyant ornamentation (indeed much of it borrowed from Loos's dread art nouveau), was nonetheless a revolutionary graphic language used as a code for a revolutionary generation—which is the exact same role art nouveau played seventy years earlier, with its vituperative rejection of antiquated nineteenth-century academic verities. Likewise, psychedelia's immediate predecessor, Push Pin Studios, was from the late 1950s through the 1970s known for reprising passé decorative conceits because in the context of the times it was a purposeful and strategic alternative to the purist Swiss Style that evolved into drab corporate modernism, which had rejected decoration

(and eclectic quirkiness) in favor of bland Helvetica. Moreover, content and meaning were not sacrificed but rather illuminated and made more appealing.

Anti-decorative ideological fervor to the contrary, decoration is not inherently good or bad. While decoration is frequently applied to conceal faulty merchandise and flawed concepts, it nonetheless also enhances a product when used with integrity and taste. A decorator does not simply move elements mindlessly around to achieve some kind of intangible or intuitive goal, but rather to optimize materials at hand and tap into an aesthetic allure in order to instill a certain kind of pleasure. However, Loos and likeminded late-nineteenth- and early-twentieth-century design progressives argued that excessive ornament existed solely to deceive the public into believing they were getting more value for their money, when in fact they were being duped through illusionary conceits. These critics argued that art nouveau (or later art deco or postmodern) decoration on buildings, furniture, and even graphic design rarely added to a product's functionality or durability, and also locked the respective objects in a vault of time that eventually rendered everything obsolete. Decoration was therefore the tool of obsolescence. And so it may be.

However, decoration also plays an integral role in the total design scheme. It is not merely wallpaper (and what's wrong with beautiful wallpaper, anyway?). Good decoration is that which enhances or frames a product or message. Today's euro paper currency, for example, with its colorful palette and pictorial vibrancy, is much more appealing than the staid U.S. dollar. While the greenback is comprised of ornate rococo engravings, separately each bill lacks the same visual pizzazz of the euro. Of course, if one is clutching a score of $100 bills in two hands, visual pizzazz is irrelevant, but putting the respective face values of the currencies aside, the euro is an indubitably more stimulating object of design because it is a decorative tour de force with a distinct function. One should never underestimate the power of decoration to stimulate the user of design.

Decoration can be defined as a marriage of forms (color, line, pattern, letter, picture) that does not overtly tell a story or convey a literal message, but serves to stimulate the senses. Paisley, herringbone, or tartan patterns are purely decorative yet nonetheless elicit certain visceral responses. Ziggurat or sunburst designs on the façade of a building or the cover of a brochure spark a responsive chord even when type is absent. Decorative and ornamental design elements are backdrops yet possess the power to draw attention, which ultimately prepares the audience to receive the message.

It takes as much acuity and sophistication to be a decorator as it does a typographer (although the two are not mutually exclusive). A designer who decorates yet does not know how to effectively control, modulate, or create ornamental elements is doomed to produce turgid work. The worst decorative excesses are not the obsessively baroque borders and patterns that are born of an eclectic vision (like the vines and tendrils that strangulated the typical art

nouveau poster or page) but the ignorant application of dysfunctional doodads that are total anachronisms. For example, a typical take-out coffee cup with its pastel, airbrushed, generic postmodern styling represents the silliest kind of knee-jerk ornamentation, neither pleasant to look at nor meaningful to contemplate. It simply reprises a warmed-over (in this case nineties) design fashion used primarily to fill space and nothing else. Conversely, the conventional coffee-shop paper cups with the faux Greek friezes printed in blue and white have more innate graphic interest than this superficial throwaway.

Consumer culture is replete with such inconsequential things that when added up contribute to giving decoration its bad name. A splendidly ornamented package, including the current crop of boutique teas, soaps, and food wrappers, may cost a little more to produce but have quantifiable impact on consumers with discerning tastes who buy them (and sometimes keep the boxes after the product is used up).

And speaking of savoring and saving, one of the most iconic of all twentieth-century ornaments is the ubiquitous black-and-white marble notebook cover, reprising a nineteenth-century design, which is now a symbol of education itself. As the cover of the broadsheet newspaper advertising supplement for the *New York Times*, Knowledge Network, it appears on the first page at an extremely huge yet recognizable size. The design concept relies entirely on various large decorative patterns and the designer has deftly filled other poster-sized pages with tight, enlarged close-ups of common textures (grooves of a vinyl record, surfaces of pigmented football, strands of undulating pasta, trimmed pages of a book, and of course the marbleized notebook cover) as a way of piquing the audience's curiosity, and thus grabbing its attention. From a distance, the patterns are totally abstract and decidedly intriguing; the closer they are, the more identifiable they become— and the more captivating. This is not prosaic decoration but visually challenging and hypnotically engaging.

There are many different kinds and degrees of decoration and ornamentation. While none of it is really sinful, much of it is trivial. And yet to be a practitioner of this kind of design does not a priori relegate one to inferior status branded with a scarlet letter *D*. Some of the best decorators are great designers because they are actually exemplary decorators.

# Sense and Sensibility: Art Directing a "Vibe"
## Véronique Vienne

We don't seem to design magazines for readers anymore but for editorial voyeurs—for page-flippers in search of visual stimulation. Most people (myself included) go to newsstands to get an image fix. We peruse titles in a slight trance, a state halfway between heightened awareness and suspended animation. There is always an eerie silence around stacks of great magazines. Engrossed in contemplation, most of us forget to breathe. All one hears are isolated sighs, usually followed by the crisp ruffle of a page being turned.

To measure the visual appeal of a magazine, listen carefully. You should be able to evaluate its design with your ears. The more quiet the room, the better the layouts.

Factoring in auditory clues to get a better read of the big picture is not such a far-fetched idea. A European publisher once told me that his company regularly surveys subscribers to find out how they feel when they hear the mailman drop the magazine on their front door. Delivered every Tuesday at a specific time of the day, the magazine falls through the mail chute and hits the floor with a characteristic thump. This sound has come to symbolize the readers' relationship with the publication.

Some readers interpret this sound as a sign that it's time to take a break, make a fresh cup of coffee and flip pages. Others get on the phone to call their neighbors to invite them to come by, pore over the layouts . . . and gossip. A number of subscribers have the magazine delivered to their office rather than to their home, so addicted are they to this weekly knock on their door.

For members of the editorial team, this magical sound is their moment of truth. They labor unremittingly to make sure that the magazine is as exciting as its thump.

A magazine is indeed a sound—a resonance in the mind of readers. To design it, you need to be as much of a musician as a visual communicator. Graphic design is only one aspect of the craft. A magazine is first and foremost a "vibe"—a "brand" in marketing parlance—what Stuart Agres, director of corporate research at Young & Rubicam defines as "a set of differentiating promises that link a product to its customers."

In other words, a magazine is a figment of the imagination of readers as much as a mental construct engineered by editors and art directors. A shared fantasy, it is the sum total of its tone, personality, and point of view. Everything matters: sound, but also thickness, weight, size, texture. Even those politically incorrect scent strips inserted in trendy magazines must be taken into account. For better or for worse, they are an integral part of the editorial message.

Some time ago, I tried to find out what it would take to extract the pure essence of a magazine and turn it into something almost as volatile as its vibe. I

managed to convince the editor of a fashion magazine to let me do a story on how her slick publication could be translated into a woman's fragrance.

We put together a team of brand experts, trend-forecasters, bottle designers, and perfumers and decided to proceed as if the magazine was any other client. Studying back issues, demographics, and circulation figures, we drew a profile of who the typical reader wanted to be. This information was used to create a brand positioning, a bottle, a package, and of course a perfume. This last phase was much the same as designing a magazine. Orchestrating olfactory notes (taking into account their power of evocation as well as their evaporation rate) was not unlike mapping out the visual impact of successive layouts.

The real surprise was how much the fragrance resembled the chic publication. The scent we designed was cool at first, with notes of bergamot, rose, and freshly mown lawn rising through a discreet veil of lemony magnolia. After a few minutes of evaporation, this transparent screen was partially lifted to reveal a mouth-watering combination of plum and musk.

It had to happen. Someone on the team suggested we insert scent strips in the magazine to test the fragrance with readers. Only then did we snap out of it. Thanks, but no thanks. We are not marketers—we are only journalists. We believe that what readers deserve is a great magazine—no less, no more.

# The Signature Style: Pros and Cons

## Steven Heller

Should an editorial art director impose a personal style on a publication? Ideally, any stylistic manifestation is the magazine's identity (and belongs first and foremost to that publication). Yet certain art directors put their own signatures on every publication they touch. The list is long: Alexey Brodovitch's hand was discernable on *Harper's Bazaar* and *Portfolio*, owing in part to the repeated use of his favorite typeface, Bodoni. Herb Lubalin, art director of *Eros* and *Avant Garde*, invented illustrative typography sometimes referred to as "smashed letters" that became his exclusive trademark in both magazines. Today Roger Black routinely uses Egyptian slab serif typefaces for virtually everything he designs, which makes his formats for a slew of different publications unmistakably similar. Likewise, Fred Woodward, art director for *Texas Monthly*, *Rolling Stone*, and *GQ*, always applies intricate conceptual type treatments to feature pages in his respective magazines. He has altered basic formats to reflect specific editorial needs of each publication, yet his style is always apparent. Some art directors are deliberately hired to inject their unique "looks." Often these signatures are customized for the respective publications, other times they are template solutions for all design problems.

All good art directors have a style, method, or manner. Some are more recognizable than others—while fewer are more original. If the art director has an imposing graphic personality, as did David Carson in the nineties alternative rock magazine *RayGun*, the result is so overt that it defines the entire publication. Conversely, if the art director has a subtle or low-key personality, the result will complement the editorial. It is not always clear what is more beneficial for a publication: the ostentatious ego, or shrinking violet, or somewhere in between? The answer varies depending on editorial prerogatives. In large part owing to its flamboyant and progressive digital design aesthetic, *RayGun* was hugely successful in creating a visual language that its audience embraced, while all non-members rejected it as yet another blow to the downfall of civilization (the perfect calculus for rebellious youth). Moreover, Carson became well known for his art directorial escapades (like setting an entire article in dingbats rather than a readable typeface or enlarging the size of page numbers to one quarter of the entire page) above and beyond the targeted *RayGun* audience, which, in turn, brought media attention to the magazine. Carson's expressive (at times chaotic) design was not a mere frame for articles, rather it was the visual content—as well as the brand—of the magazine, and the synergy between design and editorial gave *RayGun* a cutting-edge allure. Its closest competitor, the venerable *Rolling Stone*, was highly admired for consistently beautiful presentation, yet Fred Woodward's art direction never commandeered the editorial content. Balance was achieved through respect for

the word and reliance on strong photography. The lavish type openers for each feature story never conflicted with the main point of the magazine—to convey information in an entertaining and accessible manner. In both these magazines art directors imposed strong personalities, but the former overwhelmed while the latter increased readability.

A domineering art director will, at some point, be pitted against a strong editor. In the end, most magazines are driven by words and ideas, and few art directors ever rise to the top of a masthead (second is about as lofty as one goes, but the usual position is on the third or fourth tier). Strong personalities are only encouraged or tolerated as long as it suits a particular editor's mission, which includes distinguishing his or her magazine from the competition. An art director who offers a viable alternative is held in great esteem, as long as this is accomplished. But all too frequently, if the special design qualities are successful, copycats will eventually borrow, steal, and adapt. This was the case in the late sixties, after Milton Glaser and Walter Bernard designed the original *New York* magazine. Flamboyant it was not, but smart, clean, and distinctive it was—replete with personality. The format, with its Egyptian headlines, generous number of blurbs, banks, and quotes, and ample white space, was a perfect frame for the keen conceptual illustration and photography that graced its columns and feature pages. Although it borrowed a tad of its conceptual acuity from the older *Esquire* (another magazine with personality), its overall mass was unique. But after a few years, other "regional" magazines so brazenly mimicked *New York* that it began to lose its distinctive personality—one is in trouble when the caricatures become more recognizable than the caricatured— and a new format—indeed a new persona—had to be found, and with new designers who never quite injected the same specialness into the magazine.

Art directorial personalities can be dubious achievements because they are not always transferable. Herb Lubalin was the only one who could actually design like Herb Lubalin. All others were clearly imitators. The Swiss used to say design was "universal," implying that when limited to one family of typefaces and a rigid grid any designer could adhere to a system. But just think what magazines would be like if there were no distinct personalities to push those limitations. At the same time, one art director cannot always slip into another art director's skin, so for magazines that demand consistency or retain a brand presence neutral design is imperative.

Some art directors are incapable of shedding principles rooted in aesthetic or ideological beliefs. Others are chameleons adapting to any publishing environment. Some art directors establish personalities by customizing typefaces, developing stables of artists, designers, and photographers, and otherwise carving a niche for themselves and their magazines. Others readily take from the existing toolboxes. The personality can be the art director's greatest tool. So should an editorial art director impose a personal style on a publication? Yes, but it must be applied wisely.

## How to Be Your Own Client: All Art, No Commerce

### A Conversation with Benjamin Savignac
### Art Director, *DEdiCate* Magazine, Paris

*Véronique Vienne: How did you become an art director?*

*Benjamin Savignac:* Right out of art school, where I studied drawing, serigraphy, and where I dabbled in photography, I had the opportunity to design the first issue of a new hip-hop music magazine called *Real*. At the time I had very little training in graphic design, so rather than focus on layout and typography, I figured I would "set the scene" for the musicians.

There was no budget, so I had to use existing publicity shots of the different artists. But I worked them over to create collages that incorporated line drawings, splashes of color, squiggles, and patterns. So, even though I didn't assign the photographs, I was able to give the magazine a very unique look, complete with its own system of graphic codes.

This challenge forced me to develop my own artistic sense. I am not saying that I am an artist! I don't even know what being an "artist" actually means. If I had to describe my approach in any way, I'd say it was more like being a painter and using photographs as I would a canvas.

*VV: You only did one issue of* Real. *But it helped you find your "signature" style. Today you are using a similar approach with* DEdiCate*, the underground fashion magazine you created three years ago with a handful of friends.*

*BS:* Yes, I still like to combine elegant and refined images with more awkward and raw design elements. My work pits type, drawings, photography, decoupages, and blotches of color against each other.

I used to think that you had to start with a typographic exercise and use visuals to illustrate the words. But I do the opposite: I start with the image, whether it's a photograph or a drawing, and I build on top of it in an organic way, layering graphic touches one at a time.

*VV: Now, with* DEdiCate *you get to assign photographs, yet you still make collages out of them.*

*BS:* Not as much, and only on the opening spread! But I still use the collage technique for commercial assignments, and for my personal work.

*VV: Do you art direct photographs?*

*BS:* I never go to a photo shoot if that's what you mean. That's none of my business. Beforehand, I talk with the photographers about ideas that relate to the main theme of the magazine and I help coordinate the shoot with a team

that often includes a fashion stylist. But after that, I give the photographers 100 percent control. I let them shoot as if they were their own client. I don't want my opinion to hinder their creativity. I would hate for them to try to second-guess me.

**VV: Do you have a bigger budget?**

**BS:** No, we still don't have money. Everyone works for free. Photographers, stylists, models, hair and makeup artists, designers, but also the production companies that do retouching and color work as well as the photo studios, the rental houses, and the printers. All of it against free advertising, of course. The magazine is a portfolio piece for everyone.

The fact that it is deliberately noncommercial is what makes it different from other avant-garde fashion magazines that have great graphics but are product oriented. Not only are we not trying to sell anything, we don't even attempt to respect the brand image of the products we happen to feature. We are able to keep all the visuals very personal.

That said, I wish I could pay people. Eventually, I would like the magazine to become established as a regular business, with real capital behind it. But money and creativity make strange bedfellows. Money hinders everyone, even artists who say that they are not trying to make a profit.

Right now, on this bartering system, we all have the opportunity to create the universe we want. No one is there to tell us what to do. No one to suggest I make it less red, or larger, or whatever. There is no rigidity or coolness. No egos to manage.

**VV: Somehow, the circulation of the magazine is going up. You are getting a much wider distribution in bookstores and newsstands all over France.**

**BS:** Our editorial mandate is to do the things we like while at the same time search for high-quality images and great writing. It's all very intuitive and it seems to work. I cannot explain why. Each issue of *DEdiCate* has an overall theme and focuses on a specific country. The last one, with Björk on the cover, was about "interior space"—dreams, introspection, repressed feelings—and Iceland. Why Iceland? Because it felt right. The next issue is about "extraverted space"—we have an article on expressing neurosis and frustrations—while the country we chose is Brazil.

What I like about *DEdiCate* is this melting pot attitude. This "mélange" works for me. The "mixitude" of it all. That's what is contemporary about the editorial approach. I think that the future is all about this mix. You cannot prevent the world from getting all jumbled up. Whether or not you like it, there are no more boundaries between things that do not belong together.

***VV: Can you maintain this attitude in your commercial work?***

***BS:*** At long last, advertising agencies are calling me to do what I can do best. But the problem is always the client. As soon as you have a client, your relationship to your work becomes complicated. You have to talk about what you do instead of just doing it. I hope one day to be able to create a visual world that is so coherent that I no longer have to explain it to others. I don't know right now how I am going to accomplish this. It is probably a blessing in disguise: When you know where you are going, the journey to get there is boring.

# Judging Excellence: An Unscientific Affair

## Véronique Vienne

There is only one thing worse than designing-by-committee: It's judging-design-by-committee. Yet, this is exactly how this great design compendium came about: As the result of a two-day judging marathon during which forty-nine top editorial designers were locked together over a weekend and expected to collectively appraise 7,891 design entries from around the world—impartially, meticulously, and of course enthusiastically.

Why on earth would anyone want to do this? That's what we all wondered on that bleak Saturday morning last January as we gathered at Parsons School of Design in Manhattan. Divided into six teams, we were to review 1,315 entries each that first day as part of the preselection process. On Sunday, we were supposed to select the gold and silver medals—but more about that later.

I don't have to tell you that the Society of Publication Designers annual competition is not a scientific affair on par with the strict review process of the Food and Drug Administration. It's not a glamorous occasion either. The event is a no-frill/no-perk operation. All you get is a clipboard, a pencil, and a name tag. No speeches, no milling around, no fancy-schmancy coffee breaks. And please, turn off your cell phones.

Heck, you do the math. If the bleary-eyed jurors were to clock six solid hours to judge their share of the entries, they would have to look at 219 items per hour—at the rate of 16.2 seconds a pop. But if they were allowed to waste precious minutes socializing (gossiping with colleagues in hallways is so much fun), they would instantly fall behind. And before you know it, they would have less than ten seconds to glance at each piece submitted for their inspection.

Actually, the boot camp atmosphere of the event is designed to benefit the entrants. The work is assessed according to its eye appeal, as it is in real life. The judges are in the same exact conditions as readers perusing through rows and rows of publications at crowded newsstands. In this preselection process, we indeed judge books by their covers. There is no time for rationalizing the merits of the various elements on the page. And no time for turning the entry forms around to check who's the art director.

The process is not scientific, but, in the competitive context of our capitalist system, it's as fair as it gets. In other words, the process of elimination is cruel and ruthless. There is no room in it for "yes, but" or "considering that . . ." Not surprisingly, at the end of that first day, many of the judges have misgivings. Those who can still see straight find their way to the SPD party—a fabulous bash where they can socialize at last and release some of their guilt.

But there is redemption after all—on Sunday appropriately enough. The gold- and silver-medal selection process requires that on the second day you take your time to consider—and reconsider—the impulsive choices you've

made earlier. The jurors can vote to bring back entries that were eliminated. They can argue with the other members of their group to upgrade an award or demote an entry to a lesser status. They ponder. They negotiate. They laugh. And eventually they agree. An entry does not get a medal unless all six jurors support it.

As luck would have it, my group was made up of strong-minded individuals who were as articulate as they were obstinate. We all wanted to do the right thing by giving each contestant a fair hearing. While all the other groups had already packed their bags and gone home, we were still at the bargaining table, agonizing over which work was most praiseworthy. Geraldine Hessler, who co-chaired the competition, had to be called as a referee. We were bestowing too many gold medals, she insisted. Sternly, before leaving the room, she instructed us to be less generous.

At last, as the sun was setting over the frigid Manhattan skyline, we came to accept that not all winners can win the award they deserve. It was a lonely moment for sure. Yet, we all felt a great sense of pride. The quality of the work out there is simply amazing. Though we can only honor a handful of our peers, we all share the ultimate prize: We never stop trying to be better. Or, as Bride Whelan likes to put it, "Ain't we swell." And that's something we can all agree on.

# 09: Is It "Us" Against "Them"?

## Art Directing Editors: Four Brief Scenarios

### Steven Heller

If it is us against them, they will always win. Such is the reality of the editor/art director relationship. With few exceptions, editors are on the top of the masthead and art directors are below them. Editors run magazines and art directors serve editors. So rather than be "against" we should be "with" them. Otherwise the odds will always be against us.

As an art director, I've learned to art direct designers, illustrators, and photographers, but I also have had to, in a sense, art direct editors. This does not mean that I am the alpha-male in a creative relationship, but it does mean I must be willing to collaborate (and educate) in such a way that most of my creative intentions are fulfilled, while at the same time I satisfy the editor's priorities—and it is not always easy.

Sometimes the chemistry is volatile to the point of explosive when goals, aesthetics, and tastes are at odds. Other times respect by the editor for the art director allows delegation of responsibilities, with the understanding that the art director is cognizant of the editor's overarching concerns. Then a healthy give-and-take is possible. The late Henry Wolf, a legendary art director of *Esquire, Harper's Bazaar,* and *Show* magazines during the late 1950s and 1960s,

often explained in speeches at art directors' events how he and his editor, Arnold Gingrich, settled their minor disputes over editorial content. If Gingrich was vehemently against something running in the magazine, Wolf gave in almost immediately. Conversely, if Wolf was adamant, he recalled, "Gingrich would say: 'Henry, I don't like it, but you are the art director and if you do, go right ahead.'" Of course, this compromise had its limitations. After all, editors' preferences will usually take precedence, but in art directing an editor the goal is to find the best balance.

Editor–art director relationships come in many varieties. Obviously, no two people are alike, nor are their interactions with others. So each relationship requires different strategic plans, which is not meant to sound conspiratorial, but in any situation where authority is at stake viable strategies are useful. Although there are no definitive procedures in maintaining healthy relationships, there are common situations that by their very nature suggest certain approaches. Here are a few:

1. Young art director and veteran editor. Obviously, a seasoned editor will have acquired prejudices about design. In this relationship, the younger or neophyte art director cannot use "experience" as leverage, yet must nonetheless establish a climate of respect and trust. So never try to pull a fast one on the experienced editor, because, believe me, she knows all the tricks. Never try to doubletalk the editor, because it will end in anger and distrust. Rather, understand the editor's likes and dislikes and adapt your vision accordingly. This does not mean it is impossible to teach the old dog new tricks, but do so in a cautious manner. Never spring an unprecedented idea as a fait accompli. Discuss radical departures from convention beforehand. If this does not work, maybe the relationship is doomed. But remember this: if the editor hired you in the first place, there must be some positive chemistry, so build on that foundation.

2. Old art director and young editor. This relationship can be a little dicey. It is axiomatic that new editors want their own looks and often the art director is the first expendable employee during a regime change. But even if this is not the case, a young editor usually comes to a magazine with, well, young tastes. It is, therefore, essential for the art director to address and interpret and act upon those tastes and preferences, which can be the proverbial "rub" that produces the inevitable friction. In this case there are two alternatives: leave the magazine if said tastes are anathema, or stay and educate the editor on those points of design that you feel will be compatible with her vision. The key to art directing is being able to convincingly communicate intent and desire in a productive manner. Therefore, an older art director should never pull "age-rank" because it will simply agitate and antagonize—no editor wants to hear that they are "too young to understand." So use your experience to promote a dialog and apply your institutional memory toward building a healthy dependence on your talents.

3. **Young art director and young editor.** On the surface peer-to-peer relationships appear easier owing to shared cultural and social references. But an editor is an editor, and even this useful commonality is not always a guarantee for success. As long as the hierarchy is in place, the art director must be prepared to persuade the editor to accept design decisions that are beneficial to the both of you. This is accomplished through collegial communication. For starters, make no secret about your own enthusiasm for the magazine's content and how it can be greatly enhanced by your contributions. Make sure the editor gets as excited as you are about your choice of particular photographers and illustrators. And "astonish" (as Alexey Brodovitch used to say) the editor with your abilities, but do not surprise her with inappropriate solutions to editorial problems. Inexperience is often a conflict waiting to happen. Insecurity born of inexperience must be addressed early on in a relationship.

4. **Old art director and old editor.** This can be the most sublime of all relationships assuming the goals are one and respect for each other's abilities is accepted. It can also be the proverbial bad marriage. This vintage dynamic presupposes that both parties truly understand the other's wants, and act accordingly. While conflicts will still occur, the art director should know how to mitigate, ameliorate, and extricate. Disagreements between two old hands are to be expected, but in art directing the editor, the art director must be adept at arguing in an unthreatening manner. Ego plays an even larger role with experienced art directors and editors than neophytes, so be careful.

The above scenarios for art directors are just as easily applied to editors. A good one has to be skilled at "editing an art director." Again, this does not suggest master/slave domination, but rather respect for talent, skill, and boundaries. No art director wants to be viewed as a mere facilitator or messenger between editor and creatives; nor as a pair of hands that can be moved at will. From the art director's vantage point the best editor is an enabler who creates the environment in which to produce the best work. From the editor's vantage point, the best art director is an interpreter who, through design, typography, illustration, and photography, will make concrete the editor's vision. Art directing an editor is making it possible for that vision to be interpreted in the best possible way.

# Peacekeeping Tips: "Keep Them in the Loop," "Don't Be Vague," and More

## Sharon Okamoto

As former deputy art director at *Time* magazine, here are my personal tips for keeping the peace and working cooperatively with your creative staff:

• Don't be vague. Make sure your staff has clear-cut responsibilities.

• Good morale goes a long way. When you're happy at work and feel appreciated, you work harder with better results.

• Not everyone is a star and that's okay. Push people to work at the highest level they are capable of.

• Art directors should be good teachers. Don't get frustrated. Articulate why a layout isn't working so your designers will learn for next time.

• Don't let problems simmer. Get thorny issues out in the open. The problems may be more easily solved than you think.

• Everyone's entitled to a life. Cut down on stress. Keep your staff organized so people can go home at a reasonable end of the day.

. . . with your editors:

• Be articulate about your design choices. Avoid art-speak. Support your layouts with logical and journalistic reasoning.

• Pick your battles. Don't go to the mat for every disagreement. Save your strength for the biggies.

• Establish your role as a problem solver. "Make it red!" Ugh. Your editors will get better results if they instruct you on an editorial goal and let you solve the problem of visual presentation.

• Teach your editors about what you do. For instance, explain all that is involved in a cover shoot. At least they should know the complexity and cost of what they ask for.

• Keep your editors in the loop. Make sure your editor has seen all layouts and revisions and is aware of any deadline problems.

• Show examples of design that works. Showing strong layouts from other magazines can lead to good discussions about design.

• Provide options. If possible, show your editors that they don't only have one choice. You could always take a little from this one and a little from that one.

. . . with production:

• If you are going to complain about it, know how it works. Educate yourself about inks, paper, binding, etc. It's easier to fix a problem if you know the basics. Going on press, even just once, is a good idea.

• Have a point person on your staff. This quality-control person should communicate your concerns to the plant.

• Have scheduled meetings. Before the issue goes to press, meet to go over specific concerns such as color or inline problems. Once it is printed, have a post mortem.

# Cover Garbage: Who's to Blame?

## Steven Heller

The person or persons who invented magazine coverlines should be dragged out in public, stripped butt naked, and before being tarred and feathered, have this:

*Inside:*
*Special Report:*
*I Made Magazine Covers Ugly*
*Exclusive:*
*Page 2*

tattooed all over his and/or her body in Futura Condensed w/shadow and Lightline Gothic ranging in size from 12 to 72 points. This is a just retribution for their crime against magazines, because the ways in which coverlines are used today have done more to lower the aesthetic standards of magazine design than any of the other maladies affecting late-twentieth-century periodical publishing.

The coverline, also known as the "teaser" or "refer" (short for "referral"), is the headline on a front cover that announces—or sells—the lead story or entire contents of a particular magazine. With the venerable exception of the *New Yorker* (which prints its coverlines on flaps attached to newsstand copies only, so as not to impinge on the cover art, a practice it borrowed from the late *WigWag* magazine), every *commercial* magazine uses them in one form or another. Most are ill conceived.

Okay, not *all* magazine coverlines are grossly handled: *Metropolis*, for one, seamlessly integrates its refers into the overall design; *Atlantic Monthly* tastefully composes the few that it has so as not to interfere with the cover image; and *Rolling Stone*, though laden with an abundance, routinely changes typefaces to express the mood of the cover photograph. But these are exceptions to a convention that has turned the most valuable piece of editorial real estate into a waste dump of intrusive typography.

Fashion, lifestyle, and shelter magazines, like *Vogue*, *ELLE*, *Cosmopolitan*, *Vanity Fair*, *Traveler*, *Mademoiselle*, *Redbook*, *McCall's*, *Brides*, and *Better Homes and Gardens*, are among the worst offenders. Headlines crisscross their respective covers like scaffolding in front of a construction site, obstructing any possible effectiveness of the central image. But even worse, when displayed in magazine shops and on newsstand or supermarket racks, the critical mass of them form a typographic jumble that negates anything resembling a design standard. Whatever strategic benefit that might possibly be gained by having excessive selling copy on the front cover is invariably reduced to almost nil by the fact that most magazines are doing it.

The current practice of tightly squeezing as much hyperbolic verbiage as possible onto a cover started back in the late 1970s and early 1980s, when

former Condé Nast design czar, Alexander Liberman, ordered the designers of the fashion and lifestyle magazines under his powerful auspices to reject haute design in favor of techniques common to sensationalistic tabloids, like the *National Enquirer*. These tropes had already been adopted by underground press and punk publications. And in light of this, Liberman reasoned that fashion had become too frou-frou and required an injection of grit that could be accomplished through crass graphic design. Concurrently, marketing experts believed that coverlines would increase visibility and attract customers in a highly competitive field. In theory, the chaotic approach mirrored changing social attitudes; nevertheless the shift from the old to a new style—from elegance to controlled sensationalism—marked the first step in a devolution of commercial-magazine cover design from pure concept to advertising billboard.

Covers were once designed with emphasis on a strong image. In the 1930s, magazines like *Vanity Fair*, *Vogue*, and *Harper's Bazaar* didn't even use coverlines. When newsstand competition became more intense in the 1950s and 60s, coverlines were more common, but as a rule short headlines introduced a magazine's main theme or lead story, while possibly a few B-heads signaling off-leads were unobtrusively placed in a corner. When that balance between image and text shifted in the 1980s, the aesthetics also changed. Billboards composed of discordant typefaces dropped out of black boxes or primary color bands, mortised around photographs, and printed in nauseatingly fluorescent colors became the norm. Condé Nast's covers were routinely more cluttered than most, but its competitors sunk to the occasion by accordingly junking up their own. Coincidentally, as the overall size of magazines shrunk owing to higher paper costs, the quantity of coverlines grew. Even magazines that are not part of this genre, such as *Newsweek* and *Time*, have increasingly become more coverline dependent.

Once the die was cast, coverlines became a widespread "necessary" evil. Certain magazines have tried to be more tasteful than, say, *Vogue* or *Mademoiselle*, but with so many headlines to juggle even good design intentions are thwarted. On the whole, magazine covers are inferior to much of the advertising inside. Cover images are wallpaper against which headlines are surprinted, dropped out, and otherwise superimposed. As a consequence, commercial-magazine cover art and photography has declined precipitously, to the point where a startling (or even memorable) cover, like those George Lois conceived and designed for *Esquire* in the 1960s, are rare exceptions to the rule.

Another consequence is that coverlines, and therefore covers themselves, are decided upon by committees in the same way a broadsheet newspaper is planned out. With coverlines as the dominant component, editors aggressively vie to get their stories placed on the cover. The designer's role is no longer to solve conceptual visual problems, but to arrange or compose the type for maximum impact. But, even here, the job is often usurped by editors. A designer for a high-circulation style magazine, who requested anonymity,

describes one such cover approval procedure: "The cover subject is decided upon by the editor, usually a portrait of a celebrity who is hot at that moment. After the image is shot and selected, I am given a file of headlines in order of their importance, which I must then somehow lay out so as to highlight sometimes as many as three lead and three off-lead stories while retaining the integrity of the photograph. After I've managed to solve the puzzle, more or less to my satisfaction, the comp is invariably noodled to death with comments like: 'This headline is too large, this is not large enough. Why not use a color band here, or drop out the color there?' The bottom line is that the cover has to smack the reader in the eyes at the expense of design standards." While this designer acknowledges the challenge involved in trying to orchestrate so many elements, she nevertheless complains that rarely does it result in good design.

Of course, one can't blame coverlines (or their makers) for all the ills of periodical design. But the way that they have been used—the increasing number of them on magazines—has had a deleterious effect on entire magazine genres, as well as the designers that work on them. "And one last thing," adds the designer bitterly, "It is difficult to develop into a really good designer when what is acceptable is so poor to begin with."

# 10: When Is the Editor an Art Director?

## The Editor as Visual Freak: A *Paper* Manifesto

### A Conversation with Kim Hastreiter and Peter Buchanan-Smith
### Editor and Art Director, *Paper Magazine*

**An art director at a magazine is hired to contribute to the visual personality while expressing the editorial direction. *Paper* has had a strong visual persona prior to this.**

*Steven Heller: Kim, what do you expect from your new art director?*

*Kim Hastreiter:* It has been twenty years since my partner David and I started *Paper* with $4,000 in my Tribeca loft. Even in our very first issue, design innovation was a huge part of our magazine. (*Paper* was first designed as a broadsheet poster, art directed by the very talented British art director, Lucy Sisman.) I am personally a design freak and it has always been critical to me that *Paper* look innovative, break new design ground, yet always be designed brilliantly and functionally—which to me means that it would not only look amazing but also have humility as well as sparks of surprise and innovation, enough to compel the reader to stop, look, read, understand, and then want to go on to the next page.

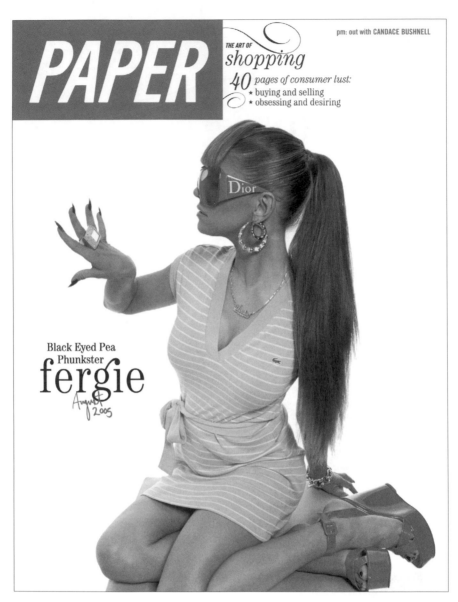

*Paper* cover, Fergie, August 2005; art director: PBS; typography: PBS; photography: Jessica Craig-Martin.

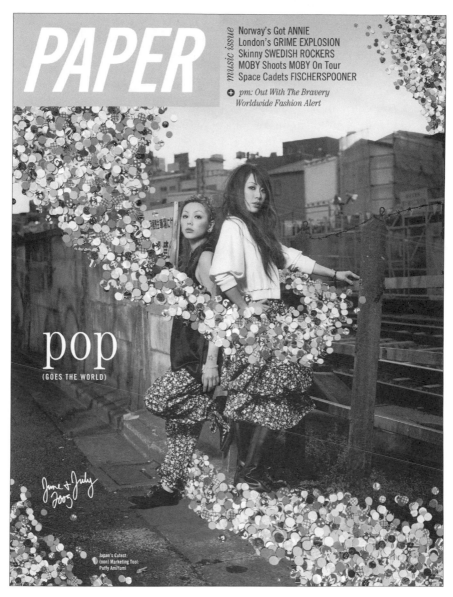

*Paper* cover, "Pop (Goes the World)", June/July 2005; art director: PBS; typography: PBS; illustrator: Brian Lightbody; photography: Danielle Levitt.

I expect our new art director to continue in this tradition by:

1. Communicating our editorial ideas and information clearly and stunningly. (It drives me crazy to see art directors whose design becomes more important than the content.) This means they must *read* the stories they are laying out. Type is not just "grey stuff."

2. Communicating elegantly and with beauty, thought, wit, and, most importantly: *style*. Although we are not a pure fashion magazine, *style* is what our magazine is really about at the core. Style with substance. We believe the two are not mutually exclusive.

3. Communicating our content with innovation.

4. My last thought is a bit unusual, as most editors and publishers are not necessarily visual freaks like me. But as I am a very, very visual person with very, very strong personal tastes, I need to be sure my art director is able to relate to my personal aesthetic, because if they clash with this, it will be very difficult. I expect my art director to be an advocate for my aesthetic. This is very personal to me. Although I am not an art director, I have very strong aesthetic opinions, which I also defend for my brand, and I would need to feel this affinity for any art director who would be taking over the visual direction of *Paper*. This doesn't mean they need to mimic me, but just to understand what I love and what I don't love, and work within that and even add to it as well. I am open to and love integrating someone else's ideas, but we need to be coming from the same visual universe or else it won't work.

We are not synthesizing our magazine for some demographic or audience. *Paper* represents us. We've always made it for ourselves. It represents our enthusiasm for stuff. So it has always reflected our own barometer of aesthetic, style, and content. I don't mean to say that I don't welcome new aesthetic choices, but I have very strong tastes.

How much of his job will be to maintain the franchise, and how much to expand it? We once did these star-shaped stickers that said, "Smells like *Paper*," "Feels like *Paper*," "Tastes like *Paper*." We'd plaster them onto stuff we liked. That is our franchise. We are eclectic enthusiasts. We separate the great from the mediocre. And *style* is the big umbrella for our brand.

Peter's job will certainly be to maintain the above. Many of us are by nature subversives and radicals here at *Paper*. We love to shock and surprise people and we also like to sometimes pull the rug out from under what we do. We like change. This is how we keep moving forward. We love to shuffle the deck. Every so often we will just move everything around in our magazine when things begin to feel dull. We have changed our logo every month for many years.

We are thrilled to have celebrated our twentieth anniversary this year but our new motto is that we need to think about *Paper* as if we were only "one year old" now. What a perfect time to refresh, change, and surprise people. We've always been leaders and we look forward to Peter's keen eye to take us to a new

place with a new package, new photography. One of the design challenges for Peter is he has not had a lot of experience working under such a strong "style" mandate. It was critical for me when I hired him to make sure he could deal with this as well as with our sometimes "lite" and humor-filled pop-cultural content. I also needed to make sure he would be able to deal with the business constraints of *Paper*. Our magazine is supported by fashion advertisers who are the core of our business. If we lose them, we lose our other categories of advertising who are "followers" of the fashion brands (like liquor, cars, beauty, electronics). The fashion business is largely based on "image" and aesthetic. Our brand will need to maintain a high level of design and a beautiful aesthetic that will continue to attract this business and hopefully grow it. We cannot change this part of our franchise.

### SH: Peter, What do you see as your role at *Paper*? How much of your job will be to continue the legacy, and how much will you change it?

**Peter Buchanan-Smith:** Luckily, I feel that Kim, David, and the people of *Paper* understand what I can bring to the table (on both a design and editorial front) and I therefore feel a real (and rare) freedom to perform the way I want to: as I've learned, it's easy for someone to say that they are hiring you because they like your designs, and another thing for them to be comfortable using those designs when it comes time to actually make them a reality. Because we're already visually in-tune, the first big hurdle has been conquered.

With *Paper*'s twenty-year legacy at stake, I don't want to create an entirely new magazine, rather build on its success and tease out its spirit. How that exactly will unfold will depend primarily on how quickly I can come to terms with the unique character of *Paper* (from the people that work here, to the printed word) and then interpret that visually. As big a challenge as this might be, it's reassuring to know that *Paper* is a place with real depth and true character.

### *Paper* is a magazine that addresses and promotes contemporary style, which means it must be ahead of the design curve.

### SH: Kim, how integral is the art director to identifying and presenting this contemporary vision?

**KH:** To me, the art direction is everything. I cannot bear the thought of aesthetic mediocrity in *Paper*. Peter's vision is modern and smart. Plus he has an elegant eye. I think this kind of modernity and intelligence brought to our readers with style will be new. We have always been leaders. We started this whole style/pop cultural magazine category in 1984 and look how many people followed us. We have never been afraid to change and lead. I can't wait.

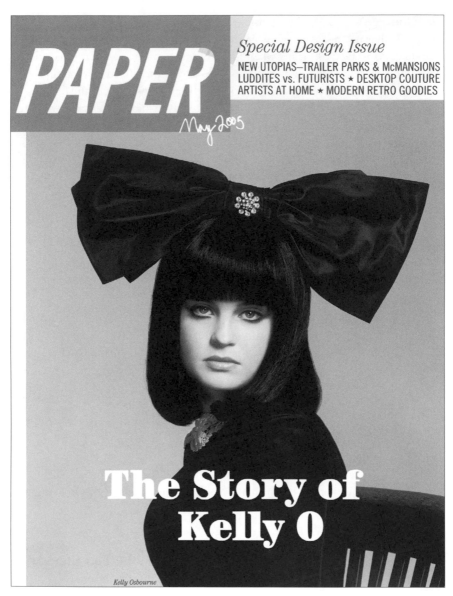

Within the image:

**PAPER**

*Special Design Issue*
NEW UTOPIAS—TRAILER PARKS & McMANSIONS
LUDDITES vs. FUTURISTS ★ DESKTOP COUTURE
ARTISTS AT HOME ★ MODERN RETRO GOODIES

*May 2005*

**The Story of Kelly O**

*Kelly Osbourne*

*Paper* cover, "The Story of Kelly O," May 2005; art director: PBS; typography: PBS; photography: Danielle Levitt.

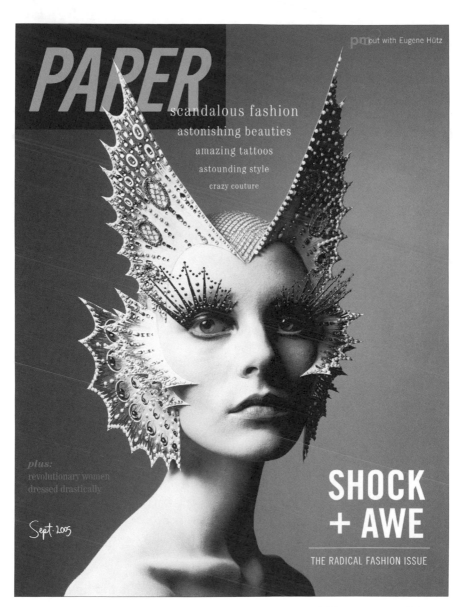

*Paper* cover, "Shock and Awe," September 2005; art director: PBS; typography: PBS; photography: Richard Burbridge.

*SH: Peter, how do you create a design environment that is unimpeachably contemporary, indeed ahead of the convention?*

*PB:* The answer to this is simple: be smart. This means working hard to understand the ingredients of what goes into *Paper* and having the sense and confidence to remove those ingredients that are spoiling the dish, and then adding new ones to give it more flavor. As I understand and take on the character of *Paper*, I hope that an honest sense of personality will be reflected in the creative direction. Most magazines are soulless, so for me an easy solution (but a difficult execution) is to create a *real* magazine that recognizes and challenges the reader's intelligence and imagination.

**Deciding on an art director is critical to a magazine. The right fit on both editorial and design sides is difficult.**

*SH: Kim, how do you determine how right the fit is?*

*KH:* For me in particular, as I am such a visual freak, this job is super critical. In searching for a new creative director, I had looked at hundreds and hundreds of books, bios, and portfolios and didn't like anything. One day, Peter dropped off a letter and a bag of his books and I jumped up and down. When I saw them, they spoke to me. They woke me up. It took *five* seconds for me to call him. I am very intuitive and live by my gut. I felt so lucky when Peter dropped in my lap. There was no question in my mind from the second I saw his work. I then needed to confirm our aesthetic compatibility, which I did by asking him to list his loves and dislikes artistically (artists, fashion designers, architects, furniture). I then told him mine. I needed to make sure he agreed with/appreciated my aesthetic.

I loved that he is a thinking person. As an art director, he is a truly editorial thinker, which is so unusual to find. He's someone who I think can contribute much more than just laying out pretty pages. He is a concept guy. He packages. He is smart and quirky, which I love. (We are all very quirky at *Paper*.) I am thrilled to have him become part of our team.

*SH: Peter, how do you know that this magazine is the right fit for you?*

*PB:* *Paper* has had to take the chances that no one else would take and had to be resourceful on a scale that most magazines can afford not to be. Now that they've just passed the twenty-year marker, and in light of the current media climate, I feel there's even more of an urgency to maintain these values, and it presents me with an extremely exciting challenge.

**Collaboration is essential at a magazine, but respecting expertise (if not turf) is key to a successful collaboration.**

**SH: Kim, what are the parameters of the Paper art director? Where are the contributions welcome and where are they not?**

*KH: Paper* has always been a vehicle for showing talent. We love to find brilliant, wonderful people and nurture them. We are collaborators at *Paper* and do not like to ghettoize people. We all contribute (and it is quite a cast of characters) but we will also defer in respect to each other's expertise. I have had my previous art director create better coverlines or write fabulous headlines. When this happens, we say thank you (not "this isn't your job"). To me, the best idea wins. It's not about who came up with it.

**SH: Peter, what are the parameters of the Paper editor? At what stage does your expertise supercede hers?**

*PB:* I feel like the parameters of everyone's position at *Paper* are elastic. Although we're each hard at work to fulfill the promises of our job descriptions, everyone is encouraged to have an eye on the larger picture and to contribute on any level at the right time and place. So far, my expertise supercedes when I can make the right case. Knowing that Kim has hired me for the right reasons makes me more at ease to stand firm and make my case and to likewise bend when I have to.

**Finally, all collaborations are based on certain standards of quality.**

**SH: Kim, what is the definition of a great art director?**

*KH:* A great art director designs and packages with elegance, power, scale, confidence, and wit. An even greater art director also thinks, reads, and strengthens existing ideas with visual power. A great art director for *Paper* can keep our brand ahead of the pack—they can create desire for it by making it fresh, provocative, surprising, and compelling. It is an abstract quality but people know when they see it.

**SH: Peter, what is the definition of a great editor?**

*PB:* A smart and trusting person with impeccable taste.

# The Woman Who Was *ELLE*: Hélène Gordon-Lazareff

## Véronique Vienne

Hélène Gordon-Lazareff used to say that women who understand how men look at them will spend all their life sipping champagne on sunny terraces. And indeed, *ELLE*, the smart-looking, weekly fashion magazine she created in Paris in 1945, showed war-weary French readers how to be that fantasy creature—the attractive and sympathetic woman men dream of meeting on the terrace of a chic resort hotel.

To capture this fizzy image on paper, Gordon-Lazareff, whose first name, Hélène, is pronounced "ELLE-n" in French, surrounded herself with men who were in love with her—and with female employees who adored her. Frank Horvart, a photographer who calls her "one of the most remarkable personalities in the magazine world," explains that there was almost no difference between *ELLE* and Hélène. "She identified with her readers to the point of never worrying about what they wanted, convinced that what was right for her couldn't be wrong for them."

Russian-born, pert and petite, Gordon-Lazareff was passionate about everything. "You have to love the people you are with," she used to say. "It's the only way to look natural." The "tsarina," as her staff called her affectionately, could only do well what amused her. It worked for her. She had an uncanny instinct for picking—or creating—the next star or the next trend. In 1947, she embraced Dior's then-unpopular New Look. In 1950, she launched Brigitte Bardot, still completely unknown, by featuring her on the cover of *ELLE*. In 1952, she hired Françoise Giroud, a dedicated feminist who later founded the French weekly news magazine *L'Express*, and became a prominent political figure. In 1958, she promoted Coco Chanel's comeback, even though, at the time, the French press snubbed the famous Mademoiselle. In 1965, she adopted designer Courrèges and his all-white futuristic vision. And week after week, she published articles by controversial female writers such as Colette, Simone de Beauvoir, Marguerite Duras, and Françoise Dolto.

I met Madame Gordon-Lazareff a couple of times in the early 1960s, when, as a high school student, I worked as a summer intern in the *ELLE* art department. I was mesmerized by her presence, much larger than her diminutive size, and by her ability to empower her entourage. The bright journalists, fashion editors, and designers who worked for her were brazenly opinionated (no one was ever fired for disagreeing with her), yet still flexible. On closing day, they almost relished the moment their tiny boss would walk into their office and say, with a glint in her eyes, "I've got a great idea: Let's change everything!" How could you argue with someone who had her finger on the pulse of one million readers?

"We all had a crush on her," says Peter Knapp, the Swiss artist and photographer who was art director of *ELLE* between 1954 and 1966, and who established the magazine's deliberately modern graphic signature. "She was intelligent, in touch with people and events, and a great judge of talent." She hired Knapp at a time when the magazine was a runaway success but needed revamping to keep up with the expectations of both readers and advertisers. "She had a good eye and knew that Swiss graphic design would be the defining style for the magazine," he explains. "She hated everything trivial, cute, and fussy—everything *kiki, coco, cucu,* as she used to say in slang." Trained at the famous Zurich art school, in the Bauhaus tradition, Knapp, with Gordon-Lazareff's support, developed for *ELLE* an elegant grid system, a restrained sans-serif typography, and a bold layout approach.

But she had another compelling reason for choosing Knapp as art director. "She could tell that I was a fan of the opposite sex—that I looked at women more than at their clothes," he says. "She wanted me to give her magazine the imprint of a straight man's sensibility." One of Knapp's contributions was to assemble a team of male photographers—David Bailey, Guy Bourdin, Fouli Elia, Robert Frank, Mark Hispart, Frank Horvart, Helmut Newton, Uli Rose, and many more—who extolled femininity as defined by men in love with women. Not surprisingly, the fashion spreads were upbeat, friendly, youthful, and seductive. "In the rarefied fashion context of the time," insists Knapp, "this was a revolution."

This strategy brought the weekly circulation of *ELLE* from 600,000 in 1954 to one million in 1960. One French woman out of six was a regular *ELLE* reader. I was one of them. I became dependent on my Monday fix—on this appreciative masculine gaze focused on my gender. Knapp's clean delivery made me feel smart, open-minded, and innovative. Seduced as I was by the heterosexual zest displayed on the fashion spreads, I never questioned the magazine's ultimate motives.

Knapp's smart cutting-edge design, while fostering a perception of avant-gardism, masked the subtle sexist subtext of the editorial message. How to attract and please a man was the driving force behind most of the articles. Keeping house, cooking, sewing, knitting, shopping, and taking care of children were celebrated. And though French people love to argue about politics, the magazine dodged the topic. In 1945, French women voted for the first time but the magazine's only comment on election days was to tell readers what to wear to the polls. And year after year it alluded to political events by describing in detail the wardrobes of the wives of presidents and heads of state. Under Françoise Giroud's influence, the coverlines and headlines often asked provocative questions, about everything from abortion to adultery—but the answers were always deeply conservative.

*ELLE*'s moniker was "The Magazine for Women Men Admire." (In French, there is a double-entendre: *Le journal des femmes que les hommes regardent* also

means "The Women's Magazine Men Admire"). Through the years, a growing number of men confessed that they indeed liked to flip through the pages of *ELLE* to "check the fashion." They got hooked, with most of them becoming fashion connoisseurs. To this day, in department stores and boutiques, French men routinely walk right into fitting rooms with their female companions to advise them on the choice of a garment—evidence of how comfortable they are with designer labels, styles, and trends, and how much women welcome their educated opinion. The best-kept fashion secret of French women is the fact that the men in their life, thanks to *ELLE* magazine, feel that they are part of the seduction charade.

Today, there are sixteen international editions of *ELLE* magazine, including Japan, Korea, and China, as well as Australia, Brazil, Italy, the United States, and Great Britain. With only a few exceptions, they all have adopted the original French graphic format as defined by Knapp almost fifty years ago. The magazine has become a global brand, with well-defined visual cues, such as bright white paper, cheerful color photography, lavish fashion spreads featuring models who are sexy, though not sexual, and clean, sans-serif typography. And most of the design rules so dear to Gordon-Lazareff are still respected. Namely: Never show a photograph without a caption. Never start a story at the bottom of a page. Never interfere with the readability of the text. And always use boldface for heads and subheads.

In the history of magazines, few founding editors have had such a lasting influence on their publication. Yet, when you call the public relations department of the New York office of Hachette Filippachi, the company that acquired *ELLE* in the early 1980s, and ask for press clips on Hélène Gordon-Lazareff, no one knows who you are talking about. In Neuilly, France, where the French branch of *ELLE* is headquartered, you have to spell her name three times over the phone before the head of publicity gets it. And when eventually you obtain permission to sift through old issues of French *ELLE* in the cramped research library, the nice lady at the desk assumes that you are a graduate student working on some obscure Ph.D. thesis.

Why is the tsarina so completely forgotten? Why is no one interested in who she was—her persona, her spirit, and her contribution? Could it be that folks who run *ELLE* magazine today are simply jealous? Indeed, when Gordon-Lazareff officially retired from the magazine in 1972, the weekly circulation was still a cool million. By the time she died of Alzheimer's disease in 1988, it had dropped to a mere 370,000. To understand why such a talented woman is today cast as a non-entity, I decided to dig through her personal life in search of an answer for such a willful omission.

Hélène Gordon was born in Russia in 1909 into a well-to-do Jewish family. Her father, Boris Gordon, a sophisticated man who loved the arts, owned a prosperous tobacco company, a small theater, and a literary newspaper. The rich little girl was raised by a British nanny, who taught her to speak English. Thanks

to Miss Woodell, Hélène, years later living as a refugee in New York during World War II, was able to adapt effortlessly to the American culture, even getting a job as a reporter at the *New York Times*. Though Slavic by birth and temperament, she was forever under the spell of all things Anglo-Saxon.

In 1917, at the onset of the Bolshevik revolution, the Gordons fled to Turkey. Eventually they ended up in Paris, their wealth somehow intact. Both intelligent and frivolous, Hélène thrived in the White Russian milieu of the French capital. Spoiled by her parents, she manifested early on a pronounced taste for expensive clothes and adoring young men. Naturally self-confident, she felt nothing was impossible. As an adult, she kept this fearless outlook. "She sincerely believed that women were equal, if not superior, to men," remembers Knapp. "That's why she wasn't much of a feminist. She never understood why women wanted to fight for something they already had."

A brilliant student in high school, well-read in French, English, Russian, and German, Mademoiselle Gordon entered the Sorbonne after graduation to pursue a degree in ethnography. In the midst of it all, she managed to get married, have a child, get divorced, and go on a mission to Sudan, in Northeast Africa, to study the life of the Dogons, one of the last primitive tribes of the Sahara. According to Denise Dubois-Jallais, a poet who worked at *ELLE* as a journalist, Hélène Gordon perfected in the African desert the observation skills she used later when deciphering the manners and idiosyncrasies of French culture. In "La Tzarine," the only published biography on Gordon-Lazareff, author Dubois-Jallais writes, "All the elements of her brand of journalism were in place. To listen. To go see for yourself. To note the details . . . To see the big picture . . . To be precise. Not to jump to conclusions . . . To work as a team. Never to take no for an answer. And to be ready to revise your world's view, if need be."

Upon returning from her African expedition in 1936, Hélène Gordon met her soon-to-be husband, Pierre Lazareff, a young and talented journalist who ran *Paris-Soir*, a progressive evening newspaper. Though born and raised in Paris, he was a Russian Jew like her. But more than their origins, what they had in common was a ferocious ambition. It was love at first sight—a love that lasted all their lives, although their sexual intimacy was short-lived. In the French tradition, they stayed devoted to each other in public and private while having affairs—with Hélène flaunting lovers too numerous to be counted.

In 1940, with France defeated by Hitler, Hélène, with her new husband Pierre and her daughter Michèle, then ten years old, escaped to New York. Fluent in English, she quickly found work, first at *Harper's Bazaar*, where she met Diana Vreeland and legendary art director Alexey Brodovitch, and at *Vogue*, where she was exposed to the formidable Carmel Snow. These American editors became her role models, though she liked to tell that she learned her métier and paid her dues as a journalist at the night desk of the *New York Times*, where she was in charge of writing and editing the women's page.

Pierre Lazareff, so articulate in French, never managed to overcome the language barrier in the United States. While his wife was busy absorbing the finer points of fact-checking (a practice still unknown today in France), he frittered time away with other illustrious French refugees, among them Antoine de Saint-Exupéry, author of *The Little Prince*. The painful discrepancy between their careers only deepened the gulf between them. While Hélène was walking down Broadway, developing in her mind the format of the women's magazine she would launch in France as soon as the war was over, Pierre, on the edge of despair, was considering suicide.

In 1944, as soon as Paris was liberated, Pierre was back in his hometown. In no time, he was his old self again, as editor-in-chief of *France-Soir*, the postwar incarnation of the progressive evening paper he had created in 1935. From 1944 to 1972, when he died of cancer, he remained one of the most respected men in French journalism, the big boss of the most popular French daily paper. "The first duty of a journalist is to be read," he used to say. The *France-Soir* office, in the heart of Paris's garment district, at 100, rue de Réaumur, is now a landmark, with the small alley in front of the building named after Pierre Lazareff, a man remembered for using his considerable charm and intelligence to get the story first.

To convince his wife to leave New York and join him in Paris, Lazareff quickly raised money for her to start the magazine of her dreams. He made room for her on the fifth floor of the *France-Soir* building, setting the stage for what would become the most talked-about his-and-her journalistic venture: Pierre and Hélène; the newspaper and the magazine; the couple that literally *made* news.

Before leaving New York, Hélène Gordon-Lazareff arranged to have the first fifteen covers of *ELLE* shot by American photographers, with color film she knew was not available in Europe. "She was the first to master color photography, still unknown in France," said Françoise Giroud. Color photography—with models wearing bright outfits and vibrant accessories—is still the trademark of *ELLE* magazine. As the French saying goes, "When there is color, there is life."

The first cover of *ELLE*, an instant success at the newsstand on Monday November 21, 1947, featured a sophisticated blond model in a chic, bright red, fitted, military jacket, sporting a top hat and an amused smile on her face: In her arms, she is holding a squirming calico cat. Unexpected and charming, the photograph was quintessential *ELLE* style: not a look, but an attitude. More dash than cash. High fashion made accessible to the woman in the streets.

"Hélène never made women feel inferior," says Frank Horvat. "In contrast, most fashion magazines today, including *ELLE*, are too clever. They give readers the impression that they are not good enough—too fat, too old, too uncool, too outmoded, too this, too that."

Antoine Kieffer, who worked with Knapp at *ELLE* in the late 1950s before going to *Marie Claire*, agrees. "The editorial content was people-oriented. Hélène liked to give parties. Her magazine was like her parties: done with flair, with everyone mingling and having a good time."

In France, *ELLE* is still a weekly magazine, "but it looks like a monthly," says Knapp. "It's no longer spontaneous. There is too much second-guessing. It has retained the clean graphic signature of the early days, but the message is not what Hélène would have called feminine."

Hélène Gordon-Lazareff slipped into oblivion long before the end of her life. Already, in 1968, during the student revolt in Paris, she showed signs of memory loss. Maybe the unrest in the streets reminded her of how she was forced to flee Russia in the middle of the night in 1917, and how, again, in 1940, she had to escape hastily to save herself and her family. By 1972, she was a mere shadow, wandering aimlessly in the hallways of the magazine she had created as her alter-ego. People couldn't help but remember the two-line poem French surrealist poet Philippe Soupault, one of her many talented lovers, had written for her in 1930: "Little me, little smoke/And oblivion in a wool dress . . ."

It would be a sad story indeed if it wasn't for all the women happily sipping champagne on sunny terraces. Take my word for it: there is nothing like it.

# Art Paul: Branding Hugh Hefner's Playboy
## Steven Heller

For the generations weaned on feminism and political correctness, *Playboy* magazine is a throwback to the Stone Age. But when it premiered in 1953, it was a breakthrough in an ossified culture. *Playboy*, in turn, enabled men to experience the sexual side of life unfettered by stultifying postwar mores and preemptive censorship that made nudity unsavory and sex taboo. Even *Esquire*, the first men's "lifestyle" magazine, which began in 1938 and published sultry pinup drawings by Petty and Vargas, had lost its bite after World War II. Which is why Hugh Hefner, who had briefly worked in the promotion department of *Esquire*, decided to invent a publication that would radically change the form and content of magazines, and in the bargain would incite something of a cultural revolution—the *Playboy* revolution.

*Playboy* was based on Hefner's belief that men had the right to be, or fantasize about being, libidinous rogues who listened to cool jazz, drank dry martinis, drove imported sports cars, maintained hip bachelor pads, and felt good about themselves in the bargain. Through the magazine, he contrived a culture that encouraged hedonistic and narcissistic behavior on the one hand and social and political awareness on the other. But Hef, as he was known, did not accomplish this alone. In fact, his message would not have been so broadly accepted (with a high of over seven million paid circulation) if not for *Playboy*'s innovative graphic approach. Therefore, the magazine's format, typography, and illustration must not be underestimated in the calculus of success, because with so much riding on *Playboy*'s premiere (Hefner invested his last dime and used his furniture as collateral to raise the initial $8,000), if it looked the least bit tawdry—like some nudist magazine—the project would have been doomed.

Moreover, if Hefner had not enticed former Chicago Bauhaus (Institute of Design) student Art Paul to become the magazine's founding art director, it is possible that *Playboy* could have languished in a netherworld between pulp and porn. At the time that Hef was introduced to Paul, an illustrator and designer with a small office under the elevated subway on Chicago's Van Buren Street, the magazine was titled *Stag Party* (after a 1930s book of ribald cartoons titled *Stag at Eve*) and the initial dummy (designed by cartoonist R. Miller) looked like a movie star/screen magazine with cheese-cake photos and puerile cartoons (a few of them drawn by Hef himself). It was not, however, what Hefner wanted.

"I was looking for a magazine that was as innovative in its illustration and design as it was in its concept," recalls Hefner, who studied art at the University of Illinois. "We came out of a period where magazine illustration was inspired by Norman Rockwell and variations on realism and I was much more influenced by abstract art of the early 1950s and by Picasso. I was looking for

something that combined less realistic and more innovative art with magazine illustration. The notion of breaking down the walls between what hung in museums and what appeared in the pages of magazine was very unique at that time and it was what Arthur was all about."

Art Paul was born in Chicago in 1925 and studied with Moholy-Nagy at the Institute of Design from 1946 to 1950. He was initially reluctant to join the fledgling magazine because he had a child on the way and needed security that he did not believe was possible with anything as speculative as this. But Hefner seduced him with promises. "He kept offering me stock and things of that nature," Paul recalls. "But the way he spoke and his enthusiasm was more convincing; he reminded me of the great dedicated publishers." The stock was a nice gesture, but the assurance of freedom to take chances in designing the magazine was decidedly more tempting. Paul agreed to do the first issue on a freelance basis, and ultimately signed on for the next thirty years (and yes, he was glad to have taken the stock).

The original inspiration for the magazine, says Hefner, came from the *New Yorker* of the 1920s and *Esquire* of the 1930s. "I was very much influenced by the roaring twenties, Jazz Age, F. Scott Fitzgerald. I thought that it was a party that I had missed." Since Hefner was raised in a typically Midwestern Methodist home with very puritan parents, "I believe that my life and the magazine were a response to that, and a direct reaction to the fact that after World War II, I expected the period to be a reprise of the roaring twenties. But it wasn't. It was a very politically and socially repressive time. Even the skirt lengths went down instead of up, which I saw as a sign. So the magazine was an attempt to recapture the fantasy of my adolescence."

Paul bought into Hefner's concept, but he was put off by the *Stag* title and suggested that the name be changed, which Hefner did weeks before going to press, and only after *Stag*, a hunting magazine, threatened legal action for infringement. "We made up a list of names that suggested the bachelor life," Hefner explains. "*Playboy* was in disuse at that point and reflected back on an earlier era, particularly back on the twenties. I liked that connection." So, with this detail out of the way, Paul proceeded to develop a format that reconciled nude photography with the sophisticated fiction and nonfiction that became hallmarks of the *Playboy* formula. For Hefner, *Playboy* was a mission to influence the mores, morals, and lifestyles of men; for Paul it was a laboratory that turned into a model of contemporary magazine design and illustration.

The deadline for the first issue was excruciatingly tight because it needed to get on the newsstands before creditors came banging at Hefner's door. So, for the first issue Paul cobbled together what he now calls "a scrapbook" of things to come. "I took on the challenge in broad strokes," Paul explains. "I said to myself, 'This is a men's magazine; I want it to look masculine. I want it to be as strong as I can make it.' But I had tremendous limitations with the printing— the printers were doing us a favor by fitting us in. I was very limited in the

number of typefaces and ended up using Stymie." Nonetheless, the slab serif Egyptian was a perfect fit, being quirky yet bold. It worked well as a logo, not too overpowering yet not frou-frou. For the interior of the magazine, Paul employed white space to counterbalance the limited color availability of the first few issues.

The cover of the premier issue was the most critical decision that Hefner or Paul had to make. Only two colors were available, which could have been a real handicap. But conceptually, nothing could be more seductive than the photograph of Marilyn Monroe (a press photo of her in a parade waving to the crowd, which Paul silhouetted) next to the headline:

> "First Time in any magazine
> FULL COLOR
> the famous
> MARILYN MONROE
> NUDE."

Hefner obtained the centerfold photograph from the John Baumgart calendar company, which supplied various nude photographs, including one of Marilyn Monroe before she became a sex goddess. Hef bought the original transparency, color separations, and the publication rights for a couple hundred dollars. As for the absence of multiple colors on the cover, Paul explains that it was a problem that turned into an asset: "I was trying to figure out how in the world I could get a magazine that was in no way publicized to be seen [by readers] on the newsstands. So I looked at magazines in a way I never had looked before. I found out how ours would be displayed, and I saw the other magazines it would have to compete with. Most used big heads and a lot of color and type. I felt that ours would have to be simple, and so using the black-and-white photo with a little red on the logo was a plus because it stood out no matter where it was displayed."

Paul initially wanted the logo or nameplate on the cover to be small and in a variable rather than fixed position, which meant he could move it around as though it were a puzzle piece. Years later, however, it was locked in at the top. Today Paul says that "some of the more innovative covers happened in the early years," when he could freely use the logo as a conceptual element—and when he had more conceptual license to manipulate the models. Much like Henry Wolf's *Esquire* covers of the late fifties, Paul's *Playboy* covers were driven, not by licentious half-nude women, but by witty ideas and visual puns, which included its trademark bunny. Paul based all his cover concepts around different ways to inject the bunny into the design. Covers became games that challenged the reader to find the trademark wherever it was hiding—tucked in a corner, placed on a tie clasp, or fashioned from the legs and torso of a cover model.

Hefner or Paul could not have predicted how world famous the rabbit would become. Hefner wanted a mascot from the outset: "*Esquire* and the *New Yorker* both had male symbols [Esky and Eustice Tilly, respectively]. So the notion of having an animal as a male symbol was a nice variation on the theme. The notion of putting a rabbit in a tuxedo seemed kind of playful, sexy, and sophisticated." The initial version was a stag drawn by R. Miller, which for the first issue was quickly transformed by pasting the head of a rabbit onto its body. "If you look at it, the rabbit has hoofs," says Hefner. Paul's then wife made a nascent bunny out of fabric for a cover. By the third issue, Paul's original drawing of the bunny in profile is what became the "empire's logo."

From the outset *Playboy* touched nerves. Despite the predictable moral outrage in certain quarters, a large number of men (and an untold number of adolescent boys) flocked to the sign of the bunny. Yet Paul argues that while sex was a significant part of the entire package, it was not a sex magazine per se. He saw *Playboy* more as a lifestyle magazine, or as the subtitle said, "Entertainment for Men." Hefner wanted to present sex as a common occurrence, not a prurient taboo. This was accomplished by doing photographs exclusively for the magazine, rather than buying them through stock providers.

"By the later part of the first year, I began to do my own photographs," states Hefner, who oversaw all the early photo sessions. "The first centerfold was in the December 1954 issue, but it was early in the following year when we got what I was looking for, a natural setting that looked less like a calendar. Arthur played a role but the concept was mine." The important breakthrough came in shots of Janet Pilgrim, *Playboy*'s subscription manager, who Hefner was dating at the time. In the picture, Hef is in the background in a tuxedo with his back turned, while Pilgrim prepares herself at the vanity powdering her nose for a date. "I was trying to personalize it," says Hefner about the notion that nudity had to be connected to "art" or be considered obscene. "That's why the classic pinup art prior to that, including our Marilyn Monroe nude, were shot in abstract settings—they were considered art studies. So what I was trying to do was to make them real people and put them in a real setting so that the nudity meant something more, it was a projection of sexuality. It was that nice girls like sex too, sex was okay."

Paul's contribution to the photography was to inject simple male-oriented objects, like a pipe or slippers, in order to underscore a human element—or to give the girls "a smell," as the painter Richard Lindner once said about *Playboy*'s photography. But Paul insists that he was less interested in nudes than the other aspects of the magazine, where he made a more meaningful impact as an art director. This included feature-page design and illustration.

Paul's first love was illustration, which he practiced in a minimalist and surrealist fashion. He says as a child he savored "the pure magic of the 1920s and 30s [illustration], which idolized the familiar and romanticized the positive side of America." He admired both Norman Rockwell and Michelangelo but

admits a preference for the former, reasoning that "fine artists like Michelangelo were in dusty art history books but the commercial illustrators like Norman Rockwell were on the shiny new covers of the *Saturday Evening Post*." As Paul became more professionally attuned, he was increasingly perturbed by the distinctions made by critics between fine and applied art, which reduced illustration to uninspired formulas. "I felt that both the fine artist and commercial illustrator had their lasting qualities. I never liked the way schools refused to place the so-called high and low art under the same roof. It annoyed me to think that illustration art was considered a lesser form of expression because it was paid for by a publisher instead of the Church of Rome." When he became art director of *Playboy*, Paul had a plan to change the prevailing view.

"To implement a closer relationship between 'high' and 'low' arts," Paul noted in the catalog for "*Playboy* Illustration" (Alberta College of Art Gallery, 1976), "I hoped to free myself from early concepts of the literal illustration and to commission pictures that needed no captions: I asked the commercial illustrators to create moods, not just situations, in their art and to work with various materials to create these moods, often forsaking painting for a construction or a collage or a photo-art combination. I asked them to be more personal in their work." Paul further commissioned "fine" artists to do what came naturally to them, offer personal interpretations. The marriage of the commercial and noncommercial artists' work gave *Playboy* a uniquely progressive edge among most publications at the time. Hefner notes that, "While we were doing and after we did this, Andy Warhol did almost the opposite of that: He took commercial art and turned it into fine art, and we took fine art and turned it into commercial art."

*Playboy* art was resolutely eclectic, ranging from minimalist to maximalist, and drawing from surrealist, pop art, and post-pop schools. The fine art alumni included such known painters and sculptors as Salvador Dalí, Larry Rivers, George Segal, Tom Wesselman, Ed Paschke, James Rosenquist, Roger Brown, Alfred Leslie, and Karl Wirsum. And Paul frequently published (and boosted the careers of) many top commercial illustrators, including Paul Davis, Brad Holland, Cliff Condak, Robert Weaver, Don Ivan Punchatz, and Tomi Ungerer, to name a few of the artists from the more than three thousand illustrations Paul had commissioned. Yet the art was not ad hoc; Paul provided tight layouts and parameters wherein the illustrator had to work. With these confines, though, freedom was granted, and the art played a truly supplementary role that earned the respect of reader and writer alike. In the catalog, "Art of *Playboy*: From the First 25 Years" (*Playboy*, 1978), *Playboy* authors were invited to comment on the illustrations that accompanied their own articles. One such about Brad Holland's drawings for a humor piece by P.G. Wodehouse was typical: "I find it rather difficult to pin down my feelings about those illustrations to my 'Domestic Servant' piece," wrote Wodehouse. "My initial reaction was a startled 'Oh, my Gawd!,' but gradually the sensation that I had

been slapped between the eyes with a wet fish waned, and now I like them very much. I was brought up in the school of the *Stand Magazine* and the old *Saturday Evening Post*, where illustrations illustrated, but I am not sure I don't like this modern impressionist stuff better."

Another innovative contribution was the manner in which he used illustration as "participatory graphics," which involved artwork in various forms and shapes printed as die cuts, slip sheets, and other surprising inserts. One of the few magazines Paul emulated was Fleur Cowles's *Flair,* which employed ambitious die cuts to enhance editorial content. Hefner concurs that *Flair* and also *Gentry*, a short-lived fifties men's style magazine, were great influences. Like them, Paul wanted an illustration to do more than lie on a flat surface, so he employed cinematic narratives using fold-outs and fold-overs to either give the illusion of motion, or shifting perspectives, or, like an advent calendar, reveal hidden messages. "I didn't misjudge Hef in that area at all," Paul says about the promises made to him, "because when I came up with ideas like that, he was very willing to spend quite a bit of money on it." For Hefner the benefits were all his: "My relationship with Art was a postgraduate course for me in art and design."

To support these ambitious special effects, Paul developed a feature-article format that, although based on a strict grid, allowed for numerous variations and surprises, including a wealth of contoured type treatments and other typo-image experiments. The nineties was known for experimental tomfoolery but during the sixties and seventies Paul was in the forefront with his experimental use of artwork and paper effects, which doubtless has had an influence on today's magazines.

Yet to separate Paul's design from the effects of *Playboy*'s overall message is to ignore an important part of the story. For many, the sign of the bunny continues to represent the objectification of women that perpetuated an unhealthy attitude and contributed to their exploitation until the sixties, when the women's liberation movement began raising consciousness. Indeed *Playboy* overtly encouraged sexist attitudes toward women for years to follow. Hefner does, however, argue that in addition to affixing cottontails and rabbit ears on fetching women, *Playboy* offered a more balanced cultural diet. *Playboy* published exemplary writing and in-depth interviews with cultural, social, and political figures; certain of the "*Playboy* Interviews" not only broke barriers, but they broke as news—for example, President Jimmy Carter's candid "lust in my heart" response to a question about whether he had ever physically cheated on his wife, which caused a furor at the time, but showed that even Presidents had male fantasies.

Hefner titillated through *Playboy*'s photography (which often presented women in the same stylistic guise as cars and mixed drinks) and educated through articles that addressed societal issues and the *comedie humaine*. In the fifties and sixties, *Playboy* was viewed as contraband for what in today's media environment would be described as no-core pornography. Which is why Paul believed that good art and design was one way to imbue the magazine with a

certain kind of legitimacy, which had the dubious effect of sanctioning the sexism within. At the same time he also pushed the limits of visual art. Paul's job was to integrate the editorial and pictorial in such a way that the reader did not experience disruption from one realm of content to another, and perhaps led them to realize that *Playboy* was not concerned with sexploitation alone.

Speaking about his role in developing the *Playboy* stereotype of plastic women Paul admits, "I didn't have any guilt feelings about it. But I thought it could be much better, and I either didn't know how to do it, or didn't have the people who knew how to do it." He did, however, take some photographs himself that were much more artful, which he describes as "designy nudes"— portions of bodies, like one of a nude foot with a high heel dangling off the end of it. "Ultimately, I wanted strong images," he says. "But I was also concerned about being sensual." In the final analysis, though, *Playboy* merely raised the level of the pinup a few notches.

During the thirty years of Paul's tenure, *Playboy* grew into a major entertainment corporation, with the magazine being only one piece of the empire. If he had not already taken the magazine as far as he could by that time, the ever-constricting corporate bottom line was infringing on his creative work, and was impetus for his decision to retire. "I wanted to leave the magazine two or three years before I did," he says. "Because, I got to the point where there was nothing more that I would be allowed to push." *Playboy* Enterprises was hiring a lot of new executives, notably Christie Hefner, Hefner's daughter, who earlier had worked for a couple of years as a summer intern in the art department, and who was now one of the cost-cutters. Hefner, who had left Chicago for Los Angeles, heard about Paul's plan to leave, and asked him what he would want to stay on. Paul really wanted to paint (and subsequently had a few gallery shows of his work), but Hefner insisted on making accommodations. So Paul told him, "I couldn't stand *Playboy*'s TV ads, and to appease me he let me do ads." Paul found it "interesting" for a while, "But as far as the magazine was concerned, I was not that connected with it at all." Nonetheless, Hefner insists that today, "The editorial concept and design of the magazine, even though it has evolved since the seventies, was and continues to be defined by Arthur Paul."

Paul, who now devotes himself to painting, is still something of a controversial figure. When he was asked to speak about his design at the AIGA Conference in Chicago in 1991, a few women designers protested on the grounds that *Playboy* created negative stereotypes and false notions of beauty. They claimed that Paul was complicitous in his role as art director, an argument that continues to ignite debate. Yet such criticism must be measured. For in the fifties and sixties many of the most editorially progressive periodicals included sexual material. Yet even *Playboy*'s imitators, such as *Rogue*, *Swank*, and *Cavalier*, gave opportunities to designers and illustrators (some of them women) that were not available in other media, and helped establish their reputations. Paul's legacy is not just a sexploitative bunny, but a forum that demolished both artistic and cultural boundaries.

# Mind Over Emotions:
## *Martha Stewart Living*'s Secret Codes
### Véronique Vienne

On the cover of her magazines, Martha Stewart could turn a short list of words into a Dada poem on a par with one by André Breton.

"an autumn river party / halloween lanterns / the evolution of tables / making bread / organizing recipes / marzipan"

"lilacs / lunch in harlem / wine 101 / personal stationery / shelves / wreaths & garlands"

"canopies / perfect burgers / backpacking in Wyoming / arranging flowers / low-fat frozen desserts / berries"

A caterer by profession, Stewart knew how to create memorable table settings or bouquets with a few simple things—found objects, ribbons, party favors, flowers, or fruits. When she became a magazine editor in the early 1990s, she was able to translate this talent on paper, making whimsical word-and-picture arrangements the same way she had decorated buffet tables or designed centerpieces for wedding receptions.

Over the next decade, Martha Stewart—with her loyal staff of editors, stylists, and designers—kept arranging and re-arranging words and images on the pages of her magazines (*Martha Stewart Living, Weddings, Kids, Babies, Everyday Food*) and catalogues, inventorying in the process every household object, every product, every decorative item, and every kitchen implement known to man and woman. A monumental undertaking in hindsight, it amounted to nothing less than the full compilation of every American domestic fantasy at the end of the twentieth century.

Martha became the patron saint of small things. Things like buckwheat pillows, cinnamon candles, marshmallow snowflakes, rickrack borders, taffy twigs, cranberry wreaths, sugar flowers, citrus coolers, baguette flatware, trumpet vases, leaf tags, wine journals, pet gifts, and miniature cupcakes. Things she would christen "good things" by naming them with that uncanny flair for words that was as much part of her genius as her ability to make a perfect raspberry-swirl cheesecake or turn a garden gate into a headboard.

Eventually, though, all good things must come to an end. For Martha Stewart, the end was cruel, swift, and unwonted. Her crime—allegedly lying to the government about a shady stock sale—had been minor. The sentence—a four-month prison term—was unexpected. But most devastating was the fate of the good things she had created. What would happen to the flower seed packets,

the ribbon organizers, and the pinecone garlands she had helped turn into cultural icons?

Encyclopedic endeavors like the compendium Martha Stewart had unwittingly assembled have always been fraught with controversy. Because they attempt to create complete systems of learning, encyclopedias are ambitious projects that are inevitably skewed. As such, they generate differences of opinion and elicit criticisms from both lay people and experts. This is the reason Martha Stewart was not universally popular—and was harshly judged by the members of the jury who eventually convicted her. What offended most people about her were not her coy views on domesticity (as annoying as they were at times), but her implicit assumptions about the "good things" she had championed.

Coincidentally, the most famous of all encyclopedists, French philosopher Denis Diderot, editor and contributor of the *Encyclopédie* (first published in 1751), was also convicted and sent to jail for three months. His crime? To uphold in his writing a secular approach, one that promoted tolerance and open-mindedness over faith and religion. In the mid-eighteenth century, in what was the dawn of the Age of Enlightenment, a "rational dictionary," as the encyclopedia was also called, was considered a daring expression of materialist atheism.

Today, Martha Stewart's decidedly secular approach is what got her in trouble as well. Like the eighteenth-century French intellectuals who penned the *Encyclopédie*, she too promoted reason above emotions, encouraging her readers and television viewers to embrace a methodical rather than a spiritual approach. Her how-to tutorials, conducted with no-nonsense precision, made no room for human errors. Impatient with all foibles—notably with the foibles of her employees—she had garnered a reputation of being a harsh perfectionist. During her trial, her reliance on alleged facts rather than contextual perceptions further damaged her case.

Martha's distrust of sentimentality was probably her greatest originality—a critical factor in her downfall, but also the reason for the success of Martha Stewart Living Omnimedia, her media empire. She perfected this dispassionate style on the covers of her magazine in the mid-1990s. During this period, she practiced amazing linguistic restraint at the newsstand. Instead of using expressive coverlines, as one would expect from a mass-market publication targeting women, she eschewed all calls to action. She was so intent on minimizing excitement that she never encouraged readers to do anything—even though the magazine was supposed to profess a do-it-yourself approach. There were never any verbs on the covers. Never any imperatives. Nothing stated in the declarative form. Gerunds, grammatical constructions that indicate that the action is uncompleted, were the only permissible forms of engagement. In the controlled universe of Martha Stewart Living, everything seems to happen in slow motion, with words like stuffing, arranging, carving, organizing, growing, wrapping, entertaining, nesting, painting, and decorating repeatedly used as nouns.

Featuring minimal word collages in the surrealist manner—"magnolias / foraging / egg decorations / furniture screens / a greek easter dinner"—the magazine covers also made a minimal use of color. Keeping the lid on emotions was a palette of subdued colors dominated by hypnotic pastel tones. More often than not, a soothing greenish hue, the archetypal Martha Stewart color, added a note of placidity to the already cool overall picture.

Once, in the May 1999 issue, I noticed a verb in the active voice on the cover of the magazine. Though it was a discreet "Make it yourself" next to a photograph of an ice cream sandwich, I was startled. What? Is Martha tampering with her message, I wondered? Is she buckling under pressure from investors who want her to relinquish some of her authority and "empower" her readers instead? I had always admired Martha Stewart's flawless determination to keep total control over her product. The woman knew exactly what she was doing and why. She gave her audience small, tidy, and concise epiphanies that did not require any personal initiative, and thus did not create any undue anxiety. In my estimation, the "Make it yourself" admonition on the cover marked a drastic departure from the magazine's initial editorial position—one that proclaimed that Martha Stewart was the only person who had the authority to make anything happen.

I was relieved to find out that the "empowering" experiment was short-lived. In subsequent issues, coverlines never again exhorted readers to take initiatives—at least, not to my knowledge. Showing a genuine understanding of the deep insecurities that motivate shoppers to spend an extra $4.75 at the checkout counter for an issue of her magazine, Martha focused her attention back again on what she did best, which was to create month after month a visual glossary of the contemplative pleasures of deferred domesticity.

Over the years, Martha's way with images had become as persuasive as her way with words. Photographs in *MSL* all captured things with the same clarity and precision as the etchings done centuries ago for the first encyclopedias. The photographs were not illustrations, they were documents showing the weave of a fabric, the texture of a fruit, the temperature of a liquid, the weight of an object, the sharpness of a tool—and the fragility of a moment of fleeting perfection. A signature Martha Stewart photograph today is one where the lens faithfully translates every nuance of the thing it scrutinizes. Nothing distracting is ever added. Shadows only serve to give more weight to a pinecone or more depth to a table setting. Artistic blur, an early *MSL* trademark now copied by every publication, is used sparingly to emphasize the creamy quality of a custard or the frostiness of a porcelain dish.

For Martha Stewart, it's all about information. Direct, jubilant, virtuosic information. While other large-circulation women's magazines dole out what they call "service"—advice, pointers, and tips—she refuses to talk down to her readers and viewers. Completely absorbed into the material world, she worships facts, small facts. Since her first issue of the magazine, in December 1990, she

has anthologized every single American episode having to do with hearth and home. Every good thing. Every holiday celebration. Every small ritual. Every family event. Every nostalgic memory, real or not. And she has done all of that without ever being maudlin or sentimental.

In the end, though, she forgot that she was human. She built her empire on things—on good things. She could not imagine that she might one day lose it all to a single instant of bad judgment. After five months in jail in a West Virginia prison, she was back at work, as determined as ever to teach women the proper way to bake cookies, yet vowing that she would no longer lecture anyone in quite the same pedantic fashion. "I really like people," she was compelled to add.

But "liking people," she might find out, is a lot less rewarding than liking the small things in life.

# 11: Who Remembers the Good Old Days?

New York in the Fifties:
When Madison Avenue Was Montparnasse

Steven Heller

During the mid-1950s through the mid-1960s, New York City was for modern art direction what Paris was for modern art at the turn of the century: a wellspring of unrivaled invention. Neither Chicago nor Los Angeles had the same critical mass of talent, or the business to support it. In New York scores of art directors had commanding positions at ad agencies and magazine publishers, where they not only made an impact on their respective products but also influenced the entire field. Manhattan was, moreover, the birthplace of the "creative," the role that heralded the shift from art service to visual communications. Madison Avenue was Manhattan's Montparnasse. Along this traffic-congested boulevard, "creatives" working in glass and stone skyscrapers changed the look and feel of advertising and magazines through an acute conceptual strategy characterized by understatement, self-mockery, and irony. In 1960 ad man William Pensyl termed this "The Big Idea."[1] Characterized by clean design and strident copywriting, wed to intelligent illustration and photography, The Big Idea was an expression of the unparalleled creative liberation that was later dubbed the "Creative Revolution"[2] and inaugurated the shift from hard sell to smart sell in advertising and publishing.

One building in particular, 488 Madison Avenue, was the nerve center of this transfiguration. For at the top, one flight of stairs above the reach of the elevators, in a windowed penthouse overlooking "Madvertising" Avenue, was headquartered the Art Directors Club of New York. This professional arena, founded in 1920, attracted an exclusive membership of advertising and magazine art directors who came from blocks around to share—or more likely boast about—their big ideas. They also judged the work for the annual competitions that celebrated and recorded the art directorial achievement that set contemporary standards. Like the bohemian cafes of Paris's Left Bank, the Art Directors Club was the epicenter for the men (and the few women) who became the legends of New York art direction.

Beginning in the late 1940s, some of the most influential media in America were also headquartered at 488 Madison—*Look, Esquire, Apparel Arts, Gentleman's Quarterly*, and *Seventeen*—as well as Raymond Loewy's industrial design office and the innovative Weintraub Advertising Agency, where Paul Rand (1914–1996) was art director from 1941 to 1954. By the mid-1950s, some of the most significant art directors worked within elevator distance of one another: Alan Hurlbut (1910–1983) at *Look*, Henry Wolf (b. 1925) at *Esquire*, and Art Kane (b. TK) at *Seventeen*. But 488 was not an island. Across the street, in the building that housed the Columbia Broadcasting System before "Black Rock" was built in TK, was home to the premier corporate design department in America, where art directors William Golden (1911–1959) and later Lou Dorfsman (b. 1918) produced identity and advertising campaigns that altered the paradigm of corporate and institutional practice. Within a few blocks of this locale worked other equally influential art directors: Alexey Brodovitch (1898–1971) at *Harper's Bazaar*; Helmut Krone (1925–1996), Gene Federico (b. 1918), and Bob Gadge at Doyle Dane Bernbach; George Lois (b. 1932) at Papert Lois Koenig; Leo Lionni (1910–1999) at *Fortune*; Steve Frankfurt (b. 1931) at Young & Rubicam; Cipe Pineles (1910–1992) at *Charm*; Otto Storch (1913–2001) at *McCall's*; and Herb Lubalin (1918–1981) at Sudler & Hennessey—to name a few. Each with a distinctive signature and methodology, they were the first "auteurs" of graphic design to define the role of the modern art director as manager, editor, and designer all rolled into one.

The job of "art supervisor" dates back to the turn of the century when its influence on advertising and magazines was comparatively inconsequential. The term *art director* gained currency a short time before the Art Directors Club began monitoring the achievements of New York's advertising and magazine profession in 1920. But prior to 1950 its competitions focused more on the artists and agencies than the art directors themselves. The club exhibited a mix, from rococo decoration by luminaries like Thomas Maitland Cleland to comic-strip advertisements by anonymous bullpen boardmen at J. Walter Thompson agency. With a few notable exceptions (such as M. F. Agha (1896–1978) at *Vanity Fair* and *Vogue*, who pioneered modern magazine design), the art

director was a company middleman following copywriters and taking direction from account executives or editors rather than a creative who molded the identity of his or her campaign or publication. The juried Art Directors Club annuals published between the 1920s and 1940s reveal that art directors slowly gained real stature in the late 1930s, but the shift was not fully realized until the postwar years. As a symbol of pending change, however, the name of America's premier commercial art magazine was changed in 1940 from *PM* ("Production Manager") to *AD* ("Art Director"),[3] but it was well over a decade until the Creative Revolution took hold.

The shift began in the late 1930s, when a generation of young modernism-inspired artists and designers aggressively sought to change the nature of American practice. Advertising and publishing had virtually ignored the nuances of good design in the modern sense, though it gave lip service to the New Typography through flagrant applications of asymmetrical styles and modernistic conceits. "What went before was pretty dull, so it wasn't difficult to make a splash," recalls Gene Federico, who began his agency career in the late 1930s and made his own splash as an advertising art director at Doyle Dane Bernbach in the early 1950s. By 1937, in the Art Directors Club annual, the names Paul Rand, Lester Beall, Will Burtin, William Golden, and Alexey Brodovitch were associated with work that rejected the vulgar conventions of commercial practice for subtle and ironic imagery and economical type and layout. Their designs bore a visual signature that both framed and distinguished their respective products. They also became representatives of a new genus: the art director/designer. "Clients began to recognize that these guys were not just sign painters," says Lou Dorfsman, who began his own lengthy career designing exposition displays. "They were accepted as artists who understood marketing."

Advertising and magazine publishing were traditionally exclusive professions. At the pinnacle were, respectively, the account executive and editor, who for the most part were ivy-league educated and belonged to the dominant social and economic class. As molders of popular taste, they made advertising and editorial decisions that catered to the biases of their fellows, the leaders of mainstream American business. It was a close-knit gentleman's club. However, by the turn of the century, New York was the proverbial melting pot of European immigrants, and by the mid-1930s, the children of these immigrants comprised the majority in the New York City public schools. At that time, in addition to the three *R*s, the curriculum emphasized skills that would propel students into viable jobs, and commercial art was a fertile profession especially suited to New Yorkers of immigrant backgrounds. So it was in this unique socio-cultural environment that the seeds of the Creative Revolution were planted.

Although the advertising and publishing industry's hierarchy was elite, they hired artists who were first-generation Italian and Jewish Americans. Secondary schools like Abraham Lincoln High School in Brooklyn and the High School of

Music and Art and the High School of Industrial Arts, both in Manhattan, offered courses in posters, illustration, advertising, and typography that combined the teaching of Bauhausian form with mass-advertising and publishing techniques. The models for these students were not the fine printer/designers D. B. Updike, Frederic Goudy, or W. A. Dwiggins, but masters of publicity, Lucian Bernhard, A. M. Cassandre, and E. McKnight Kauffer (all of whom were featured in the European design magazines, such as *Gebrausgrafik* and *Commercial Art*, that were kept in the school libraries). Many of the graduates either continued their education at art schools like Pratt Institute, Parsons School of Design, the Art Students League, and the Cooper Union (and in the late forties and early fifties Alexey Brodovitch taught a class in magazine design at the New School for Social Research), or directly entered the profession, starting out in the lower echelons. From this number many eventually advanced into jobs as copywriters and art directors.

The Creative Revolution began when the Jews and Italians assumed influential positions at agencies, influenced in no small measure by the leadership of William Bernbach (1911–1982), the co-founder in 1949 of Doyle Dane Bernbach, who popularized the creative team and encouraged radical changes in fifties advertising. (He himself was influenced by Paul Rand when they worked together at the Weintraub Agency in the forties.) Raised during the Great Depression, these virtual outsiders were psychologically driven to enter the mainstream, but on their own terms. They developed a passion for American popular culture; they devoured the comics and comic books, and many of them dabbled in jazz and other popular music forms as a way of reconciling their ethnic heritages and American lives. Those who chose commercial art sought more financial security—the Depression saw to that— but intuited that there was a potential for creative opportunity as well. So when these children of the melting pot came of age, they left their ethnic neighborhoods in Brooklyn, Bronx, Queens, and the Lower East Side of Manhattan and either by happenstance or design created a beachhead on Madison Avenue.

"Jews became copywriters and Italians became art directors," generalizes Lou Dorfsman in a statement that is disproved by his own career as an art director. But he is correct about the influx of brash, ethnic "neighborhood" kids who refused to see the world, or more precisely the marketplace, in the same way that the entrenched, aloof media professionals had since the turn of the century. "When the mask of suburban conformism was ripped away and America became aware of its ethnic diversity, it meant major changes . . . ," wrote Lawrence Dobrow in *When Advertising Tried Harder*. "We were itchy, we couldn't stand all that old stuff," recalls Gene Federico about the conventional advertising that he refers to as "different sized boxes on a page." And so the upheaval was beginning. "Our generation was fresher, wittier, more sarcastic, and therefore more ironic," adds Tony Palladino (b. 1930), the son of Italian

immigrants who graduated from the High School of Music and Art in the late forties and by the 1960s had become an advertising and editorial art director/designer. "We had an old world, European affinity, but a new world, American desire to make change."

In advertising, change was measured by the quality of ideas and the eloquence of execution. As a reaction to the grey-flannelled hucksterism of the past, the new advertising men believed in the avant-garde (i.e., futurist) notion that advertising could change the world. This was a calling, not a job. So the art director rose in stature in the fifties in large part due to a personal drive, but even more important because creative teams, pioneered by Bernbach, wed copywriters and art directors to a common goal. Art directors were required to act aggressively in all creative decisions, and art direction was so totally intertwined with writing and design that where one left off and the other began was irrelevant. Indicative of this newly realized power, art directors' names were added to agency titles; many, like Herb Lubalin, were anointed as vice presidents, and a few, like George Lois and Steven Frankfurt, became presidents.

The anthem of the Big Idea was the phrase "Think Small," a headline written by copywriter Julian Koenig that inspired art director Helmut Krone's 1959 Volkswagen campaign for Doyle Dane Bernbach. "In the beginning, there was Volkswagen," wrote adman Jerry Della Femina in his memoir *From Those Wonderful Folks Who Gave You Pearl Harbor* (Simon & Schuster, 1970). "That's the first campaign which everyone can trace back and say, 'This is where the changeover began.'" At a time when advertising, particularly automobile advertising, idolized mythic perfection, this was the first time that an ad rejected pretense and hyperbole in word and picture. It was selling at its most subtle and subversive because the Volkswagen campaign (which included the famous "Lemon" ad, which was the first time a pitch drew ironic, preemptive attention to a flaw in a product) redirected the perceptions of an entire consumer class from the notion that big is beautiful—and American—to small is wonderful—even if it's German. George Lois once noted the irony in the fact that this campaign not only pitched a tiny car in a market of behemoths, it was a Nazi car to boot.

In addition to their unrivaled sales appeal, the collected Volkswagen ads summarized advancements in graphic design dating back to the Bauhaus. Nothing was extraneous, not even a period. And yet it was not cold like the Swiss method. "It was a better use of space, or what we call 'design,'" explains Gene Federico about the shift away from formulaic layout. Although it was not the first ad to be "designed," per se, it was the first design of a national ad to reveal a decidedly American phase of modern thinking rooted in both economy and irony. Owing to this campaign, art direction was elevated beyond the board and into the boardroom. Creatives entered the vanguard of "the new advertising," while nuts and bolts business matters were left to their Harvard-educated colleagues.

In the early fifties, Federico points out that not all clients, in fact comparatively few, had "taken the bait." But by the mid-fifties clients and advertising executives saw that the new advertising made quantifiable differences in sales. "It was the beginning of the era of possibilities, a freezing of convention as breakthroughs in one area influenced those in others," says Milton Glaser (b. 1929), who co-founded Push Pin Studio in 1955 and worked with many of the leading art directors of the epoch. "It was a time when doing unconventional things had a tremendous effect; and one person could influence thousands."

The most adventuresome art directors deviated from the norms—broke the rules of type and image, rejected the hegemony of sentimental illustration—and triggered others to do so, resulting in a veritable chain reaction. Soon the followers were doing work on a par with the leaders. And among the soldiers of the Creative Revolution it was the prevailing belief that utility and effectiveness could be wed to a concern for order and beauty. From the Bauhaus came the idea that it was not important to distinguish between functionality and beauty. From the street developed the idea that the mass could be won over by intelligence. "Good Design" became a sort of mantra. "It suggested something to aspire to," continues Glaser.

Magazine art directors aspired to "good design" before their advertising counterparts did, but both reached their zenith around the same time. In magazine publishing, the older immigrants led the way. In the late 1920s, Turkish born M. F. Agha, who designed Paris *Vogue* for Condé Nast, was brought to New York, where he transformed *Vanity Fair* (under the editorial leadership of Frank Crowninshield) from a conventionally designed upper-crust magazine into an epitome of urbanity. Agha's introduction of sans serif, lowercase headlines, full-page pictures, and generously undecorated page margins proved that magazine design was more than a printer's afterthought. Agha further laid the groundwork for art direction in the fifties. ". . . [T]he art director has come to play an increasingly important role in the editorial concept of modern magazines," wrote Gardner Cowles, president and editor of *Look* magazine, in *Art Directing* (Hastings House, 1959). "He is no longer just a planner of illustrations and a liaison between the editor and artist. Today's magazine art director plays a major part in the publication structure, from formulation of editorial ideas to the production methods by which the magazine is printed. . . . I'm convinced that in the years ahead the art director will play an even more important role than he does right now."

Magazine art direction was slightly more genteel than advertising, and its pioneers, like Agha, were the aristocrats of commercial art. They set standards in the forties that held sway into the sixties. Those who prefigured the Creative Revolution in magazines but profoundly influenced it were: Alexey Brodovitch, the "White Russian" designer who worked for Deberny & Peignot in Paris; he not only streamlined the look of the venerable *Harper's Bazaar*, but transformed

fashion-magazine content by introducing conceptual photography as an alternative to conventional illustration. Austrian born Will Burtin modernized the classically elegant *Fortune* by introducing a highly sophisticated approach to information graphics. The Dutch-born, Italian-educated (with a doctorate in economics) Leo Lionni succeeded Burtin and pushed *Fortune* even further into realms of the classically contemporaneous; in addition to promoting fine artists as visual journalists, he redefined the nature of magazine-cover design by inventing the two-tiered image (different illustrations above and below the masthead referring to different themes in the magazine). Austrian-born Cipe Pineles, who assisted Agha at *Vogue* in the late 1930s, helped define an entirely new teenage market through her art direction of *Seventeen* in the late forties, and from 1950 to 1958, with *Charm*, she defined a print environment for young working women by introducing them to urbane art and illustration. Finally, Russian-born Alexander Liberman (1912–1999), the designer of Paris *VU*, followed the lead of Brodovitch by modernizing *Vogue* through fine conceptual photography.

"Today's art director [is an] architect of the printed page," wrote Charles Coiner, art director of N. W. Ayer, in *The 31st Annual of National Advertising and Editorial Art*. In the magazine field, Brodovitch, Burtin, Lionni, Pinelas, and Liberman were among the key architects. Yet they were not brazenly experimental in the avant-garde sense. Their structures were built on firm principles, and with self-assurance and authority they promoted new approaches to type and image, harnessed negative space, and most importantly applied "big ideas" to editorial design. Some art directors argue that the introduction of photography and fine art in magazines had a critical influence on advertising art direction because they tested the terrain. And if conceptual photography is the benchmark of what Gardner Cowles called the "Pictorial Era" of the Creative Revolution, then its roots must be traced to magazines.

In the fifties, before television made huge inroads, magazines were the creative wellsprings. By the early to mid-fifties younger magazine art directors enthusiastically followed their mentors and made further inroads. One of the most progressive of this generation was *Esquire*'s art director from 1953 to 1958, Henry Wolf, a young Austrian immigrant, who transformed a starchy gentleman's fashion monthly into a creative environment for photographers and illustrators. He perfected the narrative picture essay, introduced fragmented collage as illustration, and designed conceptual covers that stood without headlines. *Look*'s art director from 1953 to 1968, Allan Hurlburt, who learned from Paul Rand at Weintraub, epitomized Gardner Cowles's definition of the editor/designer. *Look* appeared in January 1937, more than a year after *Life* premiered, but until Hurlburt began as art director it remained in *Life*'s shadow. "*Life* had great pictures but no design," argues Sam Antupit, *Esquire*'s art director from 1964 to 1968, "*Look* had great photographs and was brilliantly designed." Hurlburt understood dramatic pacing and knew how to integrate

expressive typography to complement the pictorial narrative. He designed a magazine of ideas and other art directors added their own styles and dialects to this unique era: Otto Storch, who took Brodovitch's class at the New School, was art director at *McCall's* from 1953–1967 and introduced a Victorian typographic sensibility that prefigured postmodernism; Bradbury Thompson (1911–1996) brought clean classicism to *Mademoiselle* from 1945 to 1959; and Art Kane, who later earned fame as a photographer, gave his version of *Seventeen* a typographic and photographic urbanity unknown in today's "teenage" magazines. This was the era when magazine art directors enjoyed the uninterrupted, continuous runs of many editorial pages that allowed them to establish visual narratives and to kinetically pace the stories.

Browse through any Art Directors Club annuals between 1955 and 1965 and the Big Idea in advertising and magazine art direction comes into clear focus. "This was a period when expression of an idea was more enduring than style," says Milton Glaser. Of course, the selected pages and spreads in these annuals are taken out of context, and certain design biases are celebrated over others that may have existed at the time, but the dominant methods of advertising and magazine design had much in common. As Glaser further notes, New York's art directors formed a comparatively small community and the common language, the ambient art directorial vocabulary, adhered to a basic syntax: classically modern or expressively eclectic typography, conceptual illustration, and both narrative and abstract photography wed to the word. Each component was in harmony and evoked both a sense of beauty and of meaning.

In addition to common aesthetics, money was the glue that held this epoch of art direction together. According to Jerry Della Femina, advertising art directors commanded upwards of $50,000 a year (the equivalent to three or four times that amount in today's currency). "American advertising was the only game in town," says Lou Dorfsman. "The magazines were flush with ads and they spared no expense in giving art directors license to send photographers and illustrators around," adds Henry Wolf. Money was indeed available to finance Big Ideas, and Wolf recalls when he succeeded Brodovitch in 1958 as art director of *Harper's Bazaar* that he and six other staff members—an editor, stylist, photographer, and three assistants—were sent to photograph Audrey Hepburn at the Paris collections. At top magazines like *Esquire*, art and photography fees were low compared to advertising, but as Wolf notes, "the showcase was worth a million bucks."

Although magazine art directors deny that advertising influenced editorial design, there was a creative symbiosis between advertising and editorial art direction. Wolf points out that the photographers he used at *Esquire* were often subsequently hired for large ad campaigns. Federico concurs that admen looked to *Esquire* and *Look* for visual inspiration. And Sam Antupit adds that he frequently discussed the design of his opening editorial pages with agency art

directors before going to press, so their respective layouts would not conflict with each other, but had their own integrity.

Art direction further influenced a broader visual culture: "The art director, as we now define his job, has grown steadily away from his early predilection with decorative 'effects,'" pronounced the Art Directors Club of New York in the introduction of its 1953 annual, "and steadily toward a more scientific approach in the art of communicating ideas . . . He still fights in the fundamental battle of his trade—good taste versus 'buckey'—and occasionally writhing in the toils of that effort, he shows signs of schizophrenia when he must decide whether to decorate or communicate." Compared to the mass of visual effluvia, the work celebrated by the Art Directors Club proved to a significant segment of American business that shrill hawking and common-denominator thinking was not necessary to sell wares or present ideas. Advertising and magazine art direction provided vivid examples of how elegance and wit, cut with imagination, could alter mass perceptions, even taste. "[T]he art director has made tangible and practical contributions to the advancement of good taste . . . in this country," wrote Walter O'Meara in *The 31st Annual of Advertising and Editorial Art*. Whatever that slippery thing is called taste, art directors were responsible for a large proportion of how and what Americans consumed.

Nevertheless, the influence of the Creative Revolution, like the dream of reason, produced its own share of madness. Or at least mediocrity. By the late sixties, the Big Idea had become a placebo for many advertising and magazine art directors. Although there were still some great big ideas, such as George Lois's acerbic *Esquire* covers in the late sixties, there was also widespread deflation as a result of formulaic solutions. It was impossible to maintain revolutionary fervor over a long period of time. Even the most radical ideas eventually lose stridency, and are replaced by other methods. When big ideas became predictable, they are no longer big ideas.

"Everything came to an end in the late sixties and seventies," asserts Henry Wolf. "Publishers wanted to make money rather than have beautiful magazines." Or more accurately, print began to run afoul of television. As advertising art directors began turning their attention and ambitions toward commercials, magazine art directors began to feel their own celebrity subside. As the great magazines began to falter, art directors fell from grace, or at least further down the masthead. "I left *Harper's Bazaar* when I could not get thirty consecutive pages in the editorial well," boasts Henry Wolf. This should not be taken as nostalgic hyperbole, rather as indicative of the devolution of the magazines as a prime medium and of the art director as its visual impresario. With the same speed that the Creative Revolution had hit, it ran out of steam. Advertising veered further away from magazine art direction, and magazine art direction on the whole became more service oriented. The golden age of art direction ended and with it went the purity of the Big Idea.

# Notes

1. Although the term may have been used before, it appears in *Print* (May/June 1960) in a quote by adman William Pensyl of Ketchum, MacLeod, Grove, who says, "The big idea serves as the basis for all creative work." In 1991, George Lois, the master of this method, used it in the title of his book, *What's the Big Idea: How to Win With Outrageous Ideas That Sell* (Doubleday, 1991).

2. Although the original source of this term is unknown, one authoritative reference is in the title of Lawrence Dobrow's *The 1950s and Madison Avenue: The Creative Revolution in Advertising* (Friendly Press, 1984).

3. The magazine had relinquished its original name to *PM*, a daily newspaper, but the choice of the title *AD* was nevertheless consistent with changes in the profession.

# A Good Question: Does Experience Still Matter?
## A Conversation with Bob Ciano

*Steven Heller: You've been a magazine art director for many years and for many high-visibility magazines. You might even say you were part of the golden age of sixties and seventies magazines. What has changed, in your view, since those days?*

**Bob Ciano:** What has changed is the editor–art director relationship: too often now, art directors are just the intermediary between the artist—illustrator or photographer—and the editor. Sketches are submitted and the art director doesn't say yes or no or make some changes, the art director usually says, "I have to show it to the editor." This is what's changed: the lack of a mandate and a responsibility for the visual personality of the magazine. And, underlying that is a lack of trust. The art directors I assisted when I first began had control of not only the look of their magazines, but they were also major contributors to the development of stories.

*SH: As an art director, how much of the magazine's identity is in your hands alone?*

**BC:** Some, but not much, at least not currently. What has changed is the increased influence of marketing and surveys. Very few magazines are shaped by the instinct and experience of the staff alone. Now things are tested to death, after which there is very little vitality left. I am still a believer in [former *Esquire* editor] Arnold Gingrich's belief that he wanted to produce the kind of magazine he wanted to receive in his mailbox.

*SH: Could an art director like Alexey Brodovitch, Leo Lionni, or Bradbury Thompson work in the current magazine environment? And if not, what would need to change?*

**BC:** They could, but they wouldn't be able to achieve the heights they did. What needs to change are two things: trust and partnership. Editors need to trust their art directors more. They need to stop suggesting visual solutions and they need to be less literal in their visual taste. You would think that editors would welcome another sensibility to shape the personality of the magazine, but that is not always the case. It's become a cliché to say that the editor–art director relationship is like a marriage, but clichés do have a kernel of truth and this one does. The editor and art director must be on the same wavelength, but there also needs to be some autonomy in each area of expertise.

Illustration by Peter Kramer.

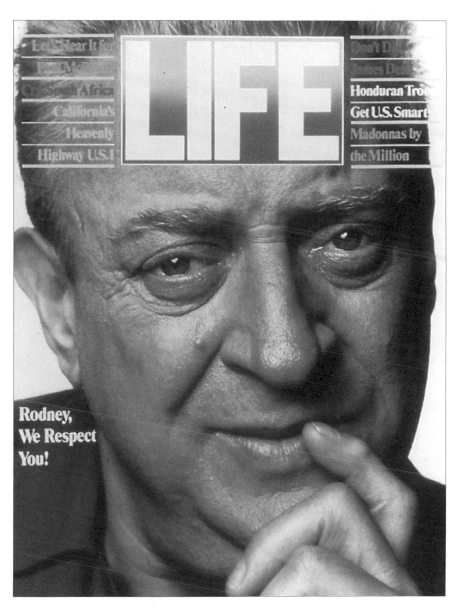

Designer: Bob Ciano, for unpublished redesigned dummy logo.

**SH: I don't want to harp on the good old days, but magazines have changed to meet new demographic models. What has improved in magazine publishing and what has been lost?**

**BC:** Sorry, but I don't think much has improved. No matter what the demographic model, now or then, the need is the same, to produce a magazine that gives the reader information, pleasure, and delight in knowing. What has improved is mostly in the way that we, as art directors, work. We now can control all aspects of production. However, I have come to believe that the advent of the computer-generated page has also been like a Trojan horse. With the siren of control in our ears, we, as designers, now not only think and design, we are expected to do production. And, no matter how fast an art director is at production, it takes time away from the "thinking" time that we had in the past when we weren't responsible for production.

**SH: Do you believe that magazine art direction can be taught? Or is it something that is only acquired by experience?**

**BC:** Yes, I think it can be taught, but not simply in the usual school setting. Schools do have an important place in the process, like teaching typography, page layout, computer skills, and the history of our craft. I think more can be learned by doing and if one can find and work with a mentor, that would be the best combination with formal schooling.

**SH: What makes a successful magazine art director?**

**BC:** Vision and a plan on how to achieve it. Also necessary is the ability to listen. We are in a collaborative business and it's important to listen to colleagues—both agreements and objections—and process those comments and convince them of the rightness of your position.

**SH: How much does graphic design play in how effective an art director will be?**

**BC:** It plays a good part in making a good art director, as it is the language and grammar of our craft, but more important in my mind is that we be good journalists. As art directors, our audience is not other designers, and although we might and do want to dazzle out peers, that is secondary to reaching the reader in a meaningful way.

# It's a Wonderful Life:
# The Art of Being Frank Zachary

## Steven Heller

In the classic 1946 film, *It's a Wonderful Life*, the hero, George Bailey (played by James Stewart), is able to see what life would be like if he had never existed. Although he is in his hometown and knows the townspeople—his mother, wife, friends, and neighbors—since he was never born, none of them know him. He learns that he had enriched their lives so much that bereft of his influence they lead very different, indeed disparate lives. Similarly, if Frank Zachary had never been born (or at least had been in another profession) many esteemed photographers, illustrators, writers, graphic designers, and art directors would probably be less esteemed, if not unknown, today. For almost fifty years, Zachary has worn many hats in publishing, advertising, and public relations as writer, art director, and editor. He has been the quintessential, behind-the-scenes catalyst inspiring—and directing—talented people to do good work.

Zachary, the editor-in-chief of *Town and Country* magazine from 1979 until his retirement in 1996, has prominently appeared on various mastheads. In fact, as a young boy in 1962, this writer first saw him listed as the art director of *Holiday*. Without understanding the nature of either graphic design or art direction, I was inspired by the striking photography and witty illustration of this magazine and somehow intuited that Zachary had made it all happen. More important, without knowing him personally I decided to follow in his footsteps, to the extent that I too wanted to be a magazine art director. It was only many years later that I learned of Zachary's extensive role not only in the development of this, one of the last great behemoth magazines, but of his contributions to magazine publishing in general and art direction in particular. He was the founding editor of the legendary *Portfolio* magazine, the short-lived journal of applied arts, brilliantly designed by Alexey Brodovitch. *Portfolio* became the paradigm of what a modern graphic and industrial arts magazine should be. And *Holiday*, for which he was both art director and managing editor, was more than just a stunning travel magazine but a wellspring for photographer- and illustrator-journalists who blazed trails in a field that was primarily dominated by decorative and mundane styles. Zachary had created working conditions where the unexpected was expected, yet novelty was always eschewed. "The beauty of Frank's work is that it never followed a single trend," says Sam Antupit, design director of Harry N. Abrams and former art director of *Esquire*. "Things that he initiated might have been copied [by other magazines] but they never approached his remarkable execution." Working for Zachary did not necessarily insure fame and fortune (though many of his "discoveries" did do quite well) but resulted in something even more valuable, the confidence to exercise self-expression, push conventions, and be more than just a pair of hired hands working a pen, brush, or shutter.

What differentiates Zachary from other great art directors is the word *journalism*. He is not a mere aestheticist, but rather a storyteller and reporter in pictures and words; he is not a simple decorator, but a conceptualist with ideas as his bedrock. "With Frank the lines blur as to whether something should be executed visually or verbally, because he has always been that rare combination of editor and art director," continues Antupit. "His brilliance is that he says visually what should be an image and verbally what should be a word. If an image is better expressed in words then he is not afraid to use the words. So in the end what you have is a concept where the verbal and the visual are inseparable." The inseparability of word and image—journalism and art—is rooted in a lifetime of activity dating back to his earliest jobs during the Depression, when in his native Pittsburgh, Pennsylvania, amidst the massive factories of this great steel town, he found his life's work in magazines.

Zachary was born in 1914, the son of Croatian immigrants. During his tough high school years he worked at all sorts of jobs "just to keep body and soul alive," he says. But he had a passion for writing, particularly poetry, science fiction, and humor, which kept his spirits high, though his efforts were rejected every time he tried to submit them to magazines. But his love didn't go unrequited for long. At eighteen he got a job with Henry Scheetz, whose family had been prominent in the publishing house of J. B. Lippincott Company, and had come to Pittsburgh from Philadelphia to salvage the ailing *Pittsburgh Bulletin Index*. Scheetz took to Zachary immediately, owing in part to the boy's talents, but more pragmatically, because he needed a low-paid staff. "He needed me alright," Zachary recalls amusedly, "and I became the staff." He quickly taught himself how to use the Speed Graphic, the classic newsman's camera, and within months became the *Bulletin Index*'s local beat reporter, makeup, and layout man, as well as its chief copy boy.

The *Bulletin Index* was like many small-city magazines of the day. It covered debutante parties and golfing events, and published witty cartoons and mildly satiric articles. Predictably, most Depression-era magazines of this kind failed, but Scheetz had a curious success. In fact, the *Bulletin Index* was a kind of precursor to the contemporary city magazine. For Zachary it was also a wonderful place to learn the trade, if for no other reason than Scheetz hired novelist John O'Hara as editor. "It was a break for me," says Zachary, "for O'Hara vicariously introduced me to the world of New York writing. He'd come in every morning, sit down at his Underwood-5 typewriter, put in a yellow sheet of copy paper, twirl it, and write. About an hour and a half later there was a perfectly typed and written short story for the *New Yorker*. Before O'Hara left nine months later to write *Appointment in Samarra*, he had changed the magazine from its society orientation to one cast in the mold of *Time*. As we began to prosper, the staff got bigger, and around 1937 [at age twenty-three] I became managing editor." In his off hours he was also the Pittsburgh stringer for *Time*, *Life*, and *Fortune* magazines, giving him a taste for life apart from the *Bulletin Index*.

Zachary took a shine to a young journalist hired as the *Bulletin Index*'s society editor named Catherine Mehler (later to become Mrs. Zachary), who, with contacts in publishing in Chicago and Cleveland, convinced Zachary to pitch the idea of selling a network of regional magazines that he would edit. "I went to see the big-money people," he remembers, "with a prospectus written by Catherine, but just couldn't make the case. But it did, however, get back to Scheetz, precipitating a major falling out between us." Jobless in the spring of 1938, Zachary headed for New York City in an old Ford with $50 in his pocket. New York was formidable in those days, although not as hostile as it has become, but Zachary recalls being "happily passed along from one place to another by very friendly guys who had never seen or heard of me, and I finally wound up, in less than a week, with a job at Carl Byoir's public relations firm." He worked in one of those legendary bullpens where thirty other would-be writers were trying to make a living while pursuing careers as short-story writers. Zachary was responsible for A&P press releases, but while his colleagues batted them out, Zachary, an admittedly slow writer, worked well into the night. This work was not his métier, but his next job as a PR man for the 1939 New York World's Fair, the largest peacetime publicity campaign in American history, was considerably more satisfying.

As assistant director for the office of magazine publicity, which handed out releases and arranged for stories and photo opportunities, he became closely acquainted with the Fair's tireless promoter and organizing genius, Grover Whelan, who in turn taught Zachary to never settle for the commonplace. In fact, Zachary and his friend Bill Bernbach (who later became an advertising kingpin) conceived and produced some of the Fair's many imaginative theatrical publicity stunts. The Fair was only a two-year event, so at its close Zachary was unemployed until hitching up as PR man for the United China Relief Fund. This humanitarian aid group, organized and supported by *Time* czar Henry Luce and his wife Clair Booth Luce, hoped to relieve the suffering of Chinese people facing Japanese aggression. Taking a page from his World's Fair bag of tricks, Zachary organized publicity events including rice bowl festivals and parades, and brought over the first two Pandas from China to the Bronx Zoo. The following year, with the United States deeply involved in the war, he took a job with the COI (Coordinator of Information), which became the OWI (Office of War Information), the civilian agency that produced major propaganda for the U.S. government. Also working there in those days was illustrator Ludwig Bemelmans, designers Tobias Moss and Bradbury Thompson, and publisher Oscar Distill, who put out a magazine called *U.S.A.* Zachary worked as an editor and picture coordinator for *U.S.A.* and *Victory*, and later worked on *Photo Review*, with the German émigré Kurt Safranski, a pioneer of photojournalism who went on to found the Black Star photo agency.

Toward war's end, with the first of two daughters on the way, Zachary sought a more permanent job. *Minicam* (which later became *Modern*

*Photography*), for which he became the East Coast editor in 1945, was a magazine for the passionate home photographer. But rather than cater only to the technical needs of amateurs, Zachary decided to reinterpret his job by creating a forum for the professional and art photographer. Among his stories were features on established figures like Paul Strand, Ansel Adams, Harry Callahan, Helen Levitt, and Arnold Newman, as well as new discoveries—all would later be employed in other magazines under Zachary's tutelage. Also at this time Zachary wrote an article on Alexey Brodovitch, *Harper's Bazaar's* legendary art director, about whom he says, "I later honed my own art directing skills just by being around Brodovitch." Quite an intimate friendship developed between the two. Another important friendship began at this time with George Rosenthal Jr., whose family owned *Writer's Digest* in Cincinnati, as well as *Modern Photography*, and who was installed as the latter publication's advertising salesman in order to learn more about the publishing business. "George was a student of Moholy-Nagy in Chicago," recalls Zachary, "and was a superb photographer. We both wanted to publish a good magazine on art and design, and talked about it often." They eventually collaborated on *Portfolio*, but first, Zachary left *Modern Photography* to work on something with the mysterious title *Magazine X*.

After the war, most major publishers were proposing new magazines to capitalize on the resurgence of consumer advertising. Curtis, the publishers of *Saturday Evening Post*, hired Zachary to be senior editor of *Magazine X*, a general-interest magazine later renamed *People*. Its executive editor was Ted Patrick, for whom Zachary had worked at the OWI. A dummy was presented to Curtis's management, but owing to corporate growth problems it was ultimately rejected as unfeasible. They did, however, buy a moribund travel magazine called *Holiday* and make Patrick the editor, leaving Zachary again without gainful employment.

He pounded the street for a while before being hired by Grover Whalen, then president of Coty, who was organizing the fiftieth-anniversary celebration of the 1898 amalgamation of New York's five boroughs into Greater New York. "Grover was a great showman," recalls Zachary, "who always wanted to do big things. And we did them. I organized the biggest parade in the history of New York at that time—a hundred thousand people, five thousand vehicles. I had the people who planned D-Day handle the logistics so that everything was timed to avoid traffic jams. I used people who helped create the atomic bomb, the Manhattan Project, to trap light from a star fifty light years away to ignite a flame at the cutting of the ceremonial ribbon. I deployed two thousand police and firemen to make certain that every building along the parade route had turned off their lights between 9 and 10 PM so that the fireworks would be all the more impressive." The event went off with only one hitch. "We stretched a ribbon across Fifth Avenue loaded with gunpowder so that when the button was pushed the star would ignite the powder and cut the ribbon. Unfortunately,

we put a little too much powder in and it blew all over, blackening the faces of the mayor, the governor, and Whalen, and stopping their watches too."

Zachary returned to magazines when his friend George Rosenthal Jr. suggested a collaboration that promised to be challenging and difficult. They wanted to produce a magazine that would be for America what *Graphis* was for Europe, only not so rigid in format. "The format itself should be a graphic experience," says Zachary. The elder Rosenthal put up $25,000 to print a 9 × 12, perfect-bound magazine on luscious paper and incorporating as special inserts everything from shopping bags to 3D glasses. *Portfolio* featured stories on graphic and industrial designers, poster artists (like E. McKnight Kauffer), cartoonists, and a variety of cultural ephemera, all innovatively designed with taste and aplomb by Alexey Brodovitch. Even their letterhead, designed by Paul Rand, was of the highest caliber.

About the first issue, Zachary says, "George and I spared no expense in buying the best paper and the best of everything else that we could. Then we decided to sell advertising. Well, we hated the ads we got. So we said, 'Hell, we're not going to mar our beautiful magazine with these cruddy ads.' We were terribly idealistic." A subscription to the magazine cost $12 a year for four issues and they garnered a few thousand subscribers. While Rosenthal worried about finances, Zachary's primary job was to develop ideas and work with writers. He would also collect all the photographs and illustrations for the stories and dash over to Brodovitch's office at *Harper's Bazaar* to plan the issues. "We got along very well because I let him have his head," Zachary recalls with fondness. "But he was no prima donna. He worked in the most fantastic way. For example, I would come in, say, at seven o'clock in the evening with the idea of how many pages we had for an issue, and how many would be devoted to each story. I would come back [the next day], and Holy Christ, there was this magnificent layout. He used the photostat machine like a note pad. He would get stats of every photo, often different sizes of the same piece, in tiny increments that might vary from a quarter inch to an inch, or from an inch to two inches, and so on. You would see him surrounded by all these stats. But as he put them down, my God, all of a sudden a spread materialized beautifully proportioned, everything in scale, with just the right amount of white space, type, and picture mass. I learned so many nuances of art directing just from watching him."

*Portfolio* premiered in late 1949, and lasted two years and three issues. During this time, Zachary was also editor of *Jazzways*, a one-shot magazine on the folkways of jazz. The cover was designed by Paul Rand, and among the interior photographers was Bernice Abbott. In addition, Zachary and Rosenthal published paperback photo albums under the Zebra Books imprint. These were the first of their kind to present good photojournalistic portfolios for just 25 cents. The titles included *Murder Incorporated*, the first book on the Mafia; *Life and Death in Hollywood*, a pre-Kenneth Anger look at the foibles of the glitter capital; and *Naked City*, the first collection of pictures by the famed New York

street photographer Weegee. Each sold between 150,000 and 250,000 copies, with all profits pouring back into *Portfolio*.

The third and last issue of *Portfolio* was its most beautiful. The dream of an exquisite, adless magazine had, however, turned into a nightmare. Though financial problems did not weaken Zachary's resolve to publish—he even approached Henry Luce to buy the magazine—George Rosenthal Sr. decided to summarily kill *Portfolio*, at a time when Zachary was stricken with appendicitis, rather than incur further loses. Nearly fifty years have passed, and Zachary's brainchild remains a landmark in the history of design.

The death of *Portfolio* in 1951 left Zachary jobless once again. This time a fateful meeting with Ted Patrick, his former OWI boss, resulted in a job as picture editor of *Holiday* magazine. At that time *Holiday* was clean and orderly, although its layout looked as if it had been made with a cookie cutter issue after issue. So as Zachary worked with the pictures, he began to make his own layouts. And these were not just picture layouts in the conventional sense, but, taking a page from Brodovitch's book, cinematic presentations. Noting the dramatic difference, Patrick offered Zachary the job of art director. "'Jesus, Ted,' I told him, 'I'm okay, but why don't you try to get Brodovitch? He's the real master.'" In fact, Zachary even took Patrick to meet the White Russian, but for some reason they did not hit it off and Patrick insisted that Zachary take the job at least temporarily.

Zachary didn't know much about typography, but did have experience laying out pictures in the Zebra Books, which taught him the value of scale. "I learned the picture is the layout. If you have a great picture, you don't embellish it with big type. You make it tight and sweet," he says, referring to his signature layouts. Soon he developed a cadre of talented photographers who brought life to the magazine in the form of thematic picture essays. Among them were Arnold Newman, Tom Hollyman, John Lewis Stage, Robert Phillips, Fred Maroon, and Slim Aarons, many of whom still work on *Town and Country*.

While photography was the backbone of *Holiday*, illustration was its soul. Zachary was under-whelmed by the prevailing saccharine and sentimental illustrative approaches found in most American magazines, and eyed Europe, specifically England and France, for the surrealistic comic vision he was looking for. "Frank brought sophisticated illustration to American magazines," recalls Sam Antupit. "Other art directors brought powerful or clever images, but Frank brought an unprecedented sophistication. Of course it came from Europe, since in the early fifties there weren't too many Americans practicing sophisticated pen work."

Through *Holiday*, artists like Ronald Searle, Andre Francois, Roland Topor, Domenico Gnoli, George Guisti, and Edward Gorey (one of the few native Americans practicing out of the mainstream) were given great latitude to develop their own stories and portfolios. Zachary avoided using the reigning stars, for "that would be too easy," but rather discovered his own galaxy. In most

cases, the artists actually transformed themselves in this environment. "I got people like Ronald Searle," remembers Zachary, "who, by the way, was drawing pretty straight at the time, to do a feature on something like the London hotel scene. The first result was pretty straightforward, so I asked him to satirize or just make it funny, and almost overnight, he changed his style, becoming the Searle that you and I know today." And Searle concurs: "Frank gave me a lot of firsts. From around 1959 to 1969 he gave me all the space one could dream of, the chance to fill it with color, the freedom to travel, and what proved to be the last of the great reportages. Off to Alaska! Cover all of Canada! Bring me ten pages on the dirty bits of Hamburg! No expense spared. The years of travel for Frank gave me experience that cannot be bought. There was only one problem, he always called me 'Arnold' instead of Ronald. Then he probably always called Arnold Newman 'Ronald,' so it balanced out."

Zachary also developed what he calls "environmental portraiture," which is common in today's magazines but was startlingly unique in the early 1950s. Says Zachary, "I would say to a photographer, 'If a guy is a multimillionaire painter, I want to see a whole lot of his paintings in the background and on top of that I want to see his castle in the background, too.' A photographer just couldn't walk in and take a picture of a subject; he had to assemble the components of the subject's life." A now classic example of environmental portraiture is a Zachary-directed photograph made for a special issue of *Holiday* on New York City showing the highways and parks czar and power-broker Robert Moses standing omnipotently, if precariously, on a red girder over the East River. The shot illustrates Zachary's willingness to expend a tremendous amount of effort to get that one perfect image for an issue whose shelf life is decidedly short. But this iconic photograph by Arnold Newman has life long after the magazine turned to dust.

For several years before his death, Ted Patrick was editor of *Holiday* in name only; he was very ill and relied entirely on Zachary, who ran the magazine both editorially and visually. In 1964, Patrick died, and Zachary admits he "was confident that I would succeed Ted as editor." Instead, there was a new group of managers at Curtis who named a new chief over Zachary. "They gave us all raises, and made me managing editor . . . but it became intolerable." Zachary and other editors objected to the cheapening of the magazine and urged the president of Curtis to intercede, who sympathized but did nothing. Abandoning his "baby" was not easy, but Zachary left to take a job with McCann-Erickson, under the famed advertising creative Mary Wells.

"To this day, I don't know what they expected of me," he says about working in a field that was foreign to him. They made me president of international advertising at Pritchard-Wood, a pretty fine agency with nine offices, headquartered in London but operated from New York." It was, however, a difficult experience, for by his own admission Zachary knew and cared little about advertising, and was not a very good salesman, which was his primary

responsibility. He lasted eight months until being moved laterally at McCann-Erickson into the Center for Advanced Practice, a fancy title for a group that was supposed to be a hothouse of advertising practice. His colleagues on this elite, somewhat idealistic, project included Bill Backer, Al Scully, and Henry Wolf. The center was to be a laboratory for experimentation with new advertising approaches, but turned sour when the breakthroughs they proposed were ignored or rejected. Zachary stayed on for three years, until in 1969 he was asked to return to *Holiday* as its art director.

One of the popular canards in the magazine racket goes, If a magazine is on the skids it must be the art director's fault. Hence, if its look is improved—if the cosmetics are freshened—the magazine will regain its spritely complexion. Zachary was asked back by the same editor who superceded him earlier to do what he should have been allowed to do in the first place. And he did put a remarkable team of talents together to make the best travel magazine on the market. But the changes came too late to reverse the deleterious market trends. *Holiday* was eventually sold, resold, and died. And Zachary, who had helped in the initial acquisition deal, was rewarded with a magazine of his own called *Status*, a struggling little lifestyle magazine, which had grown out of something called *Diplomat*.

It was Zachary who promptly changed the name to *Status* and had Salvador Dalí design its logo. As editor, Zachary was free to pump in all the energy he wanted, converting it to an amusing, entertaining, literate society magazine, done very much with tongue in cheek—in the manner of the old *Vanity Fair* (and predating by a decade the revival of the new *Vanity Fair*). He hired Patrick O'Higgins as art director with whom he "made a great team." The editorial mix was exciting; the graphics were excellent. The only problem was that the magazine was never given enough capital support to succeed. Zachary eventually had a falling out with the publisher and after a year's worth of issues, he left, again jobless—but wiser.

In late 1970 he was hired as art director of a lackluster *Travel & Leisure*, where he stayed for over a year, imbuing it with the kind of photography and illustration that was his signature and that by this time had become a standard in other magazines too. He would have been happy to stay at *T&L* had he not been offered the job of editor-in-chief of Hearst's *Town and Country*. All the experience that he had acquired over the years suddenly came together with this one assignment. He used this opportunity to effectively change this bible of high society to reflect his wit and concern for the human condition without abandoning the core audience. "I knew it was a society magazine," he says, "But it had the potential for expanding its readership because it was not just about parties and debutantes, but about the rich who had the power to do things. They were, I believed, an audience ready for socially motivated articles." The focus shifted from strictly reporting on social doings to a mix of themes, including satirical pieces on class and society. "My satirical side isn't savage or

mean," confides Zachary, who has always wanted to publish a truly sophisticated satiric journal, "it's fun satire . . . [that doesn't] tear people apart but can be amusing and witty."

Zachary's confidence in his staff and contributors results in a decidedly unique product—one that maintains certain traditions while breaking new ground. "*Town and Country* is probably the only national magazine that still does original photo essays," says former *Life* photographer Slim Aarons, who worked for Zachary for over three decades. In fact, in the face of formats based on the planned clutter and chaos most magazines celebrate today, Zachary firmly believes in the viability of a traditionally well-placed and planned editorial well in which the photo essay is a major storytelling tool.

Zachary is a rare breed of editor/art director. But how did being a former art director affect the way an editor-in-chief commanded other art directors? "I merely represented the experience of an old hand," explains Zachary modestly. "I'm a journalist, not a designer per se. I did not interfere with typographic matters, but I have always been interested in the photograph as a medium of communication, and I tried to make certain that a picture was used to tell a concrete story."

# Contributor Biographies

**Gail Anderson** is art director of SpotCo in New York and co-author of *Graphic Wit* (Watson-Guptill), *The Savage Mirror* (Watson-Guptill), and *A Designer's Guide to Outstanding Photoshop Effects* (How Books).

**Elisabeth Biondi** is the visuals editor of the *New Yorker* magazine.

**Roger Black** has designed Web sites, newspapers, and magazines around the world. Recent projects include the *Houston Chronicle* and its Web site, chron.com. He helped launch the Spanish-language daily, *Rumbo*, which has four editions in Texas and is expected to expand to California this year. Over the last sixteen years, Black and his team have worked on *Reader's Digest, Esquire, Premiere, Kompas* (Jakarta), and *Tages Anzeiger* (Zurich). They designed influential Web sites for MSNBC, Univision.com, and Televisa (*esmas.com*). Before starting out on his own, Black was chief art director of *Newsweek,* the *New York Times, New York Magazine,* and *Rolling Stone.*

**Stéphane Bréabout** is art director of *Zurban* magazine, a Paris weekly publication.

**Peter Buchanan-Smith** is the art director of *Paper* magazine and the *Ganzfeld,* and author of *Spec* (Princeton Architectural Press).

**Alex Bogusky** is executive creative director at the Miami advertising agency Crispin Porter + Bogusky (CP+B).

**Ronn Campisi** specializes in publication design, including newspapers, magazines, and books. He has designed the formats for *PC Magazine, Computerworld, Computer Reseller News,* and *Info World.* He was the design director for the *Boston Globe Magazine* and part of the team that won the 1983 Pulitzer Prize for a special magazine section titled "War and Peace in the Nuclear Age."

**Bob Ciano** is former art director for *Life* magazine, *Opera News*, *Redbook*, and the *New York Times*. He currently teaches at California College of the Arts in San Francisco.

**Nancy Cohen**'s first job after graduating from the University of Pennsylvania was at *Self*. Since then, she has been art director of *Metropolis*, *ESPN Total Sports*, *Details*, and *New Woman*. She then became art director at Carlson and Partners Advertising, where she did national print advertising for Polo Ralph Lauren (Menswear, Polo Sport, and Childrenswear), and was Creative Director of *RL GIRL*, a "magalog" for teens. She also has designed Web sites and books, including *Flea Market Fidos*. Now she works on freelance projects and cares for her two daughters, Violet and Penelope.

**Ken Carbone** is a principal of Carbone Smolan Associates in New York.

**Brian Collins** is the creative director of the Brand Integration Group at Ogilvy & Mather in New York, and is on the faculty of the MFA Design Program at the School of Visual Arts.

**Heather Corcoran** is assistant professor of visual communications at Washington University in Saint Louis and principal of Plum Studio. Her work includes book design, information and brand systems, and articles about education and visual culture.

**Phyllis Cox** is currently the associate creative director for Bloomingdale's, and is in charge of the home division in marketing. She has been art director, design director, and creative director for many publications, including *American Film* and *Bride's*. In addition, she is a painter and a designer of jewelry and furniture. A past president of the Society of Publication Designers, she is a member of the American Society of Magazine Editors, where she served as a photography judge for the National Magazine Awards, as well as a member of the Art Directors Club, AIGA, and the National Arts Club.

**D. B. Dowd** is professor of visual communications at Washington University in St. Louis and illustrator and director for Ulcer City Motion Graphics, an animation development firm (*www.ulcercity.com*).

**Louise Fili** is principal of Louise Fili Ltd, New York, and co-author of over a dozen books on design, including *Euro Deco: Graphic Design Between the Wars*.

**Chip Fleischer** is the publisher of Steerforth Press in Vermont.

**Vince Frost** is the principal of Frost Design. He has designed and art directed *Big* and *Zembla* magazines and *The Independent* and *The Financial Times*, as well as done work for Nokia, Nike, Sony, Polydor, and Phaidon Press.

**John Gall** is the art director for Vintage/Anchor Books, the trade paperback division of Alfred A. Knopf, where he oversees 250 book covers a year. Previously, he was the art director for Grove/Atlantic. His designs for Vintage, Alfred A. Knopf, Farrar, Strauss and Giroux, Grove Press, Nonesuch Records, and others have been recognized by the AIGA, Art Directors Club, *Print*, *Graphis*, and *ID* magazine and are featured in the books *Next: The New Generation of Graphic Design*, *Less Is More*, and the forthcoming *Graphics Today*. He has also written about design, covering an array of topics ranging from the history of Grove Press to contemporary skateboard graphics.

**Kim Hastreiter** is the editor of *Paper* magazine.

**Scott Hawley** was an art director and copywriter at Carlson & Partners, New York, working on the Polo/Ralph Lauren national advertising. He has also written and directed commercials. Hawley was the senior creative director for Gap, San Francisco, and was senior creative director for The Children's Place, New York. His essays are found at *www.scotthawley.blogspot.com* and *www.thelizadiaries.blogspot.com*.

**Steven Heller** is art director of the *New York Times Book Review* and co-chair of the School of Visual Arts MFA Design Program.

**Drew Hodges** is principal/creative director of SpotCo in New York, which he founded in 1987 as a design and advertising agency specializing in the theater and entertainment industries.

**Dimitri Jeurissen** is a principal at Base, a design studio with offices in Brussels, New York, Barcelona, and Madrid. The studio specializes in creative direction and brand development. In addition, it has produced its own products, created *BEople*—a magazine about Belgian culture—and established BaseWORDS, a division dedicated to creative writing.

**Lilly Kilvert** is a film production designer. She earned her second Oscar nomination for her work on Edward Zwick's *The Last Samurai*. She previously worked with him on *Legends of the Fall*, for which she received an Academy Award nomination. She has collaborated with filmmaker Rob Reiner four times, designing the sets for *The Story of Us*, *The American President*, *The Ghosts of Mississippi*, and *The Sure Thing*. Additional film credits include *Heart Breakers*, *City of Angels*, *The Crucible*, for which she was nominated for the Art Directors

Guild Award, *Strange Days, In the Line of Fire, Jack the Bear, Late for Dinner, I Love You to Death, Ruthless People,* and *To Live and Die in L.A.*

**Sunita Khosla** has over thirty-five years of experience in advertising. She was creative director for Ogilvy & Mather in India, before setting up her own creative boutique, where her major clients included Xerox and UNICEF. Her campaign for the Indian Cancer Society won several awards and has been featured in David Ogilvy's book, *Ogilvy on Advertising.* She currently heads her own corporate communications company called Resonance. She describes herself as a free spirit, a dreamer, a champion of lost causes and lost donkeys.

**Victoria Maddocks** is the design director of Kiehl's.

**Lauren Monchik** lives in New York, where she likes to make things and see things other people have made.

**Vicki Morgan** and **Gail Gaynin** are long-time friends and independent representatives who merged their talents in 1995 to form Morgan Gaynin Inc. (MGI). Working out of their downtown Manhattan office, Vicki and Gail have a small and highly respected agency that enjoys an attentive partnership with over thirty illustrators in six countries.

**Peggy Northrop** is the editor-in-chief of *More* magazine. She has worked in publishing for more than twenty years and has held senior editorial positions at *Vogue, Glamour, Redbook, Real Simple,* and *Organic Style.* She has won numerous awards for her work, including the American Society of Magazine Editors' Ellie award.

**Sharon Okamoto** worked for Walter Bernard and Milton Glaser at WBMG, Inc., where projects included magazine redesigns and prototypes. At *Time* magazine, she was associate and later deputy art director. Later she worked as special projects art director on all *Time* special issues, as deputy art director of *Life* magazine. She also redesigned *Working Mother* magazine. Awards and recognitions include those from the Society of Publication Designers, the Art Directors Club, Communication Arts, American Illustration, and the Society of Illustrators.

**Emily Potts** is the editor of *Step* magazine.

**Robert Priest** is the principal of Priest Media, an independent design practice with a wide range of publication clients, which include *InStyle* magazine's special issues, Yahoo!, *More* magazine, and the literary bimonthly *Oxford American.*

**Rhonda Rubinstein** is the creative director of the San Francisco design studio Exbrook, where she develops and packages editorial ideas. She believes design makes ideas visible, and changes how people see and act in the world. Rhonda is currently creative director for United Nations World Environment Day 2005 and recently developed the San Francisco issue of *Big* magazine. Previously, she has art directed such publications as *Esquire*, *Details*, and *Mother Jones*. In addition, Rhonda writes about photography, design, and culture for such publications as *Print*, *Emigre*, *ID*, and *Eye* and has been a contributing editor for magazines about the visual world.

**Ina Salz** is an associate professor of electronic design and multimedia at the City College of New York and the founder of InaNet, a job-listing service for editorial art directors and designers. A board member of the Society of Publication Designers, she chairs the Magazine of the Year Award. She has been an editorial art director at publications such as *Time* magazine's International Editions, *Worth* magazine, *Golf* magazine, and *WorldBusiness* magazine and has consulted at the *New York Times Magazine* and *BusinessWeek*. She is on the design faculty of the Stanford Professional Publishing Course, where she lectures on designing successful newsstand covers, among other design-related topics. A columnist for *Step* magazine and a feature contributor to *Graphis* and other design magazines, Ina is a frequent lecturer and a judge for a number of design competitions.

**Benjamin Savignac** is art director of *DEdiCate* magazine, a French fashion quarterly.

**Michael Ulrich** is the art director of *Step* magazine.

**Véronique Vienne** is a creative director, marketing consultant, and author who has written extensively on design ethics and business practices. She has edited, art-directed, and written for high-profile design magazines such as *Communication Arts*, *Eye*, *Graphis*, *Aperture*, *Metropolis*, and *Print*. A faculty member of the School of Visual Arts design program, she teaches a course in design criticism. The author of several books, including best-selling *The Art of Doing Nothing* (Clarkson Potter), she lives in Brooklyn, New York, and Paris, France.

**Laetitia Wolff,** who is currently senior design editor at *Surface*, and formerly the editor-in-chief of *Graphis*, is the founding director of futureflair, the creative conduit through which she consults on design, culture, and design trends. She is the author of the Design Focus book series (Gingko Press) and has curated a number of exhibits, including the first-ever retrospective of the graphic artist Massin. One of her current projects is a Massin monograph for Phaidon Press.

# Index

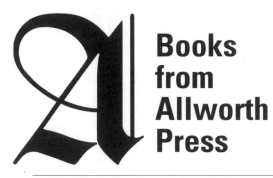

# Books from Allworth Press

Allworth Press is an imprint of Allworth Communications, Inc. Selected titles are listed below.

**The Graphic Design Business Book**
*by Tad Crawford* (paperback, 6 × 9, 256 pages, $24.95)

**Teaching Graphic Design**
*edited by Steven Heller* (paperback, 6 × 9, 304 pages, $19.95)

**Thinking in Type: The Practical Philosophy of Typography**
*by Alex W. White* (paperback, 6 × 9, 224 pages, $24.95)

**Design Literacy, Second Edition**
*by Steven Heller* (paperback, 6 × 9, 464 pages, $24.95)

**The Education of an Illustrator**
*edited by Steven Heller and Marshall Arisman* (paperback, 6¾ × 9⅞, 288 pages, $19.95)

**Editing by Design, Third Edition**
*by Jan V. White* (paperback, 8½ × 11, 256 pages, $29.95)

**The Elements of Graphic Design: Space, Unity, Page Architecture, and Type**
*by Alexander White* (paperback, 6⅛ × 9¼, 160 pages, $24.95)

**Graphic Design History**
*edited by Steven Heller and Georgette Balance* (paperback, 6¾ × 9⅞, 352 pages, $21.95)

**Texts on Type**
*edited by Steven Heller and Philip B. Meggs* (paperback, 6¾ × 9⅞, 288 pages, $19.95)

**Looking Closer 4: Critical Writings on Graphic Design**
*edited by Michael Bierut, William Drenttel, and Steven Heller* (paperback, 6¾ × 9⅞, 304 pages, $21.95)

**Citizen Designer: Perspectives on Design Responsibility**
*edited by Steven Heller and Véronique Vienne* (paperback, 6 × 9, 272 pages, $19.95)

**American Type Design and Designers**
*by David Conseugra* (paperback, 9 × 11, 320 pages, $35.00)

Please write to request our free catalog. To order by credit card, call 1-800-491-2808 or send a check or money order to Allworth Press, 10 East 23rd Street, Suite 510, New York, NY 10010. Include $5 for shipping and handling for the first book ordered and $1 for each additional book. Ten dollars plus $1 for each additional book if ordering from Canada. New York State residents must add sales tax.

To see our complete catalog on the World Wide Web, or to order online, you can find us at ***www.allworth.com.***